Fine Prints

Also by Lauris Mason

Print Reference Sources; A Select Bibliography, 18th to 20th Centuries
 (compiled with Joan Ludman)

Fine Prints

COLLECTING, BUYING, AND SELLING

Cecile Shapiro AND Lauris Mason

With glossaries of French and German terms by Joan Ludman

HARPER & ROW, PUBLISHERS
New York Hagerstown San Francisco London
1817

Grateful acknowledgment is made for permission to reprint the following:

Auction Catalog #3639 May 14–16, 1974, reprinted by permission of Sotheby Parke Bernet Inc.

Print documentation sheet for the Robert Rauschenberg, "Preview, from Hoarfrost Editions," No. RR74-688 reprinted by permission of Gemini G.E.L.

Drawing adapted from Glossary reprinted by permission of Conservation Information Program, Smithsonian Institution.

International Auction Review–Auction House Supplement from *Print Collector's Newsletter*, vol. III, no. 1 reprinted by permission.

Catalog #153 reprinted by permission of Kornfeld und Klipstein.

FIRST EDITION

Designed by Patricia Girvin Dunbar

Library of Congress Cataloging in Publication Data

Shapiro, Cecile.
 Fine prints.
 Includes bibliographical references and index.
 1. Prints—Collectors and collecting. I. Mason,
Lauris, joint author. II. Title.
NE885.S42 1976 769'.075 76-9200
ISBN 0-06-013853-X

76 77 78 79 10 9 8 7 6 5 4 3 2 1

To David and Danny, for their love, encouragement,
and expert assistance every page of the way

Contents

Acknowledgments

We are grateful to:

Helga Burton and Dr. Denis-J. Jean, respectively of the German Department and the French Department of Hofstra University for devoting long hours and great skill to helping us refine the foreign-language glossaries.

Sylvan Cole, Jr., Director of Associated American Artists, for his generosity in reading and commenting on portions of the manuscript.

Tatyana Grosman, founder and head of Universal Limited Art Editions; Tony Towle, executive secretary and major factotum; and the other members of the ULAE staff who were so gracious with their time and hospitality.

Ruth Ziegler of the print department at Sotheby Parke Bernet for sharing her wide background during a long interview.

All the museum curators who so patiently completed our questionnaires and added valuable comments.

The print publishers who supplied us with unique data by responding so openly to our questionnaire.

The reference librarians who have been so helpful and the collections that have been so rewarding at the Dartmouth College Library, the Hofstra University Library, the Great Neck Public Library, and the Jericho Public Library.

Ruth Janssen and Carol Sirefman for their skilled assistance; Lois Garrity and Mary Hogan for typing the manuscript.

The many printmakers, friends, dealers, and collectors who—sometimes by their questions, sometimes by their answers—helped to make this book.

As the Spanish proverb says, "He, who would bring home the wealth of the Indies, must carry the wealth of the Indies with him," so it is in traveling, a man must carry knowledge with him if he would bring home knowledge.

James Boswell, *Life of Samuel Johnson*, 1791.

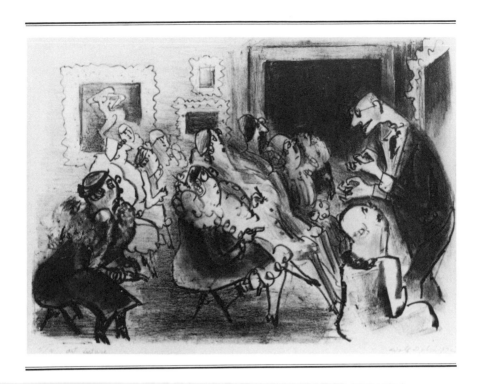

DEHN, ADOLF (1895–1968) *The Art Lecture*
Lithograph. 1932. Signed. Ed: 15. 7¾″ x 11″. Courtesy of Mason Fine Prints.

It is the peculiarity of knowledge that those who really thirst for it always get it.
Richard Jefferies, *County Literature*, c. 1880.

1. *What the Print Collector Needs to Know*

This book is for the amateur print collector, amateur in the root meaning of the term—that is, one who loves. We hope to address those who love fine prints, who collect them for pleasure, and who want to learn more about every aspect of collecting original prints. Our ideal "common reader," to use Dr. Johnson's phrase, already owns some prints, knows something about the techniques of the various media, probably has some favorite artists and periods, and has begun to put together a library of reference books as well as a print collection. Our common reader, in other words, is well on the way to becoming an advanced collector who will attain the status of "expert" without any loss of amateur standing.

Our ideal reader will also want advice about the financial aspects of print collecting—and here we believe we can qualify as experts. Since mistakes always hurt, and expensive mistakes hurt most of all, we caution that the more you know, the better you'll buy. The more costly the print the more negotiable it should be—meaning that it can be bought and sold easily, quickly, and without loss of money. If a profit can be made, whether large or small, so much the better. It is necessary, in our opinion, to be aware of dollar values in collecting because every amateur at one time or other will want to dispose of some prints as well as collect new ones.

We occasionally recall an auctioneer who was talking up a quantity of miscellaneous nineteenth-century porcelain with the comment, "This lot will be great for dealers." Then he thought for a moment and added with a grin, "But when it comes to buying antiques, we're all dealers, aren't we?" We think he was right, in the sense that those who collect antiques usually want to upgrade their collections at some time, or their needs or interests change and they find that they must sell something they bought earlier.

This is true of those who have collected almost anything, and it is surely true of most print collectors. People who have done this sort of buying and selling in certain quantities have often been referred to as "gentlemen dealers." Since we have foresworn sexist terminology and "gentleperson dealer" has an awkward ring, we'll settle for mentioning the term and noting that our ideal, print-collecting, common reader is at times a dealer too.

Some people feel that to discuss money in the same breath as art is to dirty one with the other. We recognize that argument and respect it. Certainly more than one artist has been discouraged by the attitudes that underlie "art-as-investment," and not only the conceptualists, whose reaction to the phenomenon has led some of them to refuse to create objects that can be bought and sold for the profit of others. No matter what their style, all genuine artists, presumably, except when working on assigned commission, create works without reference to possible sales and prices. Still, the fact is that art objects must be purchased with money, and since prints are bought and sold every day, one might as well learn how to buy and sell intelligently.

TYPES OF PRINTS

There are four major types of fine prints, with an infinite number of variants. The oldest method is the *woodcut*, in which a design is cut into a plank of wood. The surface that remains is inked. Since the portion that has been cut away receives no ink, only the raised surface prints when paper is placed over the woodblock and pressure is applied. Wood engraving is a variant of this technique.

Etching involves lines cut into a metal surface or plate. In this technique a design is incised into a plate that has been covered with an acid-resistant material. When the plate is placed in an acid solution only the lines that have been drawn through the acid-resistant material can be bitten into, with the result that these lines are deeper than the surface of the plate. Ink is deposited into the lines when it is rolled over the plate. Whatever ink remains on the surface is wiped away, so that only the incised portions print when the plate is passed through a press. Aquatint, drypoint, engraving, mezzotint are variant intaglio methods employing metal plates.

Lithographs are made from stone (and now metal plates) by means of a technique based on the principle that oil and water do not mix. Designs are made on the stone with greased pencils or inks. After the stone has been treated in certain ways only the portion that was drawn with the special greased material will print when the stone is inked and rolled through a lithographic press.

Silkscreens or *serigraphs*, different names for the same thing, are new-

comers to fine arts, although the technique had been known earlier. It is a stencil method in which the surface of a screen made of silk or other material is covered over with a substance that stops out the flow of ink or paint except for the design that has been drawn directly on it. The design will therefore print on paper when ink is forced through the screen by means of a squeegee.

Each of these techniques may be used for color or black and white, and in each more than one block, plate, stone, or screen may be used to make a single print. Any of these—or other—techniques may be mixed in one print. In all but silkscreen and offset lithography the image is reversed in printing. Each method has different intrinsic limitations on edition size —which may have little to do with the size of a given limited edition.

Each of the major methods is easily recognizable to the print connoisseur. Some artists work in only one of these media, others in all of them. Some artists complete the entire process from conception to printing and distribution entirely on their own; others require assistance at every step. Quality makes no reference to choice of medium.

Until recently all of these were entirely hand methods. Today some artists making prints in any medium may employ photo-mechanical means of transferring the image to the plate, although none of these methods, as employed by artists, is a reproductive process.

The foregoing definitions are extremely simplified. Somewhat more complete ones, along with most of the ancillary terms, can be found in our glossary and for those who want to know all the details and variants, we suggest the books listed under "Technique" in Chapter 6, "Building a Print Reference Library."

FORGET PROFIT AND LOSS?

There are buyers of prints, to be sure, who refuse to allow profit-and-loss considerations to sully their joy in collecting. One couple we know buys prints in the same way they buy furniture or vacations, or Indian artifacts, which they also collect. They buy what they love, where they find it, at the moment of passion. Like money spent on other luxuries—be they holidays, clothes, or Oriental carpets—they don't expect to see those vanished greenbacks again. What this couple buys is lovely, since their taste is good and their background excellent. But they have frequently overpaid, and what they have tired of can rarely be sold for as much as it cost. One of the things they loved and bought, for instance, was a charming etching of two young girls by Renoir (French, 1841–1919) for $40. The only problem is that the print is a restrike, unsigned, worth no more than $50 in the mid-Seventies, whereas if they had bought the real thing in 1960, it would have had a negotiable value of over $500. Nonetheless, this couple

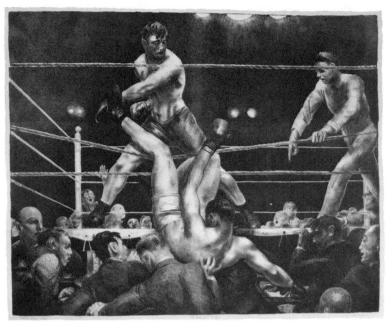

BELLOWS, GEORGE (1882–1925) *Dempsey and Firpo*
Lithograph. 1924. Signed. Ed: 103. Ref: Bellows 89. 18⅛″ x 22⅜″. Courtesy of the Collection, The Metropolitan Museum of Art, New York. Harris Brisbane Dick Fund, 1925.

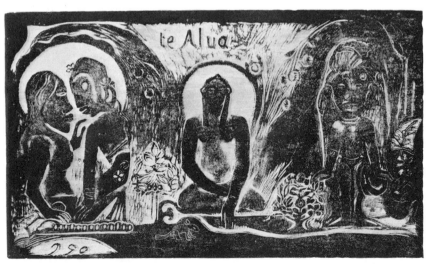

GAUGUIN, PAUL (1848–1903) *The Gods*
Woodcut on end-grain boxwood. c. 1891–1893. Ref: Guérin 31. 8″ x 13⅞″. Courtesy of the Collection, The Museum of Modern Art, New York. Gift of Abby Aldrich Rockefeller.

SHAPIRO, DAVID (b. 1916) *Waterfall I*
Silkscreen. 1973. Signed. Ed: 20. 21¼" x 29". Courtesy of the artist.

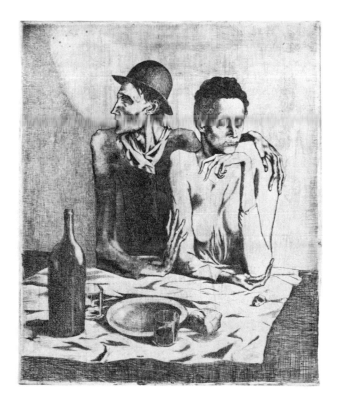

PICASSO, PABLO (1881–1973) *The Frugal Repast*
Etching. 1904. (Printed by Vollard, 1913.) Ed: 250. Ref. Geiser 2/II/b. 18⅜"
x 14¹³⁄₁₆". Courtesy of the Collection, The Museum of Modern Art, New York.
Gift of Abby Aldrich Rockefeller.

consider their money well spent if they have enjoyed what they've bought, and in any case they do not spend large sums on prints.

Another couple we know plunged more heavily and came off less well. One day they saw and impulsively bought a large color lithograph signed by an internationally renowned contemporary Spanish surrealist whose talent for publicity surpasses all his other gifts. They paid a reputable print dealer in New York $1500 for it. Nothing was misrepresented; the print was as described. But when they told us about their purchase, we were appalled because there is at the present writing little re-sale value on these color lithos. When they learned that they could have bought the print for a fraction of the price, they were dismayed. More than that, although verbally the dealer had agreed otherwise, at the crunch she was unwilling to make a cash refund in exchange for the print, with the result that the matter, sad to say, went into the hands of lawyers.

None of this could have happened if they had read our chapter on connoisseurship before handing over their money. There and elsewhere in this book we point out the various print categories, suggest which ones meet a generally agreed upon standard that allows them to be called original prints, and how to make sure you are buying a fine print at the right price.

It is exactly our friends' sort of mischance that leads some people who at first might not have wanted to tarnish art with money to reconsider their stand and decide to learn enough about dollar values in fine prints to avoid ever being stuck again. The primary trick, then, is to buy prints that you really want but which are also negotiable; that is, prints that have sufficient mobility to be re-sold at the same or at a higher price than was paid originally. The more expensive the print, the more this suggestion applies. If you are buying contemporary graphics by an artist whose prices are relatively modest, or if you are buying an older print by a forgotten or neglected printmaker, obviously it does not matter much if the print has little mobility, for you stand to lose little should you wish to sell after enjoying the image for a period.

A man we know is a print lover who adds to his collection year by year, one or two prints at a time, buying as he discovers things that please him. Yet every so often he purchases four or five new ones at a clip, often by artists whose work he has never collected before. Almost simultaneously he offers for sale through his dealer a more or less equal number of prints from his collection. He usually realizes at least as much—and often more —than he paid in the first place. The point is not that he needs the money to finance new purchases—he's a canny businessman who's made lots of money. But his taste evolves—and even he does not have sufficient space for an infinite number of prints. It is immensely gratifying to him, moreover, to find that his love of prints is financially almost self-liquidating.

Suppose, however, that you don't have lots of money, just lots of love. Then you need lots of knowledge, for there is no other route for the bargain hunter. One nice thing about prints is that collectors of them can come from almost any economic level. A man we know pops into second-hand shops, bookstores, and even antique shops whenever he has a chance to browse and a few dollars to spend. In 1973 he found a Grant Wood (American, 1892–1942) for $50 that sold for $675 in 1974. If he had been sufficiently interested in Wood's prints, he would have kept it, as he has many others. But before he was able to sell it for the right price, he had to know how to examine it carefully and how to ascertain the best current price. We discuss these later in the book.

Another time our very knowledgeable bargain hunter struck the jackpot in an unimposing antique shop in a New England village. There he found a Whistler (American, 1843–1903) signed in the plate, but without the little butterfly monogram that is associated with him. The shopkeeper was aware of his signature and even called it to the attention of our friend— but she did *not* know the value of the print. She asked $85 for the etching, "Rotherhithe," one of his better known prints. Our friend wanted to check the paper, the dimensions, and the state so that he could make sure that what he had in hand was indeed an original Whistler etching, not a reproduction. Since he did not carry a *catalogue raisonné* in his back pocket— although it did contain a magnifying glass—his first step was to buy the print with a written money-back guarantee, even though his educated eye told him that he was looking at the real thing. At home at his leisure he was entirely convinced, with the aid of the *catalogue raisonné, The Etched Work of Whistler* by Edward G. Kennedy, and a 10× magnifying glass used under excellent light, that his find was indeed a genuine impression of "Rotherhithe." He was not interested in adding it to his collection, so his next task was to find out current prices before he could offer it for sale.

Whistler prices have fluctuated dramatically, perhaps more than those of any other nineteenth-century graphic artist. His etching, "The Balcony," for instance, brought more than $2000 in the Twenties, yet sold for $100 in 1937, and in the same Depression year his lithograph, "Confidences in the Garden," went for about $20 at Sotheby's in London. By 1971 some of his etchings at a Parke Bernet auction were in the $2000–$2500 range, although there were particular prints that brought more—and lithos that realized a great deal less. By research through priced auction catalogs our friend found out his $85 print had a current retail value of about $2000.

But business was so sluggish when he offered it at $1250, first to one and then to another major dealer, that it was a third who bought it. The dealer, in turn, probably had a customer in mind or in hand who was prepared to pay the then current price of $2000. Shortly thereafter another impression of the same print was sold at a West Coast auction for $1800.

Since auctions normally reflect a price lower than retail, did our friend weep because he might have sold his for more money? Not at all, for even after deducting $125 to have the print cleaned and for the removal of old tape, he had made a magnificent profit. And if the auction had gone the other way, reflecting newly depressed prices, he might have had to sell the print for less or hold on to it for a long period, waiting for the business and/or the taste cycle to change.

How long might that be? That depends—a weaseling answer, but it does depend on your aims in buying and selling!

During the Twenties there was speculation in prints just as there was in the stock market. A Muirhead Bone (English, 1876–1953) print, according to Sylvan Cole, director of Associated American Artists, "would be sold at Knoedler's or Keppel's—the first ten impressions for $200, the next ten for $250, then $300 and up." Today his prints are in the $150 to $200 range. In a catalog of the firm of Harlow-Keppel in the early 1940s the prices surprise us, reflecting as they do different priorities. "Trois Femmes Noires" by Pablo Picasso (Spain, 1881–France, 1973) is listed at $65 while the etching "Penzance" by James McBey (English, 1883–1959) is $485; "Eight Bells" by Winslow Homer (American, 1836–1910) is $24 while Joseph Pennell's (American, 1857–1926) "The Ferry House" is $95; Ernest Roth (1879–1961) and Edward Hopper (1882–1960), American contemporaries on facing pages, are priced, respectively, at $36 for the former's "Queensborough Bridge" and $30 for the latter's "American Landscape." All these prices in the current decade have shifted in relative value to each other as much as they have over all. Today the Picasso is more costly than the McBey, the Homer more than the Pennell, and the Hopper, of course, brings more than fifteen times the price of the Roth.

What this means is only that not every artist who is highly regarded during his lifetime will maintain his reputation after death. Indeed, both strong and weak artists can lose their attractiveness to buyers during their most productive years as well—either because of a stylistic development that is unacceptable to their public (Rembrandt [Dutch, 1606–1669] is the classic example), or because, while the style remains constant, the most influential sectors of public taste move on to something else—which may be better or very much worse. And time, which smoothes out many things, will not necessarily justify one or the other evaluation, nor will there necessarily be any consistency. The paintings of Thomas Moran (1837–1925), the American landscape painter so popular in the late nineteenth century, are esteemed once again and they command impressive sums, yet prints made from any one of his more than 80 plates could be purchased in the mid-1970s for $150 to $350.

In the same way, the artists' prints now selling at high prices are not

guaranteed to remain at that level. The etchings in Picasso's Vollard Suite sold in this country in the early 1940s for about $50 each. The entire suite of 100 etchings went for a quarter of a million dollars in 1973, and in an auction during the same year a single example brought $3000. Yet in 1974 another etching from the suite went for slightly over half that figure, yielding only $1600.

Or consider, as examples, some of the prints published by the Associated American Artists Gallery. "I Got a Gal on Sourwood Mountain" by Thomas Hart Benton (American, 1889–1975) was issued at five dollars, the price of AAA prints from their inception in 1934 until 1953, when the era of the five-dollar print ended. In the mid-Seventies it brought $625. Grant Wood, a fellow Regionalist, created his lithograph "Honorary Degree" for the five-dollar print series; in a Seventies exhibition it was listed at $900. Yet many other examples in the same show, the Fortieth Anniversary Exhibition of the Associated American Artists in 1974, executed by lesser known artists during the same decade, are still available for as little as $40 to $60, and some of the prints published in 1974 were then purchasable at $15. Increments in price for the least and the most expensive will not necessarily remain in the same relationship to each other a year, a decade, a lifetime from now.

The length of time, therefore, that you have to wait to realize the maximum price for prints you no longer want depends on too many variables for the question to be answered completely here. There are changes in taste; there are economic ups and downs; artists are taken up by people of influence and dropped again; artists die, and interest in their work often dies with them; or they may happen to be artists whose work is scarcely noticed *until* they are dead—yes, even today. Sometimes an innovator's work looks merely silly as time goes by; at other times a conservative gains luster from the patina of time. And so on—no one can outguess the future.

What this book *can* do for you is guide you in the means of taking as few risks as possible in collecting; introduce you to the tools of the expert; help you to learn how to use them. We have no interest in influencing your taste, and we hope therefore to avoid esthetic judgments. What we would like to do, then, is help the print lover—the amateur who collects because the object of affection is almost irresistible. We hope to help you learn where to see prints and where to buy them, how to judge their condition and value, how to store and restore prints, how to locate the many books and catalogs that can back up a collection, and how to sell prints for the best price when there is a wish to dispose of any. For all these print lovers—and that includes just about everyone who owns or wants to own more than a few impressions—this book will become, we hope, a well-thumbed source of information and guidance.

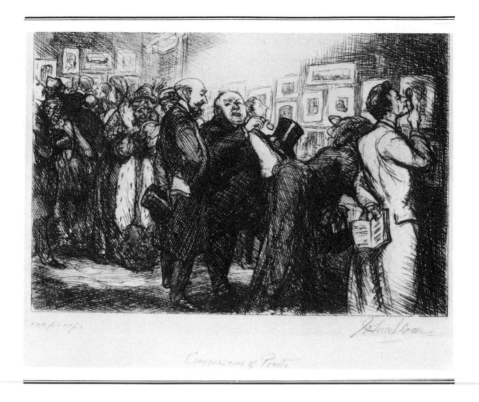

SLOAN, JOHN (1871–1951) *Connoisseurs of Prints*
Etching. 1905. Signed. Ed: 100. Printing: 105. Ref: Morse 127. 5″ x 7″.
Courtesy of Mason Fine Prints.

*For sure no minutes bring us more content/than those in pleasing,
useful studies spent.*
John Pomfret, *The Choice*, 1.31., c. 1702.

2. *Examining a Print: Tools That Inform the Eye*

By definition, the connoisseur is knowledgeable. The print connoisseur takes pleasure in learning all the details that enhance an understanding of prints—from the intricacies of the various techniques of printmaking to the types of paper used for graphics. Connoisseurs train their eyes and warm their souls by visiting the many permanent print collections and changing exhibitions open to the public. They collect whatever exhibition catalogs are available. They keep informed about print reference books as they continually enlarge their personal libraries. The cognoscenti subscribe to appropriate periodical publications and collect priced auction and dealer catalogs. These they carefully file away according to whatever system they devise to make them easily retrievable—or you may want to try the system we suggest in Chapter 7. Further, the capable collector finds out what *catalogues raisonnés* and other documentary materials are available. (We suggest consulting *Print Reference Sources: A Select Bibliography, 18th to 20th Centuries,* compiled by Lauris Mason with the assistance of Joan Ludman. It is the only such published list for the period at this writing.) Most important, the serious aspirant to print expertise should learn how to use each of these tools with skill and discernment.

THE CATALOGUE RAISONNÉ

The collector who becomes adept at reading these descriptive lists, the *catalogues raisonnés,* will be rewarded. Such itemized lists of prints may be concerned with a single artist or, less commonly, they may catalog the prints of a school, a group, or a period. The best of them illustrate each print listed. Many are in English, and others are translated into two or three languages (including English) within the same volume—but don't

fear those solely in French, German, or whatever, even if you don't command the language. The nature of a list obviates the need to know much about the grammar or construction of the language it uses, and an ordinary French-English or German-English dictionary, as the case may be, will suffice most of the time. Further, the foreign language glossaries at the end of this book translate most of the common words and phrases needed for reading international print publications.

A *catalogue raisonné* for an individual artist should list his entire oeuvre in the graphic arts (every single print the artist has executed), *at the time the book was published*. This last is crucial, since sometimes, as for instance in the case of Thomas Hart Benton, the *catalogue raisonné* has been compiled while the artist was still active, and prints executed thereafter obviously cannot be included in a work published earlier. At times, then, a supplement becomes necessary, and in some cases—that of Jean-Emile Laboureur (French, 1877–1943) is an example—the *catalogue raisonné* is in two volumes, one published while the artist was alive and the second after death ended his work. Or it might be noted that the fourth volume of the *catalogue raisonné* of the lithographs of Marc Chagall (b. Russia, 1887), who continues to produce prints, has recently been published.

All such *catalogues* are arranged in chronological order. (A notable exception is the *catalogue* made by Emma Bellows of the oeuvre of her husband, George Bellows [American, 1882–1925], in which the prints are listed as they came to hand.) Ideally, they include the following: the artist's title for each print and the date of each print's publication; the technique (etching, lithograph, etc.) in which it was executed; the number of prints planned and completed in the edition, when this is known; the measurements of the image and of the paper; the number of states and their details as known, and the size of the edition of each state, when known; the kind of paper on which it was printed; information about whether the print was signed by the artist in pen, pencil, or crayon, and if so, where on the plate or paper it was signed and/or stamped. If the plate has been canceled or effaced, that too should be recorded. Frequently, public collections where the print may be seen are listed when this is possible. Each of these items is of value, and fortunate the artist—and collector—for whom this key tool exists.

Not surprisingly, though, not every artist is documented. James Abbott McNeill Whistler, of course, is better documented than virtually anyone, with over 400 etchings cataloged and illustrated in the Edward G. Kennedy volume, and 166 lithographs documented in Thomas R. Way's *catalogue raisonné*. But John Taylor Arms (1887–1953), the esteemed American etcher, has never been the subject of a complete *catalogue raisonné*, although his wife completed a list that remained unpublished until 1975. When, in that year, an exhibition of Arms's etchings was held

at the Elvehjem Art Center at the University of Wisconsin, it became the occasion for a catalog that illustrates some of the 50 prints shown and additionally includes a descriptive catalog of all 440 of the artist's etchings, compiled from Mrs. Arms's typescript, which can be consulted in the Print Room of the New York Public Library.

Sometimes descriptive lists are tackled by graduate students in art history. One such has been done for the American painter and printmaker Charles Sheeler (1883–1965). Even when this kind of scholarly compilation has not been published the material is available to the interested collector, who may either read the typescript in the university library of origin or order copies (at a cost of about $12) from University Microfilms, Ann Arbor, Michigan. *Print Reference Sources*, referred to earlier, includes such unpublished sources in its lists.

Once you are using such an itemized list, the *catalogue raisonné*, it is essential to understand what it can and cannot do. The *catalogue raisonné* cannot substitute for the trained, loving eye, but it can consistently supplement and confirm the reactions of an experienced collector. Recently we bid successfully on a Maurice Denis (French, 1870–1943) print, sight unseen, from an English auction catalog. It was described there as "not in Cailler" (Cailler being the author of the *catalogue raisonné* of this artist's graphic work), and the print—called "Italian Garden"—was signed with two names, "M. Denis" and "Louis Moret." When it arrived we were puzzled. It looked like a Denis but somehow it did not look quite right. The Pierre Cailler *catalogue raisonné* could not help us, since we had been accurately informed by the auction catalog that it was not included. The print, we hazarded for a moment, might have been executed after the *catalogue raisonné* was completed, but we found that Denis had died in 1943 and the *catalogue* had not been published until 1968. It could be a fake, we hypothesized next, but the auction gallery is a reliable one that is in the habit of ascribing work accurately.

Puzzled, we were not happy about the print and proceeded to do some detective work. We began by looking up the second signature on the print, and after several false starts we found, with the help of Ms. Elizabeth Roth, Keeper of Prints at the New York Public Library, and her invaluable clipping file, what we needed. Louis Moret who countersigned the print, we discovered, was known for his fine copies of the work of other artists. The dates matched, satisfying us that we had bought a contemporary "après" copy of a Denis *painting*, perhaps not without value, but certainly not worth what we had paid.

We would have handled this by mail, as we did the original purchase, since merchandise inaccurately described in the catalog is returnable to every reputable auction house. But it happened that we were to be in England a short time later, so we carried the print along with us, delivering

it to the appropriate person at the London headquarters. He was most apologetic. The explanation, no doubt entirely true, was that the description of the print as stated by the consignor had been accepted without question or investigation, a mischance caused, probably, by the few days absence of the resident expert at the auction house. We were given an immediate cash refund, but the point is that we might be holding a fraudulent Denis if we had not felt something to be wrong and followed the hunch by investigation. The fact that the print was "not in Cailler" was the first clue.

That can serve as an example of a print that is not included in a *catalogue raisonné* for the best of reasons—it was never made by the purported artist. Now let's see of what use the *catalogue raisonné* can be when the print we are examining *is* listed.

Each entry has a function. If the *catalogue raisonné* contains reproductions, you will be able to see whether your print *looks* the same as the print by the same title in the *catalogue*. You can check the media as described, and even without reproductions you will have sufficient information to make sure that the published information about the date (if the print was dated) and the measurements of the paper and print tally with the print you have in hand. Pablo Picasso's lithograph "L'Ecuyère" (Bloch 999, Mourlot 333) is a relatively easily recognizable forgery because the original was printed on Arches paper, whereas the copy—falsely numbered and signed—was not. (Careful study of the image reveals differences, too, but because of the forger's lapse in matching the original paper, even the tyro can spot this one. At the end of this chapter we include suggestions on the identification of paper.)

As another example, someone we know bought a Matisse (French, 1869–1954) for a tiny price. It turned out to have measurements slightly larger—by perhaps a quarter of an inch in both dimensions—than the original, and on further scrutiny of the image and the well-documented exhibition catalog that has been used in lieu of a *catalogue raisonné*, it was clearly revealed as a reproduction. This does not necessarily mean that the person selling it deliberately committed a fraud, for she too may very well have been fooled, or she may have reasoned that any buyer paying only a few dollars for a "Matisse" ought to know that the print could not possibly be a valuable original. Yet it is the sort of mishap that leads us to reiterate that "caveat emptor" remains good advice. The buyer must beware—or be able to afford the loss. In the case of the Matisse just mentioned, the loss was relatively small and worth the lesson it taught. The wary collector, when buying from sources other than established dealers, would also do well to check both the *Print Collector's Newsletter* and the Italian periodical, *Print Collector*, when buying costly prints that tempt forgers, for each tries to report fakes as they appear on the market.

Assessing the paper, measuring the print carefully, and noting whether it matches one of the states in the *catalogue raisonné* are steps that can assist the educated eye, but once we performed the ritual carelessly and paid dearly for it. We had four prints in the "Proverbio" series of Francisco Goya (Spanish, 1746–1828). The series had gone through nine editions, we found on looking it up, and we set a price when we offered the four based on the recent prices of other titles in the series. What we failed to notice in our haste, merely running our eyes down the pages, was that these last four plates in the series by Goya had never been printed with the others. Indeed, the four had not been editioned at all until 1877 by *L'Art*, a periodical, and it remained the sole extant edition until a much more recent one, post-dating our experience, of 300 in Paris in 1974. We had sold, then, a first and only edition for a fraction of its true value, for our four composed a scarce and valuable edition. All this we learned, too late, from the *catalogue raisonné*, after many phone calls from hopeful curators sent us dashing back to the *catalogue* to find out what they knew that we had missed.

Size of Edition

The size of an edition is always an issue, given the law of supply and demand and the fact that art in our society has a price on it. To state it simply, if there are 250 impressions of a print the rule of thumb generally holds that each print in the edition is of less value than one which was printed in an edition of 10 or 20 or 30. This is true *if* the print issued in a smaller edition was done by an artist whose work is in the same or greater demand as the work of the printmaker who did the larger editions. Do as many collectors want this print? Was it done by an artist who made as great a reputation as a printmaker? Which artist has been better promoted or taken up by the most prominent members of the art establishment? These factors have at least as great an influence on price as the numbers in the original edition or even, truth to say, the quality of the work.

Edition Size Influences Price

The size of the edition alone, however, can often be a clue to price, as it is for the prints of John Marin (1872–1953), the American modernist. Fifty-four prints are extant in his highly desired mature style, executed in the period 1911 to 1933. "Downtown, the El" (1921) was published in a steelfaced (see Glossary) edition of at least 500, all of them signed. The print sold in 1974 for $1500. On the other hand, "Brooklyn Bridge, #6" (1913) was issued in an edition of only 12, and the price of this rarity at the current writing hovers around $3000.

Artists are sometimes asked why they make such small editions. The

response of Reginald Marsh (American, 1898–1954) in the Thirties is typical of many printmakers. "I do not limit the edition," he said. "The buyer limits the edition—he rarely buys, I rarely print. I usually print fifteen or twenty," he told art writer Thomas Craven, who thought his leg was being pulled, "and sell one or two in the next five years—so why limit the edition?"

Edition size seems to dictate price for Edward Hopper's prints. His entire printmaking oeuvre comprises 26 prints (six more unpublished—no prints having been made from the plates), with wide variation in edition sizes. "Night Shadows," the largest, was printed in an edition that probably exceeded 500—and it sells for a lower price now than any of his other prints. The story for Chagall is similar, for his prices frequently have little to do with the subject matter of the print, the period in his stylistic development, or those prints most highly praised or most frequently reproduced. Numerous examples could be cited in this category—prints for which edition size is the paramount element accounting for the difference in price.

Yet quite as many examples might be assembled on the other side of the ledger, examples that demonstrate that subject matter or style have become the telling variables in a print's desirability. Grant Wood's "Honorary Degree," for instance, sells today for 20 to 25 percent more than his other prints, not because it is scarce but because more collectors seem to want to own it, presumably because its subject matter is more appealing. "Breaking up of the Agamemnon" by Seymour Haden (English, 1818–1910), of which numerous impressions were made, is nevertheless very much sought after, a matter reflected in the price—which in 1975 ranged from $600 to $1200—whereas his other prints often reach no higher than $200, even though their edition size is considerably smaller.

Sequence of Numbering of Modern Prints

One of the questions beginning collectors ask most frequently about modern prints is whether those with a lower number are more valuable than prints with a higher. (Numbering prints became common practice only after World War II.) That is, is the first print—let's say 1/250—superior to and therefore justifiably more costly than the last print rolled through the press, 250/250? Our answer is that if such numbers do affect the price, they ought not to, and you would do well to ignore the matter. It is only with drypoint, and less frequently with certain other kinds of etchings, such as aquatints, that continued printing in itself affects the quality of the proof. Rare is the serious artist who will continue printing in any medium (or allow the printer to continue) beyond the capacity of the plate to produce the exact, clear, crisp image wanted. If the printmaker were not

fussy in this way, you would be unlikely to want to add the work to your collection.

Signatures

A related problem that can arise, however, occurs when someone other than the artists or their designates prints new editions or enlarges authorized editions, for such individuals too often are concerned with the money to be realized from reprinting, not with the esthetic value of the print. This is, of course, why the artist's penciled signature assumes such importance —it becomes the printmaker's guarantee that he or she was actually the person who approved this particular proof of this specific print, that the impression meets with the approval of its creator in every way. Yet having said this, we must point out that the practice of signing prints in pencil (as contrasted with a signature or special mark on the plate itself) is relatively modern, having come into general practice late in the nineteenth century. There are prints of Seymour Haden, to take an example, that are signed and others that were not signed. More than that, Haden would add his signature, for a small fee, to any of his etchings that were brought to him for that purpose by their owners, even if they had been clipped from magazines or other publications. In our own day, Ben Shahn (American, 1898–1969) was one of several artists known to be willing to sign reproductions of his own prints.

Yet the genuine signature of the printmaker, notwithstanding, is normally a means that the artist takes to assure the purchaser that the paper, the tones of black and white or color, the inking and wiping of the plate (where this procedure is pertinent)—that all these details and more meet with considered personal approval. It is to prevent the plates, stones, or screens from getting into unauthorized hands for pirated editions, from which the artist can hope for no remuneration, that many artists destroy or cancel them when the edition is complete. (Some cancel by destroying the surface, usually by drawing a large X through the plate; others make a special mark somewhere on the surface to indicate cancelation.)

Canceling Plates

Destruction is not designed to make the print less available and thus artificially more valuable, but mainly to prevent unscrupulous people from issuing at some future date a new edition that may be faulty yet still travel round the world speciously representing the artist. Some artists, rather than cancel the plates, keep them, giving themselves the option to issue second and third editions later. (Some John Sloan [American, 1871–1951] plates were pulled three distinct times, by different printers.) Others may present the plates to museums, and in many cases the publishers

of the print keep the original plates as part of the terms of payment and publication.

Restrikes

Today the Chalcographe du Louvre (Etching Establishment of the Louvre) still prints at very low cost restrikes of masters from plates in their possession, as does the Regio Calcografia of Rome and the Chalcographia de Madrid. Depending on whether one wants to praise or disparage these often worn and weak impressions, one can call them either "late editions," "posthumous editions," or "restrikes." They are in no sense fakes, however, although they are usually worth no more than the few dollars charged. Such prints always carry identifying legends. The Whitney Museum, in cooperation with AAA, in 1971 issued in editions of 100 four of Reginald Marsh's etchings posthumously, using the plates that had been donated to them. Marsh had printed few impressions, yet these later editions were sold at prices that were uninflated, ranging from $40 to $90. The prints themselves, however, were of poorer quality than the lifetime impressions.

Publishers

Before we get back to the numbering of prints and the limiting of editions, related matters, it might be a good idea to say a brief word here about the function of those who publish prints. As long as there have been prints, there have been publishers. After all, early anonymous prints were most often book illustrations, long since replaced by photomechanical reproductions. Rembrandt made use of a publisher for some of his prints; others were self-published. Today there are numerous organizations throughout the world that publish fine prints, with such houses as Frapier or Sagot in France having been active for more than 75 years, and Associated American Artists, established 1934, now the veteran in the United States.

What publishers do, essentially, is to buy the entire edition of a given print, paying the artist outright for all of them. The publishers may have sought out the artist and commissioned the print, or they may have accepted a sample for which the artist solicited approval. However they have come by the print, they pay a lump sum for ownership of every print in the edition, whether 10 or 300. (Artists are usually permitted to retain the "Artist's Proofs," most often 10 or 20 copies or a fixed percentage of the edition. These might be in addition to the trial proofs of various states they would naturally keep.) The printmaker, having received a sum that amounts to 20 to 40 percent of the retail price, is now out of it, financially, and earns nothing further from the edition directly no matter what happens to its price. When the artist sells individual prints to retail outlets, as many choose to do, either from time to time or on a steady basis, it may be years

before the edition is sold, but more can be earned from each print, since the retail price is usually split about evenly between the retailer and the printmaker. Practice varies, and in all these matters there is no entirely standard usage. After buying an edition, it becomes the publisher's responsibility to merchandise the print, and it is in the publisher's interest, as well, to prevent the appearance of unauthorized editions.

Unlimited Editions

Many artists, Ben Shahn among them, have been philosophically opposed to the whole business of numbered prints in limited editions. These printmakers believe that to make prints scarce is precious and that so doing runs deliberately counter to the inherent inexpensiveness of the graphic media. Many kinds of print media, particularly woodblock, lithograph, and serigraph, have the potential of being printed in the thousands, and there is no intrinsic reason, many graphic artists argue, for prints not to be the most democratically available of the arts. Only snob appeal and price, they say, is fostered by numbered prints and limited editions.

It is this kind of reasoning that has led such a fine printmaker as Lynd Ward (American, b. 1905), parts of whose marvelous wood-engraved "novels" were republished in 1974 under the title *Storyteller Without Words*, to refuse to number and limit his editions—calling his editions what they are, "unlimited." To this day one can go to him for a particular woodcut, and if he's out of copies, and the block is usable, he'll print a new one for you. The tradition for doing so is old—a large number of Rembrandt's plates were reprinted over and over again for a couple of centuries before they were placed in the Bibliothèque Nationale; editions of the 80 plates, yielding thousands of impressions of Goya's "Disasters of War," have been pulled since his death. Leonard Baskin (b. 1922), the American sculptor and printmaker, has called the limiting of print editions corrupt, yet he does limit some of his editions—possibly because any other choice is difficult for artists today.

Certainly it is true that prints in the past were far less expensive *at the time they were issued* than prints are today. Even allowing for an inflation that has continued for hundreds of years, the publication prices of most major prints in the past were impressively low. Albrecht Dürer (German, 1490–1538?) noted that he had sold 16 small Passions, woodcuts, for 4 florins (about $20) and six engraved Passions (16 copper engravings) for 3 florins; Rembrandt's "Christ Healing the Sick" has been called the "Hundred Guilder Print" because there is a tradition that it brought that price, which it might have done, after his death. The first state, now in Vienna, has a phrase written on its back: "de 6 print op de plaat. f. 48 gulden" ("the 6th print from the plate for 48 gulden"), or about $20. William Hogarth (English, 1697–1764) sold the six plates of "Marriage

à la Mode" for less than 2 pounds, and the series of Charles Meryon's (French, 1821–1868) etchings called "Eaux Fortes Paris" was sold by him in 1866 for 25 francs. And one of the large original impressions of the "Views of Rome" by Piranesi (Italian, 1720–1778) could have been bought from the artist for around 50¢.

We can see that prices are inching up when we note those asked by Frederick Keppel, the publisher, for some of Whistler's etchings. Keppel bought the plates for Whistler's French set (which included "The Street at Saverne") and the Thames set (among which a favorite was "Black Lion Wharf"). He had the outstanding English printer, Goulding, remove the steel facing that had been applied to extend the life of the plate, thereby producing what are considered impressions superior to the first edition. Keppel then issued the etchings in editions of unknown number, probably at least 200 to 300 prints. He charged $36 for "The Street at Saverne" and $75 for "Black Lion Wharf." Whistler ultimately disassociated himself from Keppel because he thought the publisher was charging too much above the $12, $15, or $18 a print he himself received. According to the late Harry Katz, the grand old man of American print experts, who worked for Keppel, "Whistler never forgave Keppel."

In our own time the process continues. Contemporary prints selling for a thousand dollars and more have been editioned by several publishers, and prints by big name artists costing over $500 have become almost commonplace. To take a random example, seven lithographs by Jasper Johns (American, b. 1930) were published in 1974 at $750 each. These seem to have been subject, like the Whistlers mentioned earlier, to speculation, with impressions going at auction a few months later for $2200 each. Yet even today good inexpensive graphics are available, for both Associated American Artists and Ferdinand Roten publish quality prints by recognized artists for as little as $20.

Most printmakers these days go along with the prevailing system and carefully number their limited editions. To return to our question of a few pages back: do these numbers indicate the sequence in which each was printed? Theoretically, perhaps, the answer is "yes." Indeed, the sequence of numbers may represent somewhat more than a hypothetical arrangement when the print has been made in a very small edition, in black and white, for it is not too difficult in such circumstances to keep track—should the artist care at all about keeping track. Some do, believing that if they are going to number in sequence they owe the customer an accurate rendering.

But to most artists the sequence of numbering prints is a matter of almost no moment, and in any case the process of printing makes it bothersome if not impossible to keep serial tallies. A printmaker editioning a print may discard half a dozen proofs immediately or on looking them over a week later; finished proofs may have been deliberately or acciden-

tally inked or printed in variant ways, leading the artist to set numbers two, four, and six aside. Number seven is inexplicably smudged. Number one is given to a friend who happens to be visiting the studio, and the baby tears up number three. Can you then at least be sure that the fifth proof pulled, but the first saved for the edition, number five, will be numbered 1/50? Not at all, for all the proofs, after printing, may be set around the studio to dry for a time before they are signed and numbered—a day or a week or a month later. When they are gathered together again they may be hopelessly intermixed.

When an artist makes each print "to order," so to speak, as some self-publishing, self-printing artists whose graphics are extremely difficult to print are likely to do, printing a single impression when an order is in hand, the numbering may reflect reality. Those concerned with numbers, as many collectors of contemporaries seem to be, should also notice that there are times when an artist plans an edition, say, of 20, numbering the first he completes 1/20, 2/20, 3/20 and so on—but the edition may not go further, the artist never having completed it for one reason or another. A careful *catalogue raisonné* attempts to clarify these instances.

When a print is made with more than one pass through the press, however, it really becomes virtually impossible to know in what sequence each specific print was executed, and further, the sequence can vary from color to color. From watching artists and printers edition prints we know that many things occur that make sequential numbering simply a matter of the artist affirming to the public that there were indeed 40 or 60 or 110 copies made. It is not, however, a pledge that the print numbered 59 was made before 60 or after 58.

Printing a Color Lithograph

Try to imagine the printing of a color lithograph as we once watched the process. First, sheets of paper accepting one color moved without incident through the press. They were then allowed to dry in racks around the shop. Many more than the requisite number of the first plate were printed, since the process of throwing away impressions that failed to reach standard was only beginning. Some of the products of the first color plate seemed less intense, for instance, than planned, and these were dumped. At every step the artist compared results with his original master design, making corrections and changes in the ink mixtures and on the plate.

For the second color the sheets were fed into the press in a different order from the first batch—simply by chance and because there was no particular interest in maintaining the original pattern. Then the artist and printers had several long discussions, with the result that before the third color was in place the plate was re-worked and the mix of ink altered several times before the final pass was attempted. Each change yielded a

number of "trial proofs," some of which were kept while others were discarded. Finally, the entire edition was run off.

When the printing was completed the artist gathered all the impressions together. He examined each one by one. Then, in no prescribed order and in more than one sitting, he signed and numbered each print. After he was certain that he had a sufficient number for the edition that had been commissioned—in this case 80—he signed and numbered his personal allotment of artist's proofs. Afterward, since there were still some good prints remaining, he signed but did not number additional impressions. (He could have used roman numerals to differentiate them.) These he gave as gifts to those who had helped with the printing. No one, certainly not the artist, could possibly have known which ones came off the press first or last.

The printing process frequently begins by trial and error. The print is first *proved*. That is, the plate (except for serigraphy, which uses screens of silk or other materials, not plates) is passed through the press (or rubbed with the back of a spoon) to see what is there. The first proof that emerges is the first "state." Any change that is then proved becomes another trial state, the second, third, and so on. The graphic artist will characteristically make changes based on what is revealed by printing on paper, for this image varies from what can be seen on the plate. At times the artist will preserve these successive stages of the proofs—which may become the single extant example, like the lone etching, "Saint Catherine," that has come down to us from Peter Paul Rubens (Dutch, 1577–1640), a counterproof in a trial state that has been much corrected on the paper in pen and ink. The actual finished print is no longer known to exist. Your *catalogue raisonné* will have information about various states when it can. Such trial states can be unique, and it is this—as well as the way in which they show the artist's thinking and procedures—that give them value.

Artist's Proofs have a certain cachet, although, as we have pointed out, the copies designated A/P may have been the last-born. We know an artist, who takes small interest in the numbering of prints or Artist's Proofs, who was told by his dealer that a client wanted to buy a particular print of his, but she required an Artist's Proof only, as she limited her collection of contemporaries to that category. Did he have any left, the dealer asked? The artist looked, but found none. Needing to make the sale, however, he boldly erased the numbers from the print the collector had seen and substituted the words "Artist's Proof." This is not, of course, considered quite sporting. Picture his dismay when he was told by the dealer afterward that the collector had not bought the print after all—she thought the colors in the proof the artist had brought in were much paler than those in the regular edition!

Stanley William Hayter (b. 1901), the English printmaker who has been such a seminal influence for contemporary graphic artists, said in *About Prints* that it had been his experience that

> many collectors will buy a print of one of the incomplete states of a plate in preference to a print of the final edition and for a very much higher price. The justification for this is in part the greater rarity of the print, but also, I have found, to buy such a print ministers to the ego of the client, who is in a sense claiming that the plate would have been better left in this state than carried to what the artist calls completion. It seems to me only reasonable that the client should pay for this satisfaction, and I can hardly imagine that the artist would have any objection.

Numbering, then, is for most artists simply a matter of giving one's word as to how many prints compose the edition. (We say this knowing that Ben Shahn, according to his cataloguer, often made *more* prints than the stated edition size.) Yet it is worth going to the *catalogue raisonné* to discover the total edition size even if the particular number on any individual impression is of no moment.

Which Edition?

It is equally important, moreover, to know about the various editions of a print. There is frequently a qualitative difference between the first and second or the second and third editions. Another rule of thumb has it that the first edition is the best and most reliable. Although this is not always true, it is a guide more often than not. From the *catalogue raisonné* you may be able to discover who printed each edition: the artist; a printer while the artist was still able to supervise the work (both of these are most desirable); an edition authorized by the estate; or, least attractive of all, an edition published by some unauthorized person able to get hold of the plate and print a new edition. None of these possibilities is infrequent. There are many permutations a print can go through, but if you are going to pay the price of the best edition you may as well have it—or get the benefit of a bargain on an inferior print.

Compare Signature

The signature, too, if there is one, may be compared with the information and reproductions in the appropriate *catalogue raisonné*. Make sure the one on your prospective purchase matches the description. As time goes by you will learn who signed what and where, although the variations are many. Some artists signed in the plate; others signed all their prints in pencil on the paper; some rarely signed at all until they sold a work or were ready to sell; some prints are signed with a stamp or monogram (Whistler used his butterfly, Childe Hassam [1859–1935], the American

Impressionist, a cipher); some have never been signed at all; and some prints have been signed or stamped by others—authorized and unauthorized—after the death of the artist. Most of these matters can be clarified with the aid of the *catalogue raisonné*. The signatures and stamps of both Léger (French, 1881–1955) and Pascin (French, 1885–1930) are almost indistinguishable to the naked eye, so that only by examination with a good magnifying glass can the difference between the signature and stamp be determined. In Stella's recent *catalogue* of Renoir, however, the prints known to have stamped signatures are indicated. Prints signed by the artist on the paper are more expensive because they attest that the printmaker was satisfied with this particular proof, and they are in greater demand than those stamped with a facsimile signature or those with an estate stamp.

Estate Signatures

Such is the case with Arthur B. Davies (1862–1928), a prolific American maker of prints, who left many lacking a signature when he died. These unsigned prints have since been "signed" with an authorized estate stamp, yet their monetary value is considerably lower than those on which the artist wrote his name. The same is true for the prints of George Bellows and John Sloan that have been signed by heirs. Such prints, as in these examples, may be in every way as excellent as their more expensive counterparts that chance to be graced with the artist's signature. The collector who buys them knowingly at the lower price will own as satisfying, as enjoyable an image. It will be as worthy of respect. But it will always be worth less money than its signed sibling, and no matter how values rise or fall, its value will remain proportionately lower.

False Signatures

A false signature, on the other hand, seriously devalues a print, even when the print itself is a good impression, entirely authenticated. We know of a Thomas Moran etching in which the penciled signature did not match the signature as shown in a known example. Although it was inscribed in the corner where a signature might be expected, it was so distinct from the genuine version that a novice would conclude that it had been added by another hand—perhaps early, maybe late. Possibly fraud had been intended, or it may be that the unknown party had wanted merely to identify the artist, though this last is unlikely. But since a false signature is more depressing to the worth of graphics than the omission of any signature at all, one could be seriously tempted to erase the false "Thomas Moran." Conservators have found, however, that it is almost impossible for an erased penciled signature not to leave permanent indentations that can be

observed under a magnifying glass. The presence of these traces means that removing the signature leaves a print—or that is to say, the paper around the image—doubly damaged. Yet anyone who wanted the esthetic pleasure of looking at a lovely Moran etching might have bought it at a bargain.

So, too, might the collector of John Henry Twachtman (American, 1853–1902) save a bit of money. After the artist died his son printed editions of the artist's work from the original plates, and openly and intentionally signed the prints with his own initials as well as his father's. (No original editions had been made—only a few proofs existed at his death in 1902.) These impressions are worthy Twachtman prints even though they were made posthumously. Not so acceptable are the recent, re-worked prints of the late Max Weber, one of the earliest American modernists, that bear the estate stamp of the artist made by Joy Weber, his daughter. Because these woodblocks have been re-worked, reputedly, in places where they had become worn or disfigured, they are in some way not identical to the earlier artist-approved originals. In print collecting terms, assuming that the connoisseur wants only that which is in every way authentic, such prints are of little value.

THE SCANNER OR MAGNIFYING GLASS

The foregoing suggests a sample of the kind of information that can be dug out of the pages of a *catalogue raisonné*. In pointing out some of them we have mentioned from time to time the magnifying glass. This is a worthy tool that all collectors should try to learn to use with skill. If you are unable to develop the expertise, you will often need to consult an expert— the curator or dealer—when you have questions or problems. By all means do this when necessary, for in the long run it is good practice. But most collectors soon become proficient with the magnifying glass or with scanners.

Although some professionals use table-mounted, high-powered binocular magnifiers with built-in lights, these cost upward of $125 and require considerable space. Most amateurs will be served well enough by a good hand-held magnifying glass with 5× or 10× magnification (professionals often carry them), possibly one with a built-in battery-operated light. These can be found in local shops almost anywhere, frequently in photographic equipment stores or those selling supplies for stamp collectors, or they can be ordered from Electro-Optix Inc., 35–12 Crescent Street, Long Island City, N.Y. 11106.

A pocket-sized magnifier that travels with you will enlarge your knowledge and skill every time you take it out and hold it up to a print, whether in a museum, at an auction, or when looking at prints at a dealer's. While

amplifying your connoisseurship it can help to reveal fakes—deliberate frauds, especially photomechanically reproduced images of valuable original prints. We use the adjective "valuable" because inexpensive graphics rarely lure the counterfeiter. After all, if a fake can be made to sell for thousands, why bother to make one worth only hundreds?

Yet even among relatively moderately priced prints shady transactions have occurred. An unscrupulous commercial printer translated into a large color silk screen a black and white wood engraving by Jacques Hnizdovsky in the late Sixties without bothering to ask permission and without paying a fee, selling thousands of copies for a few dollars each. But the aim was to steal a charming image rather than a world famous name, and the printer's use of Hnizdovsky illustrates the inadequacy of our copyright apparatus to protect artists, rather than an attempt to forge a costly print. It seems to us that the pirated use of Robert Indiana's "LOVE" calligraphy on a host of commercial items is similar.

Picasso's "Frugal Repast," which has been called one of the finest etchings of the twentieth century, is an example that certainly qualifies for the terms "famous" and "valuable," and it is more typical of frauds involving prints. It has been reproduced photomechanically with the deliberate intent of cheating the customer. Copies have been sold to naive collectors as originals, especially before the existence of this fake became widely known and exposed in print periodicals.

Any experienced person who carefully examined the print in good light under a magnifying glass could have become suspicious because the regular pattern of dots made by the half-tone screen, inherent in this kind of photographically reproduced image, would have been a clue. This pattern of dots is similar to the large Ben-Day dots visible in newspaper photographs, particularly when they are magnified, and to those dots so frequently enlarged and exploited by Pop artists like Roy Lichtenstein. But they are not always easy for the beginner to see, particularly when they are obscure because a fine-meshed screen has been used. You may find yourself able to recognize the tell-tale pattern on one image as you practice at home comparing fine prints with newspaper, catalog, and book illustrations, and totally at a loss with others. It takes experience to get the hang of it. Fortunately this is not the only use of the magnifying glass nor the only way to expose fraud.

There are reproductions—line cuts, in the main—in which no half-tones screens are employed—no fine lines or dots to give the game away. The print most likely to require a reproductive process that uses screens is one with areas of massed greys or blacks, as in aquatints or lithographs.

Signatures are easier to examine and are always worth noticing. Those written in pencil will almost always, as we've mentioned, leave on the

paper some indentation that is visible with magnification. Stamped signatures (those etched or lithographed onto the plate) will not. Using the glass to ascertain whether the signature is penciled will result in no guarantee that the signature itself is genuine—though it will go far on the trail of suggestion. You can compare it with the original in the *catalogue raisonné*. Magnification will show, too, if there has been an erasure, which leaves raised rough abrasions on paper. Be suspicious, if that's what you see! Keep in mind, however, that many genuine graphics are signed in the plate or signed with a stamp, with no loss of value. With the help of the *catalogues raisonnés* on the artists whose works you are investigating you will discover each printmaker's usual system of authorizing prints, and you will be able to make comparisons that will resolve, or initiate, doubts.

Once you have become sufficiently familiar with graphics to recognize readily the various print media, you will be able to use the magnifying glass to examine prints more closely. Magnification will show, for instance, whether you are looking at an etching or a drypoint or a combination of the two, with, perhaps, some aquatint as well. You will be able to examine the characteristic grain of the stone on lithographs, and will find yourself knowledgeably aware of when you are looking at one of the newer photographic techniques, which are frequently combined with the more traditional ones. Experienced connoisseurs can, with the aid of the glass, observe the characteristic strokes of a particular artist, or see lines that have been tampered with, as often happens in fakes. You will admire the soft turn of marks made by the burr in drypoint, and if it is missing, you'll want to find out why.

The magnifying glass will allow you to check the condition of a print more accurately than you can with the naked eye. You'll want to do that before you bid at an auction, for the better a print's condition, the greater its value. Additionally, because the condition of the plate or stone from which a proof has been pulled is important—with worn plates yielding inferior images—it can often be helpful to peruse the enlarged sections carefully. Paper, too, reveals its secrets when it is enlarged, and unnoticed stains, marks, small tears, replacements of paper losses will leap into view.

All of these examinations can be made better when a print is out of its frame, which leads us to emphasize: *when you are considering buying any print, always remove it from its frame before making a decision.* If for any reason this is not permitted, either don't buy the print, or buy it only with a written, money-back guarantee.

Not every hoax is a clever one. Remember reading about the counterfeit dollar bills that passed successfully for years with a crude picture of a man identified as George Wahsington? We, too, were once offered a print, with

a substantial asking price, on which the first name of the artist, Arthur B. Davies, was misspelled in the "signature."

Aside from such glaring boners, it is only when the print is out of the frame that its condition can really be determined. Is it pasted down? Have the margins been cut? Has the print been repaired, and if so, unprofessionally? Affirmative answers to these questions lower the value of the print— to you as well as to anyone else who may want it. It is only when the print is out of the frame that you can be sure whether the paper is that which the *catalogue raisonné* specifies for the edition or is typical of the printmaker or the period. It is only when the print is out of the frame, moreover, that the magnifying glass can be used skillfully.

We saw a Braque (French, 1882–1963) print at Sotheby Parke Bernet that was framed between two sheets of glass. The face of the color lithograph could have been adhering to the glass, it seemed to us. Since we were interested in purchasing it, we asked that the print be removed from the frame but we were refused. We could not examine the print, and in this case, even more crucially, we feared that the front surface might stick and tear when the covering glass was removed; we decided not to bid on this lot. It went for an excellent price to a buyer who evidently had no such qualms. On the other hand, Parke Bernet is almost always unusually reliable and patient with collectors, complying willingly with most of their requests and extending themselves beyond their obligations. Several years ago a collector bought a Matisse print called "The Fox" at a Parke Bernet auction. Later, experts at Parke Bernet saw another print of "The Fox" that had been consigned to them afterward. They were so impressed by its obvious superiority to the first, which they recalled, that they suspected that the one knocked down earlier was in some way questionable. They contacted the person who had bought it, asked and received permission to compare the two, and were convinced that the first had all the earmarks of a fraudulent copy. Parke Bernet at once voluntarily offered to return the client's money. Their action was admirable and not atypical.

Even if your connoisseurship is still somewhat shaky, you need not get stuck on prints. The top auction galleries are more reliable than the second rank, just as the top dealers are more responsible than those who include some doubtful merchandise, but it goes without saying that reputation alone does not guarantee the best buy. In addition to consulting a *catalogue raisonné*, and examining the print with a magnifying glass after removing it from the frame, try always to buy prints, when purchasing through a dealer, with a money-back guarantee based on your own confirmation of its authenticity.

Now that you have the print out of the frame and you have looked it up in the *catalogue raisonné* if one exists for this artist, and examined it under

good light and magnification, it is time to measure the print in order to compare the measurements with those stated in the *catalogue*.

Every serious collector should own a good accurate ruler that measures in inches and fractions thereof on one side and the metric system on the other. Since even England has gone over to the metric system, Americans are virtually alone in measuring in inches. It will be easier to glance at your two-way ruler, perhaps, than to memorize the following little chart:

> mm = a millimeter equals .001 (1/1000) of a meter,
> which equals .03937 of an inch.
> cm = a centimeter equals .01 (1/100) of a meter,
> which equals .3937 of an inch.
> dm = a decimeter equals .1 (1/10) of a meter,
> which equals 3.937 inches.

Or to put it the other way, an inch is 2.54 centimeters. For us, it's simpler to use our rulers than to multiply.

You'll use your two-way ruler to measure the image size on prints you are doubtful about. You'll check the measurements of the print in hand against the measurements reported for that print in the *catalogue raisonné*. If the measurements differ only slightly, you have small cause to be suspicious if there are no other indications of fraud. Papers stretch and shrink, especially if they have been moistened for printing, as they frequently are, and they vary according to the conditions under which they have been kept. But if there are gross deviations, look further. Something is wrong.

You will also, by measuring, be able to tell whether the paper has been trimmed (that is, the margins cut down), a practice that is now virtually extinct, but one which even museums were guilty of for a time when they wanted a print to fit into a particular size of mat, frame, or storage portfolio.

PAPER AND WATERMARKS

Watermarks can be a clue to fakes and a fascinating study in themselves. But fair warning: watermarks can also *be* fakes. Nonetheless, not every forger bothers to use faked paper—or properly documented watermarks— so examination of the watermark can at times yield information.

During the sixteenth, seventeenth, and part of the eighteenth centuries watermarks were commonly used as a means of identifying the manufacturer of paper, each mark signifying a particular maker. Frequently water-

marks also indicated when the paper was made. It will be clear, then, that watermarks can help place the age of the paper in relation to the print-maker. Even the beginner can compare the watermark on a print with the watermark in the *catalogue raisonné* or the marks for the period reproduced in reliable reference books. If your printmaker lived in the eighteenth century beware of nineteenth-century paper, although the reverse could be legitimate.

Other factors that identify paper serve the print detective. Paper is essentially of two types: laid or wove. Laid paper is made on screens, with lines visible when it is held up to the light. On wove paper no lines can be seen. Both may be hand-made, as fine papers still are. Machine-made papers are likely to use wood pulp in their manufacture, which means they contain acid—and that, in turn, means that they will deteriorate within a relatively short time. This accounts for the fact that many early prints are in far better condition than some from the nineteenth and twentieth centuries, since before industrialization almost all European papers were made from rag, not wood, and were acid-free. In Chapter 5, "Preserving Prints," we will discuss acid-free materials available today and their role in the conservation of prints.

It was not until fairly recently, about midcentury, that it was generally realized that the use of acid-laden paper in mats—and even in prints—was resulting in horrendous damage. Since then those artists who had strayed have returned to rice or rag paper, usually wove, for their graphics, and museums and collectors have been learning more about paper conservation, applying what they have learned, and disseminating their findings. Everyone is now so conscious of paper, in fact, that it has become customary for artists or their publishers to specify the paper on which an impression has been printed when it is exhibited or announced in a brochure or catalog.

Even distinctive watermarks have been rediscovered. (Not that the custom was ever entirely lost, even in common commercial use. You have probably noticed more than once the easily read legend in the watermark of typing paper or fine stationery, for instance.) The firm of George Miller, fine-art lithographic printers, sometimes used a "GM" watermark on their papers, and the printer and publisher LaFranca, in Locarno, Switzerland, whom we have watched make paper in his studio, frequently uses in the watermark the initials of the artist for whom he is making the paper. Earlier in this century personal initialed papers were handmade for George Bellows and Grant Wood, among others, and more recently Robert Rauschenberg participated in making paper in which the watermark identified him.

Such special marks in the paper on which the graphic image is printed can give a collector the satisfying sense of owning something special, the pick of the litter. Such marks, and the knowledge of them, can add to the

romance and excitement of collecting. The methods of making paper, the differences between oriental paper made from rice and occidental paper made from rags are important studies in themselves. The interested reader can do no better than to start with Dard Hunter's book, *Papermaking: The History and Technique of an Ancient Craft.*

After examining prints, the next step is to buy them.

ROBBE, MANUEL (1872–1936) *La Choix de l'Épreuve*
Color acquatint. c. 1900. Signed. Ed: 19. 17″ x 12″. Courtesy of Mason Fine
Prints.

If a man look sharply and attentively, he shall see Fortune; for though she is blind, she is not invisible.
Sir Francis Bacon, *Of Fortune*, c. 1600.

3. *Buying a Print: Dealers, Publishers, Auctions, Serendipity*

DEALERS

The best and most consistently reliable source of prints, old and new, is the print dealer. One way of finding those whose offerings mesh with your requirements is to look through the hundred or more ads that appear regularly in the *Print Collector's Newsletter*. It is published six times a year, and the variety of dealers listing themselves increases steadily. Print dealers advertise in many general art periodicals, such as *ARTnews* and *Studio International*, but PCN contains the most concentrated list of active dealers in prints of every period. See also our international list of print dealers.

Although the Northeast is the mecca of print dealers and galleries, buyers are found everywhere, and you'll be surprised to notice some of the remote spots from which an occasional dealer advertises. The credentials of those who use the advertising columns of PCN are not examined by this publisher any more than they are by any other publication, but those who advertise there are likely to be reliable: Print vendors using their space are aiming for business with some of the most sophisticated clients in the country.

Dealer Catalogs

The first thing to do—after scanning the page and eliminating those dealers whose offerings are entirely outside your area of interest—is to write to the pertinent ones requesting their stock lists and exhibition catalogs. Even when catalogs are not specifically announced in their notices, dealers are likely to prepare check lists regularly—some annually and others monthly—and they will be glad to add your name to their mailing lists. Many of these

catalogs announcing offerings are free; there may be a charge for others ranging from $3 to $7. You may want to look over these catalogs in your nearest print room before ordering. It is from the pages of these catalogs that you can shop for prints no matter where you live or where the dealer does business. In fact, many dealers have no shops and conduct their trade by mail. Such dealers are not necessarily less expensive than those inhabiting the most impressive galleries at prestigious addresses, even though those who work out of office buildings or their homes save substantially on overhead. No matter what their locations, active galleries doing a large volume of business can usually set a fair price, in part because they are often in a position to buy entire collections at a good price. (Smaller businesses must pass these by.) When these galleries re-sell such collections piece by piece to the public, their prices can reflect initial savings. There are times, as well, when a collection is purchased primarily because a portion of it is of interest to the dealer or a specific client, and this, too, may enable them to sell the remaining prints at a lower markup.

Many of these dealer catalogs are illustrated. All are priced. By studying their pages you can comparison shop the world, and most important, you can learn about what is available in your area of concentration, whether it be Old Masters or modern prints.

Once you have a catalog, save it. And not only save it, file it away. You will find many long- and short-range uses for every catalog in your collection. First, each will add to your reference library. Second, you will always be able to refer to a catalog to discover or remind yourself which dealer had what prints, for once dealers have carried particular prints or artists they are likely to have them again—or the print you've had second thoughts about may still remain in stock. Further, each catalog you receive gives you permanent possession of another list of prices at a specific date. Print prices in general, or for your particular favorite, may move up or down from that date on, but with the catalog, you have the historical facts at your fingertips. There are occasions, too, when the reproduction in a commercial catalog is the only record of a print known to us.

Write to Dealers

Once you've studied a checklist or catalog, don't be hesitant to write to the dealer whose offerings interest you—either to find out more about a particular print, or to see if the firm has a similar impression you have been searching for, or to ask any other reasonable question. Most dealers are happy to correspond with potential customers, and you will usually receive a courteous reply. But if you see a print announced that you are certain you want, and the price is right, don't be slow to pick up the telephone to clinch the sale. It's common practice, and may guarantee that you will get there before the next person.

Dealers Specialize

Most dealers specialize, though to be sure there is some spillover at times. But the gallery that handles Old Masters is unlikely to carry Robert Rauschenberg, and you will rarely see Dürers where the emphasis is on nineteenth-century Americans. Some dealers, in fact, have very limited specialties. An extremely successful one in New York has made a career of buying and selling twentieth-century French modernists—and these, moreover, are in the main the earlier prints of Matisse, Miro, Picasso, and Rouault. Masters Gallery, in Los Angeles, sells *only* prints and drawings by Picasso. A Connecticut dealer restricts himself mainly to the prints remaining in the estates of recently deceased American artists with modest reputations. Such graphics have a market value, though a small one, and the dealer, without large sums to invest, is performing a needed service for both buyers and sellers. In this case, in fact, the catalogs are of particular value among scholars.

Know One or Two Dealers Well

Since dealers specialize, it follows that if you as a collector specialize too, you ought to become acquainted with those who sell prints in the area in which you are most concerned. The expert background and myriad information that such people are likely to have can be helpful to you. You will find them willing to share their knowledge freely, especially with those who trade with them consistently. Once they know you, they will often tell you before others when prints of interest to you are on the market, and because of the quick turnover an immediate decision on your part will allow, they may be able to give you a price advantage. Further, a dealer aware of your area of continued collecting may even arrange to include you in the major purchase of a collection that comprises your favorites. Depending on the conditions you and the dealer have worked out before going forward with such a purchase, you may come away with one or more prints you covet— at noticeable savings.

The more you know about a period, a style, or an artist, the more expert a collector you will become. The best advice one can give to a collector is to specialize, specialize, specialize. Concentrate on an area, a period, or an artist, and learn everything possible about your chosen passion. From this you will reap satisfaction, understanding, and financial rewards. Yet as obviously good as this advice is, not all of us are temperamentally suited to take advantage of it. Don't despair if you are one of those who flits happily from Bewick to Blake or from Jongkind to Jasper Johns. If you enjoy the works and they enhance your life you will learn something about prints from every one of them, and your wide-ranging understanding may serve you as well as your fellow-collectors' narrower depth serves them.

ADVERTISEMENTS

Dealers who are regularly and entirely engaged in the selling of prints will be the primary continued point of purchase for the serious collector of fine prints. Yet there are other useful and legitimate sources that every aficionado should be aware of.

Most collectors have probably noticed and even responded to ads in their Sunday papers, particularly those in the Arts and Leisure section of *The New York Times,* distributed nationally, and similar sections elsewhere. In these pages you will meet again some of the same names you have come across in *PCN* as well as dealers new to you. In addition you'll see one-shot ads from private parties—people "wishing to dispose of a collection" or those purporting to be similar innocents. Be careful! Such prints may have questionable authenticity, their condition may be poor, and the price asked may be unrelated to the real world. As with any other print you buy, especially when making your purchase through the mail, you must commit yourself only to examining it "on approval." This will give you the requisite opportunity to check by means of your reference material on the authenticity, condition, and price of the print. Although you may find through such sources good impressions at fair prices, you must be especially watchful for the get-rich-quick operator who works out of a hotel room rented for the occasion, or the supplier of large numbers of graphics, most of them supposedly by "big names," for certain kinds of benefit auctions.

CLUBS

There are several print clubs (which are also publishers) that operate on a membership basis, with members paying an annual fee that is usually applied toward purchases. In return, members most often receive regular mailings of brochures and first choice on newly published work; sometimes they are also given discounts, bonuses, and print-related books as inducements to membership. Prints are frequently sold framed, saving their purchasers a bothersome chore. Among these clubs are one or two that offer a very wide selection of prints, in terms of quality and price (not synonymous), but a few have a limited choice of artists. Some of the better known clubs include the Sponsor Members of Associated American Artists; Collectors Guild, Ltd.; Fine Arts 260; and Original Print Collectors Group, Ltd. The last three sell only via their membership arrangements.

PAINTING GALLERIES

Galleries that deal mainly in paintings also at times exhibit and/or publish prints by the artists they handle, or they sell prints by other artists that incidentally come their way. Some art galleries routinely sell prints from small or large collections maintained in secondary rooms. You will see their display advertisements, too, in the art magazines—and you should subscribe to at least one of these magazines. Some galleries regularly have print exhibitions that are worth, as the *Guide Michelin* says, a journey. One gallery on Long Island, an hour or so from New York City, has made a tradition of annual print shows—John Sloan, Arthur B. Davies, Whistler—with excellent catalogs that have themselves become collector's items. Whether or not you're in a buying mood, make a point of keeping informed of such print exhibits, for visits to them will enhance your perceptions.

FRAMESHOPS

At the opposite end of the roster from prestige galleries are the many frame shops that dot the country, yet these, too, often routinely carry graphics as part of their stock. Framers have a long and honorable tradition, and lucky is the collector who has a capable and conscientious framemaker nearby. Their help in conservation is essential. You can be certain, too, that the craftsperson who mats and frames prints for you is doing the same for others. When a collector, therefore, wants to dispose of a print or two, the framer may be asked to sell it, for every collector knows that other print-conscious individuals are likely to walk into the frameshop from time to time and notice a quality print displayed. The framemaker normally takes such a print on consignment, although that is not an invariable rule.

Surprising items can turn up in a shop. Sometimes, for instance, an artist, rather than a collector, will ask a frameshop to hang a group of prints. Indeed, there are galleries that began as modest frameshops, and even some Madison Avenue places continue today to do the lucrative and steady work of framemaking that started them off as dealers. Artists exhibiting in frameshops may have few other outlets, enabling collectors to make their own discoveries informally and under no pressure. There are also print publishers who distribute prints by contemporary artists to the shops of selected framers throughout the United States.

MUSEUMS

Museums, the prime place of print exhibitions if not of sales, can in the case of contemporary printmakers be a source for collectors. The prices at print annuals and biennials are either stated in the catalog or are available on direct application to the artist. Almost every museum will help you locate the address or telephone number of an exhibiting printmaker whose work you may hope to acquire, although few are prepared to perform the services of dealers. Names and addresses of most artists are listed in *Who's Who in American Art*, available in libraries. We were pleasantly surprised when visiting the Philadelphia Museum of Art to notice a number of fine prints offered for sale at the museum. The Museum of Modern Art in New York, the Baltimore Museum of Art, the Memorial Art Gallery of the University of Rochester are among others that sell prints, usually under the auspices of their art lending services.

Print lovers will find themselves entranced by museum bookstores even when they don't offer prints, for their displays of art books will seduce them into browsing through the ones they have not seen before.

OLD BOOKSHOPS

Old bookshops are a good source of prints. The close relationship between books and prints does not have to be spelled out, for the earliest *printed* books were *printed* with illustrations *printed* from wooden blocks. The many meanings and uses of the word "print" are among the reasons a book like this is necessary. In your own neighborhood and when you travel, drop into one or two of those musty and rewarding places where old books are sold, for you may uncover treasure.

WHEN TRAVELING

And speaking of traveling, you may want to call on a dealer who has sent you a catalog when you arrive at a new place. You will surely want to check our list of museum print rooms in advance, so that you can write ahead and make arrangements to visit.

YELLOW PAGES

Even if you are planning a trip to a part of the country where you know of no museums or dealers or print cabinets, don't give up on opportunities to ride your hobbyhorse: check the yellow pages for dealers, bookstores, framers, galleries. You can do this in advance, if you wish, for most large

libraries are well stocked with classified telephone directories from almost everywhere in the United States.

As a collector you probably come into contact now and again with other collectors of fine prints, and in this way you may upon occasion come to know of either individual impressions or entire private collections in search of new homes. Even when you would like to own some of the prints in a collection, however, you may not have sufficient funds available to swing the entire group, or you may not want to have the problem of disposing of the remaining items after you have taken your pick. At such times a dealer may be of as much assistance to you as you can be to the dealer. If you have been the source of information for a collection the dealer wants, for instance, the particular print you covet may be your finders fee. Or you may be paid a fee, usually 10 percent, which you may prefer to take out in trade. Or your dealer might give you the opportunity to buy certain prints from the collection at an attractive figure agreed upon in advance.

Dealers, then, come in a variety of permutations and can be helpful to you as a collector in dozens of ways. We've sketched the ropes, which are easy enough to learn. We'll be taking more space to tell you about auctions because their story is more complex and many private collectors are less familiar with them. But for most print lovers, auctions will never replace print dealers as the best place to buy graphics. And dealers continue to be the main source of prints by contemporary artists.

AUCTIONS

Once upon a time—before World War II—more than 90 percent of the exchange of works of art was conducted through dealers, with perhaps 10 percent of the objects passing through the world's auction houses. Today it is estimated that half the art that changes hands passes at some point through one of the more powerful auction houses here or abroad. Although bidding is still dominated by the professional, the private collector appears at auctions in ever increasing numbers. The print collector, then, needs to know whether buying through auctions is worthwhile in terms of price and in terms of discovering otherwise elusive graphics. Collectors deserve information about which auctions at what houses are likely to be productive; how to go about buying at auction; what the terms of auction purchase are; and what the risks and advantages may be.

Established Price

Happily, we can say at the outset that the buyer of prints at auction has a decided advantage over the collector of paintings, furniture, porcelain, or other objets d'art: prints are multiples. No item is unique. There is always another like it somewhere. This means that there almost always is an established price somewhere. Even if inflation has raised the price over what it might have been two or five or ten years earlier, or a sharp swing of fashion has reduced its "value" over the same period, a price has probably been set for a nearly identical, rather than merely a similar or comparable, item. This gives every print buyer a reliable guide, the amateur as well as the professional.

You can usually discover the established price by means of the priced dealer catalogs and priced exhibition catalogs you have been collecting and saving or will consult in print rooms, and you will check priced auction catalogs from sales pre-dating the one you plan to attend. In addition, at such major auctions as those conducted by Sotheby Parke Bernet (the last name pronounced by the knowing to rhyme with barrette, not beret), there is a list of estimated prices accompanying the auction catalog.

Estimated Prices

The prices in the catalog are not conjured out of the air, nor even based on the whim of the seller. If, for instance, a print has been sold at some time in the past for $600, then the estimate may read $500–$600, or $600–$700, or $500–$700, depending on the catalogist's evaluation of the current market for that print. But buyers may be reasonably sure that somewhere in the estimated price lurks an earlier known price, as in our example the figure $600 appears three times.

Reserve Prices

But what about the "reserve" price, you may legitimately ask? The reserve price is the minimum price agreed upon by the seller and the auction house. At present the reserve price is a secret kept by the seller and the auction house. Since there has long been criticism of the secret reserve, there is always a possibility that the rules governing it will be changed.

Let us suppose that in the case of the hypothetical print we've used already as an example the seller asks for a reserve of $1000 despite the fact that the established price of the print in the past has been $600. The auction house in such an instance will normally refuse to sell the print at the reserve suggested by the selling client. Their "standard advice to sellers," according to interviews we conducted and the SPB catalog notes headed "important information for prospective bidders," is "that reserves

be set at a percentage of the median of the estimates, generally somewhat below the low estimate shown in the estimate sheet."

It will be obvious to anyone paying close attention that "a percentage" and "somewhat below" are not exact words, but what SPB is apparently asking the seller—and advising the prospective buyer about—is to place a reserve, let's say, of $450 on an item estimated at $500 to $700. How frequently this advice is followed is not a matter we can judge, but we can point out that SPB docs insist that "in no case do we permit a reserve to exceed the high estimate shown in the estimate sheet." In this case, the reserve could be as high as $700, but no higher.

One of the things this means for you, as buyer, is that it is extremely rare to be able to buy at such an auction as Sotheby Parke Bernet's for much below the estimates as listed in the estimate sheet. Unlike, say, certain estate auctions where anything goes, there is usually a minimum price below which no item will be sold. Therefore, even if a blizzard, an electrical failure, and a taxi strike all cooperate on the day of the sale, you still will not be able to walk out of an SPB auction with a stack of prints purchased at a small fraction of their estimate—although weather and other conditions that keep down the attendance of buyers can affect prices to your advantage. A reserve price is set precisely *because* extraneous affairs can upset prices badly, and although not every lot carries a reserve, the SPB catalog warns that "bidders should assume that *all* lots have protective reserves."

"Yes, yes," we can hear an eager new collector demand, "but what happens if no one in the audience is *willing* to pay even $450 for your hypothetical print? Suppose I offered $425, and that was the highest bid. Wouldn't they have to sell it to me?"

Buy-ins

No, they would not. And there would be nothing illegal or even faintly shady about their refusal, since the auction house has stated its policy clearly under "Conditions of Sale" in the catalog. Sotheby Parke Bernet in these circumstances would "buy-in" the print. They would do this quite literally by "buying" the print by means of their agent, who would make the bid. The auctioneer might appear to be taking the necessary bid "off the walls" or from the air, for nothing would be publicly announced. Those in the audience would not be informed then and there that the piece had failed to reach the reserve. If they were busy marking their catalogs with sale prices they might simply jot "$450" and quickly go on to the next item.

Naturally enough, criticism of this aspect of auction practice has often been sharp. Currently, those concerned learn about "buy-ins" only when

the list of prices achieved is published shortly after the sale. Although in the past buy-ins were stated in exactly the same way as other prices—our $450 buy-in appeared as though it were the actual price paid—now such buy-ins become part of the record because they are omitted from the list of sales prices. If you look at your list of prices paid when it arrives and find lots 71, 72, 75, 77 included with sales prices, and 73, 74, and 76 omitted entirely, you can conclude that you are being told obliquely that those lots failed to reach the reserve price. But you will have to guess the reserve price, for at this date reserve prices are not a matter of public record.

The seller, when the reserve price is not reached, gets back the print that has been unsuccessfully put up for sale and then bought-in by the auction house. In addition, the seller must pay the auctioneers a reduced commission amounting to 5 percent of the last bid received from the public. In our example the last bid was $425, so our unfortunate owner would owe SPB $21.50—and continue to own the print.

Minimum Price Guarantee

If, however, the owner had elected to sell under the terms known as a "minimum price guarantee"—also a confidential price agreed upon between the seller and auction house—Sotheby Parke Bernet itself would actually *buy* the item that had been placed on the auction block if it failed to reach the minimum price guaranteed. The price for this certainty is a surcharge of 7½ percent of the guaranteed minimum, over and above the standard selling commission. Let us deal with our same hypothetical print. The guaranteed minimum might realistically be $500. The commission therefore would normally be 25 percent. (Commissions range from a high of 25 percent to a low of 10 percent on lots worth more than $15,000, with steps between.) Therefore the seller would be paying SPB a total of 27½ percent, or $137.50. In such cases the print would become the property of SPB, and would be so designated in the catalog the next time it is put up for auction. Such owned pieces, as they accurately state, "form an insignificant part in the Galleries' overall business." Their agents would bid on such lots at a subsequent sale only to protect their reserve.

Prices

The great attraction of print auctions is that their prices tend to be lower than those charged by dealers at the retail level. We hasten to warn that this is true of the *overall* picture, although it can be untrue for individual impressions, which may zoom for a variety of reasons. It may be that there is a sudden and inexplicable surge of interest in a particular artist. Sophy Burnham implies in *The Art Crowd* that Andy Warhol had a friend bid up "Soup Can with Peeling Label" in order to establish a price higher than any of his works had achieved before. Whether this is the fact in this

particular case or not, it is unlikely that artists or dealers or collectors with substantial holdings in a particular area have not attempted to manipulate the market at one time or another. Or a collector or dealer may be determined to own a particular print because it completes a collection or has long been coveted. An instance that comes to mind involves a Charles Burchfield lithograph that came up at auction in 1972 for the first time in many years. Its low estimate of $250 attracted a full field of collectors to enter the race when the bidding began. Then two men competing from almost adjacent chairs bid each other up to $850, setting a new price record for Burchfield (who made only three lithographs), with the foreseeable result of bringing many other impressions of the print out of hiding at subsequent sales. Once his prints were no longer so rare, again predictably, the new high was not maintained.

Ill-informed private parties sometimes have mistaken ideas of a print's value and bid each other up, another force for an auction record. Or that well-known phenomenon, auction fever, may take hold and push prices beyond those any dealer would dare ask. It is certainly true that at any given auction, prices can be buoyant with an eager crowd or depressed with an unresponsive audience. We hope that you as an informed and calculating buyer will learn to sit on your hands when the scene gets frenetic, and know when to wave them when the bidding is desultory.

Because there are pitfalls for the amateur, there are dealers and others who warn them away. "An auction is a dangerous place," cautions a prominent dealer. "If you're going to collect, you're competing with a combination that's unbeatable . . . people who know the most and are willing to pay the most for that kind of art." But his warning actually underlines our thesis: We urge *you* to know the most, and we further urge you to know prices. Let the other collector set records.

Even if you think that buying prints at auction will not be your métier, you owe it to yourself to visit once or twice, if only because the auction room is the place where you can watch dealers in action, meet fellow collectors, and make the scene in as quiet or flashy a way as you care to. Some people are fascinated by auctions in the same way that others are engrossed by prizefights or horse races—there is always a winner and at least one loser. For some fans bidding becomes a form of betting. Yet for other collectors auctions are a bore, their notion of drama and action unsatisfied by monotonous drones from the auctioneer or the steady movement of prints on and off the podium. But go to an auction soon, if you have not yet sat through one, and decide for yourself.

Analyze the Catalog

Before arriving at an auction to bid, however, read the catalog. Analyze it carefully. Learn what the "code" words mean. The SPB catalog, for in-

stance, carries a glossary of terms in its introductory material. One detail, among others, that it calls to your attention refers to signatures. "A print is described as 'signed,' " the note says, "only if it has, in our opinion, been individually signed by the artist. Signatures of doubtful authenticity may be indicated by a question mark or by such terms as 'bearing a penciled signature.' No mention is made of signatures in the plate." The unwary bidder who innocently assumes, then, that "signed in pencil" and "bearing a penciled signature" mean the same thing can be badly burned. And readers should consider themselves alerted to the ordinariness of signatures in the plate.

Learn Terms

Familiarize yourself with the significance of such standard catalog terminology as "wear along edges," "light stained," and "cut close." Observe what is meant by these terms by visiting the auction gallery during the designated viewing period when you may examine the prints to be offered for sale. If prints are framed, at the major houses you may ask to have them removed. At others you must take your chances—so buyer beware. While constantly comparing the prints and their catalog descriptions, discover if you can see for yourself the difference between "fine" and "good" prints. Learn to spot what may have been tactfully omitted from any catalog description. If you have not done so before the viewing, consult appropriate *catalogues raisonnés* after you have looked at the prints that interest you. Such steps are part of the process of educating yourself toward connoisseurship. They assure that you'll soon be well prepared for your first actual sale.

Mark Maximum Price

If you intend to bid, even timidly on one small lot, have a maximum price you are prepared to pay marked firmly in your auction catalog, and do not allow yourself to be carried even a bit higher. Will power is all, especially in the beginning. Some bidders, as everyone knows, appear to bid by a mere flick of the eyebrow, a twitch of the lip, an instant of eye contact, or even by telepathy, but we advise that nodding your head in assent or raising your hand high when the auctioneer asks for the next price are less esoteric, though at least equally effective, methods of signaling bids.

If you would like to bid on a print at auction but are unable to attend in person—you live elsewhere, plan to be on vacation, cannot spare the time, or any one of a hundred reasons, including a certain diffidence about entering the fray—there are two possibilities open to you.

Mail Bids

You can bid by mail. About a fifth of the 3000 prints sold at Sotheby's in England in 1971 were sold on bids made by mail. Before bidding on prints this way you should have attended a sufficient number of auctions to have become easily conversant with auction catalog terminology, so that you know, for example, what to expect when the catalog uses a term like "hinge staining." You'll know whether that means the print is marred or not. Adrian Eeles, head of the print department at what was then Sotheby's writes that he enjoys

> the challenge of trying to describe a print as concisely and fairly as possible. *I only ask the reader to learn the language of the house.* [Italics added.] I admit that this is difficult, if you haven't had the opportunity to view a print sale with the catalogue description at your elbow. Someone who can actually view the prints treats the catalogue more as a guide (where to look for repairs, whether the set is complete or not) and then makes up his mind about what to bid on and for how much. The postal buyer must place his reliance on the written word. Likewise, he must be mindful of those things left unsaid. By this I mean that deliberate omissions can be as telling as fulsome details.

Our advice, therefore, is to postpone mail bidding until you have become familiar with the entire auction procedure, have studied a variety of auction catalogs, and have attended a few print auctions in person.

Before you mail your offer you may write or phone for further information about the impressions you hope to buy. (You can do this, too, even when you plan to participate personally.) Unlike prints bought from dealers, auction prints are not purchased "on approval," so you should try to know exactly what you are getting. You may be sure, however, that reputable houses stand behind their catalog descriptions. If a lot has been inadvertently misrepresented, particularly in terms of authorship, the purchase price will be refunded. According to the major auction galleries few mail buyers ever complain of errors, and when they do their money is returned without fuss.

Bid Sheets

Once you decide to bid, you will need to fill out a bid sheet. On it you will include the following information in addition to your name, address, and telephone number. (Telephone bids must be confirmed by letter or telegram, or by cable if bids are made overseas.) You must supply a bank reference if you have not previously traded with an auction house. Then you will list each item by lot number, signature, and the top limit of your bid. It is worth mailing your bid as soon as you have made a decision, since in the case of identical bids, it is the rule that the first to arrive takes

the prize. Xerox your bid sheet so that you will have an authentic copy if necessary. The auction house will execute your order—that is, bid on your behalf—at the lowest price possible in terms of reserves and other bids.

Sealed Bids

How does this work? Let's go back to our example, the print with an estimate of $500 to $700, the one for which the last publicly recorded auction sale price was $600. You decide it is worth the same $600 to you, and you submit a sealed bid by mail. But bidding is sluggish that day; it's the second to last item to come up in the sale; and the print fails to reach its reserve, which as you remember, we put at $450. At $400, bidding stops and the auctioneer can draw nothing further from the dwindling audience. Now he will bring out your bid, but *not* for the $600 you have offered.

Let's imagine that bidding on the print has been moving up in increments of $50. That figure, then, is the amount by which your bid will top the previous one, so that it will come in at $450. (Members of the audience may wonder where the bid comes from, since they will not notice any activity from the floor. Yet there is often a special person, quiet, discreet, and stationed in the auctioneer's range of vision, who submits sealed bids; or the auctioneer may take such bids from notes in his ledger or stored in his head.) The auctioneer will continue to seek bids after your proxy bid, but if none are forthcoming, he will knock down the print to you for $450, $150 less than you offered.

Yet you can lose even a high offer mailed to an auction because auction houses will not accept a "buy" bid, that is, one in which you give the house carte blanche to overtop all other offers. You are required to set a limit on the top price you are willing to pay. To flog our example again: you might decide that the print is worth $850 to you and leave that as your offer. But the print may be worth $1000 to someone else, in which case you lose the lot. Or there might have been another sealed bid higher than yours, guaranteeing that yours was never in the running. At an auction you attend in person you can adjust to matters as you proceed, but when operating via the mails, your first high bid is your final one.

If you win, you will be informed by the auction house. Underbidders normally receive only the list of prices achieved. (Some houses accept stamped self-addressed envelopes with which to notify losers.) Successful bidders will receive an invoice within a few days of the sale. In the case of overseas purchases they are offered a choice of shipping methods. We strongly recommend that you have prints packed flat and sent by airmail—and don't forget to request specifically that your shipment be fully insured. Airmail is much the best way for prints to travel—it is faster, it avoids the damage that can come to a shipment sloshing about the hold of a ship, and

it eliminates that bothersome and expensive middleman, the custom's broker. We have found that our prints sent from overseas by air have been professionally packed and carefully mailed, arriving in excellent condition.

Commission Dealers

In addition to buying by seating yourself at an auction and raising your hand at the right moment (and noticing that the regulars have favorite seats—some remaining aloof in the back, others sitting under the eye of the auctioneer, one or two appearing to dash in by chance just in time to make a spectacular bid), and bidding by mail, there is a third method of buying at auction: You may commission a dealer to make bids for you. The fee you will pay for this service varies, but it is normally about 10 percent of the purchase price. In return for this sum you will be the beneficiary of dealer expertise—an examination and report to you on the print before the sale. The dealer will also relieve you of the details of payment and delivery. In addition, there is a possible saving resulting from that elusive factor known as auction knowhow, a matter more art than science, about which agreement is not possible. There are those who maintain that the timing and increment of a bid—whether it comes early or late, whether it has to be dragged out of the audience or comes trippingly off a multitude of tongues—affects the ultimate price of an object at auction. If this seems likely to you, then the dealer offers another advantage: You can suggest a range of possible prices you are ready to pay for each item, although you will still need to be firm about top prices. You can provide a dealer with a series of alternative bids, so that if you fail to win one print you want, you can make the high bid on another. Finally, dealers may be your choice if auctions frighten or bore you, yet you hate to forego the prints you can acquire at them.

No matter how you go about it, auctions are not without risk. Auction purchases are a gamble—riskier than buying through a dealer, and also more time consuming.

Risks

In our experience, "rings" are not one of the risks. Members of rings operate by agreeing not to bid against each other on lots they want, so that the object will be sold to one of them, they hope, at a lower price than it would have been had all bid freely. Then, after the auction, the members of the ring conduct their own auction, privately, with the highest bidder among their limited numbers winning the piece. Rings clearly operate against the consignor and against the auction house, which makes its profit on its sliding scale of commissions. As an independent buyer, however, you can bid as high as you think appropriate, regardless of whether a ring is conniving. We have seen such a variety of private collectors and dealers

come away from auctions with excellent buys that we believe few *print* auctions are subject to manipulation.

Yet the gambling element must be acknowledged, and must always be one the collector purchasing at auction is prepared for. Bids can soar because there is a collector or dealer present who *must* have a particular print, and prices will go sky high, carrying you along if you're not careful. Sometimes there's an unprecedented run on an artist, who may be just the one you're looking for. Some days everyone is euphoric, and you can't buy a thing. Or you may not be experienced enough to appreciate the difference among "good," "weak," and "excellent" impressions, or you may not have examined the print closely enough to notice how soiled it is, or you may not realize how depressing to the price that small, poorly repaired tear near the corner can be. But if you proceed carefully, study the auction catalog, examine the prints with catalog in hand, ask the willing attendants any questions you wish, buying prints at auction can be a gratifying way of adding to your collection.

Extra Costs

There are certain extra charges you must remember to include when calculating the total cost of a print at auction. At American auctions the seller pays a commission to the auction house for making the sale. At English auctions both buyers and sellers pay commissions. The specific terms are announced in the appropriate catalog. On the Continent the standard procedure has the buyer paying a 15 percent commission on purchases in Switzerland, 20 percent in Germany, and 10 to 16 percent in France. In addition to these charges, it is wise to be aware that in all cases it is the buyer who pays any applicable taxes. Additionally, the buyer who wants works shipped will pay all packing and shipping charges. Since there is frequent change in buyers' surcharges, check current practice before you buy.

Auction Catalogs

We have made a point throughout this section of urging collectors to study auction catalogs carefully. We urge, further, that every serious American collector subscribe at least to the Sotheby Parke Bernet print sales catalogs. This is expensive—though not as expensive as the European catalogs, which can run as high as $15 and even $30 each.

There are five print sales a year at Sotheby Parke Bernet in New York. Two of them are major sales, in November and May, which include Old Master as well as modern prints, and three of them, in December and February and June, focus on minor prints, most of which are estimated under $1000.

We reproduce a page from the Sotheby Parke Bernet catalog for the

175

Lot 578

576 *Le Combat* (Bloch 301), etching, 10 October 1937, signed in pencil and numbered 29/50, with margins, in good condition, framed

398 x 495 mm
15¾ x 19½ inches

One of the major prints of this important period in the artist's work. The subject derives from the long tradtion of representations of gladiatorial combat in European art.

See illustration on facing page

577 *Non Vouloir* (Bloch 360, book No. 36), etching, 1942, one of 20 impressions accompanying the first 20 copies of the book by Georges Hugnet, with full margins, in good condition, framed

136 x 119 mm
5⅜ x 4¾ inches

578 *Le Pichet Noir et la Tête de Morte* (Bloch 395; Mourlot 35), lithograph, 20 February 1946, signed in pencil and numbered 34/50, printed to the edges, tape hinged, otherwise in good condition, framed

$5000.

4/6000 est.

323 x 442 mm
12¾ x 17⅜ inches

One of the most important still life subjects in the artist's graphic oeuvre.

See illustration

sale in May, 1974, in order to point out their typical practice. The lot number, 578, appears first. This is followed by the title as given by the artist or as the print is usually referred to and known by others. It would not do to translate the title into English and call this print "The Black Pitcher and the Skull."

Next, in an invariable sequence, will be found the *catalogue raisonné* reference numbers within parentheses. This print is number 395 in Bloch's catalog, and number 35 in Mourlot's. (Mourlot cataloged Picasso's lithographs only, whereas Bloch included all his graphics.) This information makes it simple for you to check back and helps to authenticate the print.

Next the medium, in this example a lithograph, is reported. Then comes the day, month, and year on which the print was signed, followed by a statement that it *is* signed, and with what material. Another entry might read "signed in red crayon," or "signed in ink." After information about the signature, the number of this specific print is stated in the form of a fraction, with the denominator telling the total number of prints in the edition and the numerator giving the serial number of this print. "34/50" tells the reader that among 50 multiples, this print is numbered 34.

What follows is a descriptive note that the lithograph is printed to the edge of the paper—in other words, there are no margins. Reading the measurements in the *catalogue raisonné* will make it clear whether the margins have been cut or the lithograph was printed in this way originally.

"Tape hinged" means that the print has been hinged to its mat by means of an acidic tape, which constitutes some degree of deterioration to the print. This is implied in the subsequent laconic words, "otherwise in good condition." (Note that "good" does not always mean the same as "excellent," "mint," or "perfect.")

Next there is a note that the print is framed. This may be convenient, but it is a very minor matter to the serious collector. The description continues with the dimensions of the print, height followed by width, which are given in both millimeters and inches.

Next to last, in this though not in every entry, the catalogist makes a sales comment: "One of the most important still life subjects in the artist's graphic oeuvre." The person writing the catalog wants to clue in prospects to the print's value, but must be chary of superlatives, for too frequent use of them would cause the reader to ignore them all. Finally, the attention of the collector is called to the reproduction—"See illustration." You may be reasonably sure that lots pictured are considered among the more important items in the sale.

In addition to the series of specific items to be expected and relied upon in the SPB print auction catalogs, you will have observed that we have written in our catalog, as is our habit, both the estimate as it appeared in the list provided ($4/6000) and the actual price that was paid: $5000.

Sotheby Parke Bernet in New York and in London publish the most detailed of all auction catalogs in English but all catalogs should be studied before and after sales, and all should become part of your permanent print reference library. Now notice the differences in the page reproduced between these American and English catalogs and those produced by Kornfeld and Klipstein, whose annual June auction in Berne, Switzerland, is considered by leading dealers the single most important print auction in the world. It is also the outstanding annual business and social event. About 1500 prints change hands at these prestigious auctions, with the 1974 catalog including almost 200 pages of illustrations.

Kupferstiche, Kaltnadelarbeiten und Lithographien 1945–1958

917. Faune musicien et Danseuse. Kaltnadel. (27 500.—)

* Bl. 1341. 1945. Eine der schönen graphischen Arbeiten, die der Künstler im Spätsommer in Antibes schuf, dem ersten Aufenthalt im Süden Frankreichs, nachdem der Künstler während des ganzen Krieges in Paris festgehalten worden war. Das Blatt hat keine Auflage erfahren, sondern ist nur in einzelnen Probedrucken bekannt geworden. Das vorliegende Exemplar ist auf festes Bütten gedruckt, mit Rand, von der unfacettierten Platte. Im Rand unten rechts vom Künstler in Bleistift signiert. Entgegen den Angaben bei Bloch handelt es sich teilweise um eine Kaltnadelarbeit und nicht um eine reine Radierung. Der vorliegende Druck ist an einzelnen Stellen stark gratig. Von grösster Seltenheit. Sauber in der Erhaltung, mit minimalem Lichtrand.

Siehe die Abbildung, Tafel 175

918. Les Pipeaux. Radierung. (27 500.—)

* Bl. 1347. 1945. Ein weiteres graphisches Blatt aus dem Herbst von 1945 in Antibes, das keine Auflage erfahren hat und das nur in wenigen Probedrucken bekannt wurde. Druck auf festem Bütten, von der unfacettierten Platte, unten rechts in Bleistift vom Künstler signiert. Von grosser Seltenheit. Aus Slg. Louis Fort, dem Drucker des Blattes. Siehe die Abbildung, Tafel 175

919. Les Pipeaux. Farb. Radierung. (27 500.—)

* Bl. 1349. 1945. Ein weiteres graphisches Blatt aus dem Herbst von 1945 in Antibes, das keine Auflage erfahren hat und das nur in wenigen Probedrucken bekannt wurde. Druck in Grün auf Japan, mit Rand, unten rechts vom Künstler in Bleistift signiert. Von grosser Seltenheit.

Siehe die farbige Abbildung, Tafel 25

920. Tête de Femme. Lithographie. (10 000.—)

Bl. 375. Mourlot 1. 1945. Tadelloses Exemplar der Auflage, rechts vom Künstler in Bleistift signiert und links auf 50 numeriert. – Picasso schuf in den Jahren 1919 bis 1930 einzelne Lithographien, um dann dieses künstlerische Ausdrucksmittel für viele Jahre gänzlich aufzugeben. Im November 1945 erschien der Künstler in den Ateliers von Mourlot, um dort die lange Reihe von lithographischen Meisterwerken zu schaffen, die Picassos Ruhm als Graphiker in aller Welt verbreitet hat. Das vorliegende Blatt ist die erste Arbeit dieser Serie und wurde gleich am ersten Schaffenstag, dem 2. November 1945, vollendet. Als Hilfsmittel diente ausgeschnittenes Umdruckpapier.

921. Tête de jeune Garçon. Lithographie. (25 000.—)

Bl. 378. M. 8/III. 1945. Tadelloser Druck der Auflage, unten rechts vom Künstler in Bleistift signiert und links auf 50 numeriert. Sauber in Druckqualität und Erhaltung, mit leichtem Lichtrand.

922. Nature morte au Compotier. Lithographie. (15 000.—)

Bl. 379. M. 6/III. 1945. Tadelloser Druck der Auflage, rechts vom Künstler in Bleistift signiert und links auf 50 numeriert. Picasso hatte am 2. November 1945 mit neuen Lithos bei Mourlot begonnen. Dieses Blatt datiert vom 16. November und ist bereits die 6. Arbeit.

Siehe die Abbildung, Tafel 190

923. Jeune Fille aux Grands Cheveux. Lithographie. (12 500.—)

Bl. 380. M. 12/VI. 1945. Eine der ersten Lithographien der Nachkriegszeit vom November 1945 in einem tadellosen Exemplar der Auflage, rechts vom Künstler in Bleistift signiert, links auf 50 numeriert.

Siehe die Abbildung, Tafel 190

924. Tête de jeune Fille. Lithographie. (12 500.—)

Bl. 383. M. 5. 1945. Tadelloses Exemplar, rechts vom Künstler in Bleistift signiert und links auf 50 numeriert. Eine der ersten graphischen Arbeiten, die 1945 bei Mourlot entstanden.

925. Le Pichet noir et la Tête de Mort. Lithographie. (10 000.—)

Bl. 395. M. 35. 1946. Tadelloses Exemplar der Auflage, auf gelblichem Velin aufgezogen, links in der Darstellung in Bleistift vom Künstler signiert und im knappen Unterrand auf 50 numeriert.

3,400

144

We note "Le Pichet noir et la Tête de Mort" again. (And we realize instantly, if we had not before, why titles are never translated.) A glance shows us that the entries are much more succinct than the ones we have already examined, and that the estimated price is given as a single figure, in Swiss francs, in a right-hand column. The names "Bloch" and "Mourlot" are abbreviated, making life a bit more difficult for the uninitiated— but the novice doesn't belong at Kornfeld and Klipstein's auctions anyway. The year of the print's execution is announced, no month and day. Although edition size—50—is noted, the serial number of this particular lithograph is omitted. The medium appears immediately after the title. Catalog readers are not told if there is a margin or not, nor what the condition of the print may be, nor even its dimensions. And there is surely no promotional material telling readers that this print is "important" or "major" or "unique." Such brevity is accounted for not so much by the fact that Kornfeld and Klipstein's auctions are geared for professionals, which they are, but by the fact that they stem from a different catalog tradition. Interested readers will note that we have jotted in our catalog the actual prices achieved, in U.S. dollars.

Other Kinds of Auctions

PB84 [Parke Bernet] in New York City, like Sotheby Belgravia in London, frequently includes prints in estate sales. In these catalogs the descriptions are briefer, less scholarly, yet still viable parts of the record. At both of these sales places, as at other estate sales you may attend, it is possible to make real discoveries—as well as to doze through dreary sessions during which nothing worth looking at is shown.

Main Print Auctions

The main print auction sales for collectors are the four already mentioned at SPB in New York, the annual sale at Kornfeld and Klipstein in Berne, the fifteen or so print sales held annually at SPB London, and, a more recent addition, the print auctions at SPB in Los Angeles. In addition to these, there are regular print auctions at the Hôtel Drouot in Paris, and there are several worthwhile German houses. Various important sales are staggered to synchronize with long-existing auctions. For instance, a new art fair has been held in Berne in the last few years, closely embracing the dates of the K&K auction. The Plaza Gallery in New York often schedules its print auctions for the evenings of the days on which SPB announces its sales, a logical move, since many of the same people are interested and are in New York. Their catalog is more in the nature of a list. Although you cannot subscribe to it, you can pick it up when it is announced. The youngest American print auctions, run by Martin Gordon, are also designed around SPB schedules.

Home Talent

American auctions are the only truly international auctions today. At them one can buy English, French, Italian, Dutch, or Japanese prints of any period. At English auctions, on the other hand, rarely will an American print surface, except, perhaps, the occasional print by an American who studied or lived in England. (Yet English auctions are excellent for Old Masters.) The works of English printmakers rarely collected elsewhere will come up for sale frequently. German auctions are international, but heavy in German art, especially the German Expressionists. The differences of each country's auctions make it worthwhile to become a world-wide shopper for prints by means of the major auctions and their descriptive catalogs.

Auction Announcements and Records of Prices

Announcements of forthcoming auctions appear in the *Print Collector's Newsletter* and in the quality art magazines—a list appears in Chapter 6. A sampling of representative auction prices is published regularly in *PCN*, and much more complete lists can be consulted in *International Auction Records* by E. Mayer. (Volume 8, 1974, is $52. Back issues are still available.) Since this compendium is published in July of each year, it is inevitably outdated by six months. There is also *Art at Auction*, edited most recently by Annamaria Edelstein, which is also published annually for $25, but its print information is much less complete.

SERENDIPITY

Almost anyone advising the print collector, especially the newcomer, will caution against the least likely sources of good graphics—the junk shop, antique store, country auction, and the like. The Cassandras are right. As they insist, browsing in such places is time consuming, and most collectors lose heart before they uncover treasure. Dreadful castoffs are crazily priced; skim milk masquerades as cream. Yet we know collectors who can smell out worthwhile prints in the most discouraging hideaways and they garner the bonus satisfaction of rescuing valuable lost impressions from almost certain oblivion.

Everyone has a remarkable success story, which all the rest of us hope one day to be able to duplicate. One collector, in attempting to deflect our interest from dreams of glory actually adds glitter to the lure. "It is the dealer that the collector needs so as to actually make a collection," collector Arthur Vershow begins, stating a truth with which every print collector must agree. "It is most important to frequent reliable dealers who can be trusted to represent a print accurately," he continues, still garnering easy nods of assent from all of us. Then he goes on to relate briefly his own

remarkable discovery: "From my own experience, the energy expended in antique shops rarely has brought results. I did once find a complete set of Hiroshige's 'Fifty-Three Stations of the Tokaido Road' in an antique shop for $5. Fourteen years has not brought a comparable triumph, but hope springs eternal."

That's an exciting treasure, even once in fourteen years. The collector follows these remarks with the best suggestion we know for "bargains." "The greatest bargains are those prints, purchased at a time when they were not generally desired, trusting one's own judgment as to their true merits. In 1954, almost any of the prints of Redon, Beckmann, Kandinsky, or Kokoschka could have been purchased for about $5 to $40 each. There certainly are equivalent prints of artists of merit available today."

One dealer insists that he never "finds" anything, since he makes his purchases at the well-known auction houses or through reputable dealers. Yet he, too, in the guise of warning us off, tells a success story any collector might dream of emulating.

> The only find I ever made almost ended in disaster. And I didn't look for it. I stepped out of my London hotel and walked two doors down and there, in an antique-shop window, was an Audubon watercolor. And we looked at each other for some time. It was the study for a plate he did for the *Quadrupeds,* and I decided that although these were rats, I liked them anyway, and I went in, and I said, "Those are very beautiful rats, and they seem to be American." (It wasn't signed where you could see it.) And there were notes on it, indicating how it should be printed, which later turned out to be for the *Quadrupeds* book. Anyway, I made this comment to the dealer, and she said, "I think they're ghastly!" So I said, "Well, then?" She said, "Well if you really want them, they're nine pounds ten." So I said, "I never wanted anything more." And I took them.

The dealer goes on to tell how it happened that he decided to sell the watercolor, at auction, for a 9000 percent profit. If our arithmetic is correct, that means the watercolor brought close to 900 pounds, a tidy sum that somehow does not prepare us for his conclusion: "I can't ever remember 'finding' anything else, and I think it's a complete waste of time. If one wants to spend one's time with little kinds of obscurities, fine. Hunt where there are little kinds of obscurities." Yes, of course, if you consider an Audubon watercolor some kind of obscurity.

Printmaker S. W. Hayter, however, has the final word:

> Then . . . we have the gamblers. Here the overriding motive is to obtain by the exercise of knowledge and experience prints which have far greater value than the sum one has paid for them. Either by the exercise of the faculty used to pick winners on the racecourse, or by finding in an unlikely place a known print of great value, not known to its owner, the object is to obtain possession of a print which has, or with time will have, great value. The people (and this must include most of my friends) who prowl the flea

market in Paris, the antique shops and junk yards of various countries, hunting for bargains, are clearly in this category. It is an error to suppose that such things are not possible to a man with some knowledge. The sculptor Jacques Lipchitz happened to notice, in the window of an establishment in New York which auctions old furniture, a Martin Schongauer print in a museum frame. As the sale was to be some days later he made use of the privilege that buyers have to leave a deposit in case no higher bid is made on a lot: he left five dollars. At the sale, owing to the absence of any person aware of the value of a fifteenth-century print, or needing the frame more than he needed five dollars, he acquired the print for four dollars. This almost constitutes another category: the browsers in printshops or along the quays of Paris, the patient souls who go through portfolios and stacks of papers in the street markets in the hope of finding a lost masterpiece, whether for venal or aesthetic satisfaction.

The moral we can draw from the story is that the very knowledgeable—such a sculptor as Jacques Lipchitz and probably the others in Hayter's circle belong preeminently in that category—are capable of knowing the difference between gold and dross. The needle-in-the-haystack game is for those who know a great deal, who are always learning more, who have the time and patience for unproductive sifting, a love of prints that impels them ever onward, and a small enough pocketbook so that there is a real incentive to find prints at prices they can manage to pay. For the rest of us, dealers, in the main, and, secondarily, print auctions will continue to reward us as basic sources.

A list of regularly scheduled print auctions follows. Every potential buyer at auction should study a catalog of the sale well in advance. Prices of catalogs change, but none are free. Many can be subscribed to on an annual basis. This can be expensive, so all but active professionals must be selective. The best catalogs today include estimates, and for a small extra charge you can have the list of actual prices achieved. As explained earlier, these can be valuable and should be retained.

Most auctions are held at the same time year after year, but since specific dates do change, we have indicated, when possible, only the usual season of sale.

We have relied heavily for this list on the pioneering compilation made by Jacqueline Brody in her article in the *Print Collector's Newsletter* in March/April 1972. Very little in the print auction picture has changed since then, so we have made few additions or deletions.

MAJOR PRINT AUCTIONS (U.S.)

Los Angeles *California*
Sotheby Parke Bernet, 7660 Beverly Blvd., 90036.
Two or three print auctions held each year include mod-

ern and contemporary prints. Catalogs in English give few details on condition; estimates included.

New York **New York City**
Martin Gordon, Inc., 1000 Park Ave., 10028.
Semi-annual sales. Catalogs in English, fully illustrated, describe condition; estimates included.

Sotheby Parke Bernet Galleries, 980 Madison Ave., 10021.
Five print sales a year include all periods. Catalogs in English describe condition; estimates included.

PB84, 171 East 84th St., 10021.
An auxiliary branch of Sotheby Parke Bernet. Weekly auctions frequently include some prints. Catalogs in English, available at exhibition, contain no details.

Plaza Art Galleries, Inc., 406 East 79th St., 10021.
Periodic print sales. Catalogs in English, available at exhibition; not detailed.

MAJOR PRINT AUCTIONS (FOREIGN)

Austria **Vienna**
Dorotheum, Dorotheergasse 11, A-1011.
Frequent print sales. Catalogs are in German with estimates included. Experts validate sales.

Belgium **Antwerp**
Campo, 47 Meir 55.
General sales occasionally include prints. Catalogs in Flemish and French give some details.

Denmark **Copenhagen**
Arne Bruun Rasmussen, 35 Bredgade, 1260.
General sales occasionally include prints. Catalogs in Danish give few details on condition.

France **Paris**
Guy Loudmer, 30 place de la Madeleine, 75008.
Periodic print sales held at the Hôtel Drouot and Palais Galliéra; mainly French and 20th century. Catalogs in French give few details. Experts usually validate sales.

Maurice Rheims & René Laurin, 1 rue de Lille, 75007.
Periodic sales held at the Hôtel Drouot and Palais Galliéra.
 Catalogs in French give few details. Experts usually vali-
 date sales.

Ader Picard Tajan, 12 rue Favart, 75002.
Print sales held regularly at the Hôtel Drouot and Palais
 Galliéra. Catalogs in French contain few details.

Berlin *Germany*
Galerie Gerda Bassenge, Erdenerstrasse 5a, 1-33.
Auctions held in spring and fall include Old Masters, other
 periods, and books. Detailed catalogs in German include
 estimates.

Cologne
Lempertz, Neumarkt 3, 5.
Print sales held in late spring and fall include prints of all
 periods. Catalogs in German contain details and esti-
 mates.

Hamburg
Ernst Hauswedell & Nolte, Pöseldorfer Weg 1, 2-13.
Print sales held in late spring and fall include quality Old
 Masters and modern. Catalogs in German describe con-
 dition; estimates are included.

Heidelberg
Helmut Tenner, Berghcimcrstrasse 59, 69.
Occasional sales of books, Old Master and modern prints.
 Detailed catalogs in German include estimates.

Munich
Karl und Faber, Karolinenplatz 5a, 8-2.
Print and book sales held in spring and fall. Detailed cata-
 logs in German include estimates.

Galerie Wolfgang Ketterer, Villa Stuck, Prinzregenstrasse
 60, 8-80.
Print sales held in late spring and fall feature Art Deco,
 Art Nouveau, modern art. Detailed catalogs in German
 (English translation available) include estimates.

London *Great Britain*
Sotheby & Co., 34 & 35 New Bond Street, W1A 2AA.
About fifteen sales each year include Old Master and

modern prints. Catalogs in English describe condition.

Sotheby Belgravia, 19 Motcomb Street, SW1X 8LB.
Frequent print sales include English, Victorian, and decorative prints. Catalogs in English describe condition; estimates included.

Christie, Manson & Woods, 8 King Street, St. James, SW1.
Six to nine print auctions each year include Old Master and modern prints. Catalogs in English give details on condition.

Italy

Milan
Finarte, Piazzetta M. Bossi 4, 20100.
Sales include 19th and 20th-century prints, often Italian. Catalogs in Italian give limited details on condition.

Netherlands

Amsterdam
Sotheby Mak Van Waay N.V., Rokin 102.
Occasional print and book sales. Catalogs in Dutch and some English give few details.

Sweden

Stockholm
Bukowski, Arsenalsgatan 2.
An antique store that holds a general auction including prints each spring and fall. Catalogs in Swedish are not detailed.

Bokauktionskammeren, Norrtullsgatan 6.
Auction house is owned by the city of Stockholm. Prints and books included in weekly auctions. Catalogs in Swedish are not detailed.

Switzerland

Berne
Kornfeld und Klipstein, Laupenstrasse 49, 3008.
Most important auction house specializing in prints. Series of sales in June include prints of all periods. Detailed catalogs in German; estimates included.

Geneva
Galerie Motte, 10 Quai Général-Guisan, 1204.
Occasionally sales include modern and decorative prints. Catalogs in French are not detailed.

Lucerne
Galerie Fischer, Haldenstrasse 19, 6000.
Sales in spring and fall include prints. Catalogs in German; estimates included.

JOHNS, JASPER (b. 1930) *The Critic Smiles*
Lithograph, hand colored in silver, gold and aluminum. 1966. Crayon signed in image. Ed: 40. Ref: Fields 54. 13″ x 11¼″ (sheet 25¼″ x 20⅛″). Courtesy of the Collection, The Museum of Modern Art, New York. Gift of the Celeste and Armand Bartos Foundation.

A work that aspires, however humbly, to the condition of art should carry its justification in every line.
Joseph Conrad, *The Nigger of The Narcissus*, 1898.

4. *The Contemporary American Print: Midcentury to the Present*

If galleries, collectors, art magazines, and the public ignored contemporary printmaking, there would soon be few prints made. This guide to collecting, therefore, is as concerned with today's prints—prints made by living artists—as it is with the prints that compose our heritage. But such acute changes in printmaking practice, merchandising, and exhibition have occurred in the last twenty-five or thirty years that collectors may profit from exploring with us some of the differences.

There is more, today, of everything—more prints are produced, more people collect, more dealers sell, more money is paid for individual impressions, and more cachet than ever attaches to collecting—perhaps even more than in the Twenties, when the rage for Whistler and other etchers was at its height.

The continued growth of the appeal of prints is not owed to a single force or a lone figure emulated by a host of artists or collectors. Rather, it has been steadily burgeoning for decades, and a variety of talented printmakers—sometimes aided and encouraged by connoisseurs and entrepreneurs—has kept it going.

One of the ways in which artists and museum professionals have nurtured growth has been by establishing regular print exhibitions, which have proliferated in the last several decades. In 1947, when the Boston Printmakers Annual and the Brooklyn Museum Print Annual (now Biennial) were initiated, only a handful of regular national print exhibitions could be counted as permanent features of the American scene: the shows of the Library of Congress, begun in 1943; the Philadelphia Print Club (established in 1914 and for a long period the sponsor of several annual print exhibits); the Northwest Printmakers, formed in 1928; the San Francisco

Art Association, whose print exhibits have been transformed through varying incarnations; and the Society of American Graphic Artists (known as SAGA), which has changed its name several times but not its annual exhibition policy since its inception in 1915. The first sponsors of print exhibits in America, SAGA's were for many years the most important in the country.

Some of these many new annuals and biennials are sponsored and juried by artists—as the shows by SAGA for instance, always have been. Others are supported by institutions, with printmakers judged or invited to participate by museum people, critics, or fellow artists. And some shows are selected and sent on the road via commercial enterprise—by publishers or dealers selecting prints under one heading or another from among those they have for sale. Whatever the auspices, the increasing number of traveling shows attracts wider audiences to prints.

Art schools and workshops run by printmakers supplied new vitality during the middle years of the century. The renowned English printmaker Stanley William Hayter moved his Atelier 17 from Paris to New York in 1940, attracting some of the most talented students here during the fifteen years he remained. Encouraged in experimentation with etching techniques, his students, as they became professionals, generated ever-widening waves of influence. Harry Sternberg, during an overlapping period (1933–1966), taught graphics at the Art Students League to many students who are now notable in the print world. In 1943 Mauricio Lasansky came from South America to found an important print department at the University of Iowa, which long supported one of the best university art schools. Within ten years his division was sending out skilled artists, some of whom, in time, became seminal printmakers. Fritz Eichenberg, who had arrived here from Germany in the Thirties, initiated the vigorous undergraduate print department of Pratt Institute in 1947. Gabor Peterdi taught printmaking at the Brooklyn Museum Art School from 1949 to 1953, its most active period. Art school and university print departments had functioned earlier and elsewhere, but these concentrated new efforts—sparked by active, exhibiting printmakers—galvanized attention and awakened many a moribund department; they also attracted talent to the graphic media.

Printers and print workshops were the necessary backup to continued growth. Lithography, especially, has always been the print medium requiring highly trained printing skills, and like etching, special printing equipment. The oldest continuing American fine-art printing establishment is the firm of George C. Miller in New York. The story goes that in 1917 Miller, then a young printer working in a commercial shop, began fine-art lithographic printing when he was asked by artist George Bellows for help in

printing a difficult lithograph. They were introduced by Albert Sterner, an artist who had been trained in Chicago as a commercial lithographer decades earlier. Other artists followed Bellows, and a few years later Miller opened his own place. Printing for artists is still carried on there under the direction of his son, Burr Miller, and it is only a small exaggeration to say that there was scarcely a lithographer in America, between 1920 and 1950, who did not at one time or another have work printed by the firm. Other printers contemporary with George Miller were Anderson Lamb and Bolton Brown—an artist, active until his death in 1936, who did professional lithographic printing for fellow artists (including Bellows) during many of the same years.

Another artist important to the rediscovery of lithography as a fine art in this country is Joseph Pennell, who early in the century, "following in the footsteps of Whistler, produced a number of unusual lithographed views of the New York City skyline and of industrial sites while serving as a teacher and vigorous champion of lithography at the Art Students League. Charles Locke, a gifted printmaker, succeeded Pennell in 1927 as lithography instructor at the League. . . . Other classes in lithography were offered by Konrad Cramer at Woodstock, New York, beginning in 1923, and painters such as Adolph Dehn, Louis Lozowick, Yasuo Kuniyoshi, and Stuart Davis made imposing contributions to the medium during the Twenties. By 1930, with new lithographic printers in New York City, Chicago, Cleveland, and other cities, lithography was established as a viable form."

During the Thirties lithography was further invigorated by the Graphic Arts divisions of the WPA Federal Art Project. Although artists employed by the Graphic Arts divisions worked and experimented in various media, there was an emphasis on lithography, perhaps because their first director, Gustave von Groschwitz, was always particularly interested in it. Even during the short years of the Project's life, experimentation with color lithography was encouraged and, according to Lynd Ward, for a time the head of the workshop in New York, about ten percent of the work there was in color lithography. Yet the first American exhibition of color lithographs was not held until 1950 at the Cincinnati Art Museum, where von Groschwitz had become Curator of Prints in 1947.

In the Forties students at the Art Students League, as well as those at a few art schools elsewhere, had opportunities to learn to print their own lithographs, although some chose to have their proofs pulled by Will Barnet, for a time the printer at the League. Even a few New Yorkers outside the League went there to have work printed by him, among them Philip Evergood. All the same, Garo Z. Antreasian speaks for many artists who lived outside these centers when he describes his struggles to make litho-

graphs in the late Thirties and early Forties. The gap in the tradition forced such artists virtually to re-invent lithography in their effort to make prints.

In 1951 printmaker Margaret Lowengrund established a New York place of exhibition for artists working in the graphic media, the Contemporaries Gallery. A few years later it had a print workshop for artists, so that it was possible to exhibit and sell in the gallery prints made in the shop. In 1956 Lowengrund, "with a prayer" and some financial help from the Rockefeller Foundation and Pratt Institute, transformed her gallery into the Pratt Center for Contemporary Printmaking. Despite her early death the printmaking center continued at a new location as a workshop and place of exhibition, first under Eichenberg and now under the direction of Andrew Stasik.

By the mid-Fifties artists could choose among such professional and cooperative lithography studios as Lynton R. Kistler in California, Lawrence Barrett in Colorado, Reginald Neal in Mississippi, and Robert Blackburn's Workshop (later called Creative Graphics Workshop and currently the Printmaking Workshop) in New York, but outside these centers it was becoming increasingly difficult to find stones, presses, or printers. Some artists who lived at a distance from fine-art lithographic workshops used to order stones from printers such as Barrett and Miller, work on them, and then return them for printing—a cumbersome method that could never have been entirely satisfactory. In 1959 the late printmaker George Lockwood opened the now well-established Impressions Workshop in Boston. (Most of these studios included etching presses along with the lithography equipment). Print media other than lithography were the primary concern of artists and students using graphic artist Letterio Calapai's workshop near New York University. It was later to move near Chicago, where it remains. At virtually all these workshops artists could create prints on their own or with the assistance of professional printers. Etchers who wanted help from printers could get it first from John Andersen and then Burt Andersen. Ernest Roth, the etcher, sometimes printed for other artists during most of the first half of the century.

Many American artists, nonetheless, went to Paris to have work printed, for in the European tradition printers usually executed all the craft work involved with graphics, and French printers were considered the finest. But Americans have long been a do-it-yourself kind of people attaching no stigma to work with the hands and priding themselves on the ability to make things. Printmakers in America had usually functioned within this tradition, completing with little or no assistance each step of the graphic process. They not only etched or engraved the zinc or copper, incised the wood or metal, crayoned or brushed the stone—they actually inked the

plate, wiped it, set it under blankets and rolled it through the press—to describe, briefly, etching procedures.

Although professional printing for artists in the United States has become commonplace in the last decade for a variety of reasons, there are still many artists here and abroad who continue to carry through the entire printmaking cycle. Indeed, not a few printmakers believe that it would be impossible for another person to give them more than minimal physical assistance in printing. Carol Summers, for instance, wets the paper for his woodcuts with turpentine after they have been inked, and he alone can choose the exact moment of saturation that makes them glow. Many of the prints in David Shapiro's little "Winter Walk" intaglio series were printed from cardboard plates, and only he can nurse them through the large editions of 250 published by Associated American Artists. Similarly, when he "inks" a color woodcut he is actually dabbing over the plate with oil paints rather than rolling the color on, so that he is re-painting again and again for each print, a process that no printer, however skilled, could duplicate.

Home-grown, self-reliant ingenuity was so pervasive until fairly recently that Una Johnson, then curator of prints at the Brooklyn Museum, underscored it by saying in 1956 that "one of the distinguishing features of prints in the United States is that the majority of them are printed by the artist himself (sic) and not by a professional craftsman-printer as is so often the case in France. Thus each print is uniquely and completely a creation of the artist, and the entire edition is free from the mechanical perfection of a professional printing shop." Today, twenty years since those lines were written, they are no longer as true. The publisher Brooke Alexander, for instance, reports that fewer than 1 percent of the prints he deals with are printed by the artist alone. A few years ago, in fact, one of the reviewers of the Brooklyn Museum Print Biennial asked, "Where is the thumbprint of the artist?" his query patently a derogation of the immaculate—but to the critic, vacuous—perfection of the professional printing displayed.

Since 1956 there has been a virtual explosion of printmaking workshops, both professional shops run as business enterprises and cooperative shops run by artists. It is often the latter that account for the artist-printed proofs that a few publishers report as the only type they distribute, but it is the former that are novel and powerful. Two workshops begun in the late Fifties, independent of each other but one coming hard on the other's heels, are probably most responsible for this new development.

In 1957 Tatyana Grosman set up Universal Limited Art Editions in the garage of her home on eastern Long Island. An entrepreneur—daughter of a publisher and wife of an artist—she bought a press, hired a printer,

commissioned artists (the first of them Larry Rivers), and carried a portfolio of prints around New York until she was able to interest dealers and museums in her wares. She was probably the first person in America to assume all these roles, and she performed them with enviable success. Before she came along not only had American artists printed their own work, they had "published" on their own too—artists bought the paper and ink with their own funds, printed on their own or co-op presses, and peddled the product to such dealers as they could find. The Grosman example has myriad imitators, so that today anyone with sufficient backing can approach an artist, however famed, offer a sum for an edition, take it to a craftsperson for printing under the supervision of the artist, and then merchandise it to the many new outlets dotting the country.

Imitators have often followed another of Grosman's examples—soliciting prints from well-known painters who had never before made prints. One result is that there are many "printmakers" today entirely divorced from the earlier American tradition of printmaking, which nonetheless continues to flourish. Many of these new printmakers do not know or want to know how to make prints on their own, and some of them may even look upon the making of prints as an easy system of reproducing the images for which they are famous, thereby making it the high road to easy money.

But there might not have been enough printers to produce these multiplying impressions, at least of lithographs, if the Tamarind Lithography Workshop, founded in 1960 by June Wayne with grants from the Ford Foundation that eventually mounted to well over a million dollars, had not been training printers. (Her initial Associate Director was Clinton Adams, and Garo Z. Antreasian was the first Technical Director.) Tamarind's first charge was to teach fine-art lithographic printing, and in this it has succeeded admirably, establishing meticulously high standards of excellence. The Workshop remained in Los Angeles for ten years, and when Ford Foundation support ended it was taken under the wing of the University of New Mexico in Albuquerque, where it continues to operate as the Tamarind Institute, under the direction of Adams. Tamarind alumni, many of whom have set up their own workshops, now provide most of the facilities for the increasing number of artists making lithographs and for the print publishers who are involved with what has become a many faceted business enterprise generating important sums.

Because lithographs, especially large, color lithographs, have become so much more noticeable in the last decade, many people in and out of the art world have unwittingly assumed that lithography has come to dominate current American printmaking. But this is not the case, as a cursory count we made recently bears out.

We compared the relative numbers of lithographs in representative print exhibits in 1948, 1960, and 1975. In the 33rd annual of the Society of American Graphic Artists in 1948 fully a third of the works displayed were lithographs. In the 18th Library of Congress exhibit in 1960, when neither ULAE nor Tamarind had yet made an impact, lithography was still the most frequently employed single medium except for "intaglio" (a confusing term as it is now used, since engravings in steel, collographs, etchings, aquatints, and drypoints are all one form or another of intaglio processes). But by 1975, when some claim lithography is ascendant, only eleven of the 100 prints in the 53rd SAGA annual were lithographs. Etchings were far better represented, as were other forms of intaglio printing.

How to explain the popular assumption? The answer may lie in the increasing number of print publishers who sell to the growing number of print dealers. In *numbers* alone—numbers of impressions—it is probable that there actually are more lithographs being made now than there have been heretofore.

There is more of everything. No doubt, today, because of the continued growth of art school and university print departments, the phenomenal interest in publishing, the training of printers, the new collectors supplied by the new dealers, there has been an enormous expansion in the output of print editions. And although virtually all fine print editions are limited (fewer than 20 to as many as 250), the actual number of impressions printed in each edition is higher than it was before 1950, when many artists pulled 10 or 15 prints from a plate and called it quits. We estimate that at a modest count printmaking has increased at least tenfold since 1950—although to our knowledge no one has kept statistics that allow us to prove the point. But take a look at our impressive list of dealers and compare their ranks with those who were around at mid-century—Weyhe, AAA, and Kennedy in New York, Sessler in Philadelphia. Few need be added to complete the roster.

Another impetus to print collecting born during the Fifties was the International Graphic Arts Society, known as IGAS. Founded as a non-profit venture in 1952 with the blessing of the prestigious Print Council of America, and functioning somewhat in the manner of a Book-of-the-Month Club for prints, it offered to the general public admirable modern prints at modest prices. Patrons subscribed by paying a small fee and by guaranteeing to purchase a minimum of three prints annually. Some bought many more. The prints themselves were commissioned by IGAS, with the entire edition bought—"published"—by the society from the artists. Before it went out of business in 1967, IGAS had sold 62,000 impressions, and under its aegis many new collectors were born. Although

Associated American Artists has published and sold via its member catalogs and gallery inexpensive as well as costly contemporary prints (publishing between 1934 and 1974 more than 1500 *editions*), no *solely* subscription club has yet equaled the staying power and quality of IGAS. A current list of American clubs which are merchandising prints appears in Chapter 9.

More prints and more places to show equal more collectors and more places to buy: the first pair could not exist without the second. If there were no market for prints some artists would continue to make them, to be sure. Art history's pages are crammed with stories of artists who refused to discard a technique—or a style or subject matter—for which the art market had no use. Yet it can be safely asserted that were collectors suddenly to turn their backs on prints they would drive the publishers and dealers out of the print business, with the result that the number of prints produced annually would be reduced to a small fraction of what it is now. It is not the flag only that follows the dollar!

The thousands of prints created annually are far from languishing on the marketplace—they are purchased by collectors and hung on their walls all over the world. The schools, the workshops, the entrepreneurs, the exhibitions, the clubs, the dealers already cited are acknowledged as sources of the stream. Additional origins suggest themselves. One might argue that despite the current recession the middle class since World War II has become more prosperous than it has ever been before. Sections of it have raised their aspirations in home decor from reproductions, acceptable in an earlier era, and low-priced paintings made for the market by commercial "fine" artists, to original prints, which they can now afford. The prints of "name" artists sell for far less money than their paintings, yet the sense the buyer has of owning something special can be equally great. Future cultural historians may conclude that one of the contributions of Pop artists, whose prints have been actively merchandised, was to make prints "popular" again in a sense similar to that in which Currier and Ives prints were popular Americana. They were inexpensive, almost everyone of a certain class liked them, they cut a wide swath across the nation. In another paradox, the grand entrance of the Pops and other superstars of American art may have contributed further toward the popularity of prints. Either by trailing clouds of glory or because of the record prices these media figures command (always a sign of value for most people), they have added a certain status and panache to print collecting, heretofore mainly scholarly and private.

The record prices achieved by some prestigious artists and publishers have excited both envy and dismay. More than one collector has said to us, "I wouldn't dream of spending more than $——— on a print." (You

can fill in the figure, for some put the mark at $100, some $500, some $1000, the common ground being an upper limit beyond which the collector will not budge.) It is fair enough to ask, however, whether the unprecedentedly high prices are justified.

According to Kenneth Tyler, the master printer who founded Gemini G.E.L. (where an individual print can cost as much as $6000 retail), and then the Tyler Workshop in 1974, the prices charged are not arbitrary estimates of what the traffic will bear, but represent, rather, the cost of production, plus the sum the artist requires for his work, plus a reasonable profit. (In a production setup where a print may use more than 50 screens, for instance, and where editions rarely are larger than 50, costs per unit can indeed be huge.)

But according to Sylvan Cole, whose Associated American Artists gallery stocks few of these glamor issues, printmaking for some of these artists and their publishers is "a license to print money." Hank Baum, a dealer who gives an extension course in print collecting at the University of California, says that "most, if not all, publishers care little about the artists or collector, but see printing editions as a fast-buck method of cashing in on the interest, but limited knowledge, of the public."

Although among these costly editions there are prints unsold, despite sophisticated huckstering and glossy brochures, many are snapped up so quickly that only favored patrons are enabled to buy them, and some impressions shoot way up in price when they appear at auction shortly after the edition is floated. Shades of the stock market! How their values will hold in the long run is a matter of speculation—none of these artists or their work has been around long enough to judge what they will be worth in ten or twenty or thirty years.

The peak dollars achieved by the go-go names may have tended to draw along with them the prices of other living printmakers, although our constantly inflating economy probably has as much to do with it. Any collector of American moderns might like to know that a 1956 Society of American Graphic Artists' catalog lists an Isabel Bishop etching at $20; in their 1971 show another of her etchings was $50. Karl Schrag charged $45 for a color etching at the earlier date, $125 at the more recent one. June Wayne asked $25 for a lithograph then, $500 in 1975. And so on. The point is that every printmaker charges more this year than last, in part because of the economy and in part because prints have become more desirable.

Print dimensions have expanded even more markedly in the last twenty-five years. It is difficult to cite comparisons from catalogs, since only more recent ones state the dimensions of prints along with the name of the artist, the medium, the title, and the price, but visit any exhibition that includes

large numbers of pre-1950 prints if you want to confirm our impression. Increased attention to documentation, along with more lavish catalogs for museum and dealer shows, is part of a trend too. The enlarged sizes as well as the greatly increased use of color in printmaking, which used to be almost entirely in black and white, must surely be elements in the eagerness with which contemporary graphics are sought. Prints, after all, were originally most characteristically found in books, and the size of a page in a book remained until recently the standard, however unconscious, for the size of a print. Now graphics can hold their own in home decoration with paintings—Gemini G.E.L. is said to own a seven-foot lithograph stone (actually two stones joined together), and Leonard Baskin's "Man of Peace," its image almost six feet tall, must have been the largest woodcut ever made when it was first pulled in 1952, and may indeed still hold the record.

Not all modern prints are oversize but most of them are much larger than prints in the past. Posters, too, are signed, numbered, and collected, and some artists have executed prints in series that are intended to be hung in sets that cover vast walls. Conversely, the expanding dimensions of the print sank the miniature print for a time. Recently it has bobbed up again, with Pratt Graphics Center reviving the sort of annuals for miniatures that had earlier been underwritten by the Society of American Graphic Artists (1939 to 1960) and the Philadelphia Print Club.

It is probably the technical changes in printmaking that have made the remarkable differences between new prints created in the Seventies and those of earlier eras—increased technical diversity and experimentation have puzzling contradictions. (Progress and change are not interchangeable words or concepts.) Many artists working in the print media, especially etching, have infinitely more skill and technique at their command than ever. They gouge in and build up their plates of every material in ways that had never been dreamed of, and they print on and with everything from paper to synthetics to silk. This is one reason that the print has been defined and redefined and argued about constantly in recent years.

It's worth keeping in mind when looking over definitions of prints that no artist is obliged, no matter what the definition, to love, honor, and obey it. There is no license or test for artists that forces them to abide by any set of rules. Any exhibiting society, dealer, museum may—and should, if it wishes—specify its definition of a fine print and limit itself to prints that fulfill those guidelines. In fact, California and Illinois have passed print disclosure legislation, and regulatory statutes have been considered in New York.

But no definition worked out by one group is ever going to define all the work that another group insists are fine prints. As a collector you must

decide for yourself whether to admit to your canon prints that employ photographic techniques, prints made entirely by master printers from designs by artists, monoprints, machine-printed graphics, unlimited, unnumbered, unsigned prints—to name a few of the areas of fierce disagreement. Whatever your criteria, make sure that you are entirely clear about what you are buying when you pay for a print. Every dealer and publisher can tell you a horror story about rip-offs of naive collectors, but it's always the other guy who is the perpetrator.

With all the technical changes and experimentation, we discern the emergence of two distinct categories of printmakers: one might be dubbed traditionalists, no matter how experimental visually or technically; the other is dependent on the craft skills of the professional printer. Among the latter can be found most of the biggest names published by the best known publishers at the highest prices with the most painstaking documentation (because they most tempt fraud). Artists in the first group evolve a print by thinking about image and materials, developing their pictorial ideas by consulting only their own notions, without thought, usually, of sales or market. For those working in the latter category the publisher may "assist in the selection of the image," as one told us with pride, may suggest dimensions, paper, medium, printer. The resulting print will have to be marketable if the publisher is to stay in business, whereas artists are notorious for surviving despite a paucity of sales and acclaim. The difference between the two methods of producing prints might be compared to home cooking and restaurant meals—one, from menu planning, to marketing, to preparation, to serving, to cleaning-up is done by an individual. The other depends upon secondary staff at every step along the way. Some home cooks are dreadful while others are superb; the same can be said of restaurants. But one difference is certain: the latter is more expensive than the former and must cater to the taste of a broader clientele.

With the other changes surrounding prints in the last twenty-five years, how has the image changed? Prints have been less immediately responsive than other media to pressure from the kaleidoscopic swings of the art world—abstract expressionism, pop, op, minimal, color field, conceptual, photorealism—some of the most overwhelming stylistic contenders of the last several decades. Throughout the mini-revolutions in taste many printmakers have continued to develop and exhibit what for lack of a better word we must call more "traditional" imagery. (This was true even when a viewer had to make a determined search in order to discover a recognizable object among the newly made paintings or sculpture in either the commercial galleries or the museums.) This results in part from the technical and craft demands of the media which, except for the publisher-sponsored prints, prevent novices from inundating the field. Print exhibi-

GEMINI G.E.L. PRINT DOCUMENTATION

8365 Melrose Avenue
Los Angeles California 90069
213 651-0513

Print No. RR74-688

(II)

Artist Robert Rauschenberg
Title Preview -- from Hoarfrost Editions

Period of collaboration September to December 1974
Right to Print date September 17, 1974
Cancellation date transfer images - not applicable
Date signed December 1, 1974
Medium transfer and collage
Size: H 69" W 80 1/2" Edge: selvage and cut
Signature location bottom, at left
Processing and proofing Charly Ritt, Tony Zepeda, Ed Hamilton; screen: Charly Ritt, Robert Knisel
Edition printing Charly Ritt assisted by Tony Zepeda and Ed Hamilton; screen: R. Knisel, J. Wasserman
Collaboration and supervision Ron McPherson

Process Sequence

1	offset printed image of ostrich egg transferred to silk chiffon
2	offset & screen printed image of Kronos transferred to silk chiffon & paper bags
3	newspaper imagery transferred to silk chiffon
4	paper bags glued to silk chiffon with acrylic polymer matte medium
5	screen printed car at right and newspaper imagery at bottom right transferred to silk taffeta
6	screen printed car at left transferred to silk taffeta
7	newspaper imagery at center and bottom left transferred to silk taffeta
8	
9	
10	
11	
12	

NOTE: 2 holes machine stitched at top right and top left to accommodate nails for hanging.
Chiffon machine stitched at top right and top left to affix to taffeta.
* See below: The Master Proof was assembled by the artist and became the guide for the printers' Right to Print Proof.

	No.	Paper				
Edition	??	silk chiffon and silk taffeta				
Artist's Proofs	10	"	"	"	"	"
Trial Proofs	7	"	"	"	"	"
Color Trial Proofs	3	"	"	"	"	"
Right to Print Proof	1	"	"	"	"	"
Printer's Proof II	1	"	"	"	"	"
Gemini Impressions	3	"	"	"	"	"
Cancellation Proof						
Other Proofs S.P.	2	"	"	"	"	"
* Master Proof	1	"	"	"	"	"
Change Inc.	1	"	"	"	"	"

We declare the above information is correct:

Artist _Robert Rauschenberg_ Date _____

Gemini G.E.L. _B. Felsen_ Date DEC. 7, 1974

GEMINI PRINT TERMINOLOGY

Right to Print

The first impression achieved in the proofing period which meets the esthetic and technical approval of the artist and Gemini. Each print of the *Edition* must be identical to this standard.

Edition

The body of prints identical to the *Right to Print* proof. Two numbers are used in the signing procedure: the upper one is numbered consecutively beginning with 1 and indicates the number of that print within the *Edition*; the lower number indicates the total number of prints in the *Edition*

Printer's Proof II

A proof pulled for the printer of the *Edition*.

Artist's Proof

A proof of good quality which closely matches or equals the standards of the *Edition* prints.

Trial Proof

Generally, a proof which varies from the *Edition* in imagery, printing sequence, has added or deleted elements, or in some way the printing has differed from the *Edition*.

Color Trial Proof

Generally, these proofs have the same printing elements as those in the *Edition*, but there may be a sequence which differs, or has been added or deleted as in the *Trial Proof*, or there may simply be a color variance. Both a *Trial Proof* and *Color Trial Proof* may have been pulled at any time during the proofing period or while the *Edition* is being printed. They are signed if the artist feels they have a desirable quality of uniqueness which gives them special merit. Occasionally, there is an overlap in intent between the *Trial Proof* and the *Color Trial Proof*.

Working Proof

A print which has at least one printing element and upon which the artist has added work by hand.

Progressive Proof

A series of proofs primarily intended to illustrate the development of the image of the finished print. One set of *Progressives* shows each color or element singly. The other set shows the actual development of the completed print as each color or element is added, one by one.

State

The result of an artist developing a variance in a previously resolved print resulting in a complete *Edition* with accompanying proofs. The variance may involve a change in color, elements or printing sequence.

Gemini Impressions

Prints identical to the *Edition* pulled for exhibition purposes.

Cancellation Proof

To assure that no further proofs can be pulled from the printing element after the *Edition* has been printed, the printing element is cancelled by either the artist or printer. In the case of the lithograph, the printed image is fully inked and then defaced by the use of a sharp instrument or a stone hone. In the case of the screen print, a chemical substance is added to the stencil to effect the *Cancellation* mark, thereby preventing future use of that image. In both cases, one impression is pulled of the defaced element to document the act. This impression is signed and dated by the artist. When a print has more than one color, the most complicated and involved color plate is chosen for cancellation. The *Cancellation Proof* may or may not have the complete color printings. If the artist decides to print a particular image in an additional *State*, the *Cancellation Proof* would be pulled after all *States* have been printed.

Signing Procedure

At the completion of the printing of the *Edition* and its proofs, the approved prints are then signed and numbered by the artist. In some cases, the artist may also inscribe the title and the date

Chop

Each signed print bears an embossed, dry stamped or printed form of the Gemini *Chop*. It is generally placed adjacent to the artist's signature and is accompanied by a copyright mark. Each *Edition* and its accompanying proofs has its own identifying number which is inscribed in pencil on the reverse side of the print adjacent to the *Chop*.

tions have been less subject to every museum or critic-touted "break-through" because so many open, juried print annuals remained in existence during this period. Many museum-sponsored juried *painting* annuals and biennials, by contrast, slipped away either because of sharply increased shipping and handling costs or because their supporters were unable to manage the astronomical post-war surge of hopeful entries. Frequently those that remained were selected "by invitation," always another story.

Invitational exhibitions, as the Brooklyn Museum print biennials have become, are far more responsive to the newest fashions than juried shows, for often the curators who assemble them go out in search of whatever is new, like department store buyers, with novelty one of the criteria. Jurors, to their dismay and delight, must by necessity select from those works submitted. Our theorizing gains support from the 1975 SAGA catalog, which reproduces most of the prints included in the show. The staying power and refinement of a variety of modes evolved in earlier periods is evident, yet to choose one example, photorealism—*au courant* in 1975—is not to be seen. It seems to us that juried print shows, even when the jurors are not artists, are more likely to remain in the control of artists than invitational exhibits; they are more likely to represent what most artists are doing, rather than what curators admired in what artists were doing.

A wry admiring acknowledgment of the persistence of the figurative image was wrung from one of the earliest and most influential gurus of Abstract Expressionism, critic Clement Greenberg. After serving as the single juror for the first Davison College print annual in the early Seventies, he wrote in the catalog that he was not only surprised to discover the persistence of the figurative image more than twenty years past the birth of Abstract Expressionism, he found himself forced to affirm that the figurative prints were, over all, superior to those which were abstract.

We, too, noticed at the 1975 Library of Congress Print Biennial, juried by three printmakers, the very tiny number of abstract prints as compared with those employing recognizable images. But unlike the 1975 SAGA show, photorealism in prints was forcefully evident.

Yet because of the many artists and sponsors involved with prints, there is an incredible variety of visual imagery available today for every print collector. The dealers listed in this book and many others have in stock an array of prints in every medium, style, and price. Adventurous collectors should consult this list, and they should also visit the exhibits of annuals and traveling shows in order to discover what is being produced by the print world—whether it is work by the most recent art school alumni or by oldtimers discovered and undiscovered. Workshops, too, often hold regular exhibits at which works printed on the premises can be purchased, some

at nominal prices, and collectors may arrange to watch the printing process at a workshop or printing establishment. Everything you learn about print-making will add to your enjoyment of prints, and every print show you see will add to your connoisseurship. You will soon discover, if you have not already, that collecting has its own creativity.

AFTER SUNG MING HSING *Old Chinese Paper Making: Soaking of the Bark of the Mulberry Tree in Running Water*
Woodcut. 1634. Courtesy of The Bettmann Archive, Inc.

A little neglect may breed great mischief . . . for want of a nail the shoe was lost, for want of a shoe the horse was lost, and for want of a horse the rider was lost.

Benjamin Franklin, *Poor Richard's Almanack*, 1732–1757.

5. *Preserving Prints: Basic Conservation*

CONSERVATION OR RESTORATION?

Conservation and restoration are two distinctly different matters, although the terms are often used interchangeably. To conserve a print is to maintain its present condition, good or poor, whereas to restore a print is to return it as nearly as possible to its original state.

For the typical print collector *conservation* is the business of serious concern, since most prints purchased through dealers are in decent condition. Our goal is to see to it that they remain as fresh and clean in our keeping as they were when we acquired them—and this applies as much to prints literally fresh from the press as it does to Old Masters. Indeed, there are many respectable museum print collections where, because allocated funds cannot stretch beyond that point, conservation is carefully practiced and restoration is rare or postponed indefinitely. Restoration is a highly skilled, time-consuming, and usually expensive craft, no less dangerous for the untrained amateur to undertake than self-medication or stunt flying. Since conservation is the constant, everyday, continuing responsibility of all collectors, we'll discuss it before going on to restoration.

CONSERVATION

Examine Print and Mat

When you have any reason whatever to question the state of preservation of a fine print, your first step after acquiring one for your collection should

be to remove it from its frame, if it has been in one. Check on the materials and condition of the mat, backing board, and hinges as well as on the condition of the print itself. Assuming for the moment that the impression has been excellently conserved thus far, you will want to make sure that the materials with which the print is surrounded will continue to preserve it from injury or decay.

Acid-free Matboard for Sandwich Mats

All fine prints should be appropriately matted and backed whether you plan to hang them on the wall or keep them in permanent or semi-permanent storage. If they are not correctly mounted, matted, and hinged, even for short periods, deterioration will begin, a process more difficult to reverse than prevent. Proper matting materials are *always* made of 100% acid-free matboard. Acid-free material is the first essential of print conservation. Everything else in modern paper conservation is predicated upon it. Both the "window" mat itself and the backing board (between the two of which the print is sandwiched) must be acid-free board. An outer layer of acid-free matboard covering an inner core of other material, except where that has undergone special chemical treatment, will not do the trick. Acidic inner layers can in time contribute to the decay of the mat or backing surface and eventually mar the print. Suppliers of matboard whom we have found satisfactory are listed at the end of this chapter, as are sources for all other materials recommended.

Framemakers

A problem for those who insist on acid-free matboard, sometimes called "museum board," is not its widespread availability, but the difficulty of finding a framemaker as convinced as you are of the importance of using the best matboard as a conservation material. It is easy enough for a skeptical framer to agree to work with the materials you specify and then make your mats from whatever board comes to hand. If you are unfamiliar with the appearance of acid-free matboard, which is slightly more expensive than other matting boards, or if you do not remove the newly matted print from its frame—an unlikely occurrence—how can you be certain of the materials your framemaker is using? Discovering a framer you can trust, therefore, can be as essential and as difficult as finding an auto mechanic you believe in. Perhaps a museum or print dealer in your locality will be willing and able to make a recommendation of a framer if you cannot locate a worthy one on your own, or a conservator who is nearby may have suggestions.

To insure an accessible supply of acid-free board, you may find it best

to provide your framer with sufficient material each time you have a print matted. You may, in fact, find yourself teaching your framer everything he does not know about conservation. The diagram on page 80 could be helpful to your framer, too. Or, if you have the rare combination of skill with tools, a large worktable, good light, the time, and the incentive, you may decide to learn to cut mats yourself. There are many good manuals that will guide you, including some of the technical books included in our bibliography. But if you employ a framer, as most people do, do not allow yourself to be dissuaded from any of the following recommendations for responsible conservation.

Acid-free Materials

Look at the sketch below of an open, hinged mat. All the parts and materials are clearly visible. The print itself (C), of which we see in this sketch only the back (or verso), has been printed, we'll assume, on acid-free paper. Acidic paper, which includes most modern papers although not those papers on which fine graphics are printed, inevitably changes color, as does newsprint, with the passage of time and exposure to air. Moreover, it initiates discoloration in other materials with which it comes into contact. For this reason every component of a fine print's mat must be made of acid-free, permanent materials. These include (A), the window mat itself, (B), the backboard and (E), the hinges. 100% acid-free materials for the mat and backboard are available in two ply or a double, four ply thickness. The latter is more handsome and sturdy and therefore often preferable, although two ply is a suitable choice when a print is to be mailed or stored, for instance.

Hinging Mats

Once both the matboard and the backboard have been cut to the appropriate dimensions they must be hinged together at the top, preferably with linen tape. Acceptable though less desirable for this purpose is a gummed cloth tape manufactured by the Dennison Company. The print (C) must also be attached to the backboard (B) so that it will not slip down in the frame or move and become wrinkled. Years ago, in some cases, this was accomplished by the pernicious practice of pasting prints onto the backboard, by slathering the entire verso with paste, by gluing the work along the edges of its margins, or by using masking or Scotch tapes. (When a print is described in an auction catalog as "laid down" or "taped along the edges," one of these conditions is meant. Inevitably the value of the print is lowered.) We fervently hope that no one damages impressions in this way any longer.

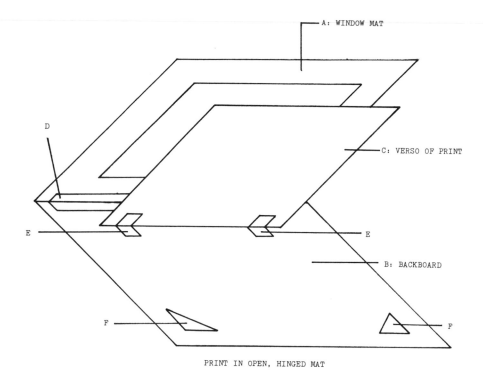

D

C: VERSO OF PRINT

E E

B: BACKBOARD

F F

PRINT IN OPEN, HINGED MAT

Hinging Prints

The best advice today is that prints be joined to their backboard by means of nonstaining Japanese vegetable paper (*E*). Hinges can also be satisfactorily made by the printmaker of rectangles cut from scraps of the same acid-free paper as was used for the print edition. Most prints require only two hinges, as shown in the sketch (*E*), although heavier and larger prints such as those made by many printmakers in recent years, may be more securely attached with four and more.

Adhesives

The adhesive that is used on the small hinge surfaces should be a nonstaining vegetable-based paste made with wheat or rice flour and water. Never employ an animal or synthetic glue. And never, *never*, NEVER use pressure sensitive tapes. Notice in the sketch that the hinge area should require a small amount of adhesive which in turn makes contact with the matboard and the verso of the graphic work. Normally, the hinge is attached to the verso at the edge of the margin, making the possibility of damage to the image side of the print small. But there are times—for instance, when the print has no margin—that this type of hinge might have to be applied directly to the back of the printed surface. The usual hinges may also be inadvisable if the print is very old and worn or if it was originally printed on inferior paper.

Corner Envelopes

The solution in these circumstances, when hinges set behind the top margin are impossible because there is no margin or risky because of the condition of the paper, is the use of triangular corner envelopes (*F*). These are rather like the small triangular pieces that used to be sold for mounting photographs in scrapbooks, and should be made by you or the framer from mulberry or nonacidic rag paper. Acid-free glassine is now manufactured too. In the diagram only two "F" pieces can be shown, although four would actually be needed to hold a print securely. Each of the four corners of the print can be inserted into these triangles, which will then hold it in place within the mat without touching the print with adhesive. Ready-made plastic clamps are also manufactured today for this purpose.

Fabric Mats

Sandwich mats (also called gallery or display or window mats) made of 100% acid-free materials are the choice of collectors, museums, and deal-

ers. If a given print might be more esthetically pleasing matted in linen or silk, the same sandwich mat is recommended. The fabric selected should be laid down over the nonacidic matboard. The adhesive here, too, must be a neutral vegetable paste. Furthermore, between the image surface and the underside of the fabric surface (the verso of the window mat) a thin layer or spacer of acid-free board should be placed in order to forestall the possibility that contact between the print and the fabric is destructive to the image.

Variant Mats

Some prints, however, cannot be matted in the standard window mat— either because the image has been printed to the edge of the paper (not uncommon in modern graphics), or because the margin of an older print has at some time in the past been cut away. In these circumstances there are two possible solutions, in both of which the backboard (B) remains the same as described earlier. One way is to cut the "window" to a size *larger* than the paper on which the image is printed. This would create a matboard margin even though the print itself had none.

T-bar Hinges

The second approach would omit the window mat altogether, retaining only the backboard; there would be no sandwich. The print would then be attached to the backboard by means of a different hinge, a hidden T-bar, as shown in the small sketch below. This will hold the print securely. It is also the suggested means for holding a print in the oversized window mat outlined above. Because there will be no window mat to prevent the image surface from touching the glazing when the print is framed, a spacer of nonacidic material will have to be tucked between the back of the glass and the recto of the print. Another variant of the T-bar, also known as the "pendant" hinge, is shown in the bottom sketch. It is very strong and for this reason is sometimes used instead of the standard hinge (E) shown in the illustration of a typical window mat.

Standard Mat Sizes

Once the print is housed in a hinged window mat of 100% acid-free board, it is ready for framing or storage. We suggest that all collectors get into the habit of having their sandwich mats made in two or three standard sizes, such as 16″ by 20″, 20″ by 24″, or 24″ by 30″. These dimensions should suffice for all but the largest of contemporary graphics. You'll be surprised how much easier standardizing your mat size makes it to move prints from storage to wall and back again. It not only enables you to

1. FOLDED-UNDER HINGE

RECTO OR IMAGE SIDE OF PRINT

VERSO

2. FOLDED-UNDER HINGE WITH T-BAR

(HIDDEN HINGE)

3. T-HINGE

Drawings adapted from the <u>Glossary</u> published by the Conservation

Information Program, Office of Museum Programs, Smithsonian Institution,

mimeographed, n.d.

interchange frames; it also allows you to handle, arrange, and store graphics with much less difficulty. Just the other day we were talking to a couple who have lent their prints to several museums that have sent them on tour. To transport their matted and framed prints from their home to the first museum, they needed to have lined crates built. Since these are expensive, they saved the crates in their garage—and they told us that they finally realized the true benefit of using standard mats and frames when, a couple of years later, they lent another group of prints for a similar tour. Once again they were able to use the original crates, avoiding the expense and bother of having new ones made.

<div align="center">STORING PRINTS</div>

Solander Boxes

If your matted print is now going to be stored—that is, kept off the wall—it must be put in a suitable place. Collectors with fewer than a dozen or two surplus prints—and by surplus we mean those for which there is no room on the walls of their homes—may want to use a Solander box for storage. Solander cases—invented by Daniel C. Solander, an 18th-century Swedish botanist—are sturdy, covered storage boxes, reasonably airtight, for storing unframed prints, drawings, and documents. They are hinged on one of the long sides, and the top lifts up. Each Solander box can comfortably hold twenty to forty matted, unframed prints. The boxes themselves come 3″ deep in such sizes as 17¼″ by 23″, 20¼″ by 25″, and so on. They can also be made to order in custom sizes.

Protection from Handling

If a print is going to be removed frequently from the Solander box, it will need to be protected from fingerprints, dirt, and concomitants of handling and temporary storage. To protect the image the print should be covered with an envelope of cellulose acetate, a thin, clear synthetic that goes under such trade names as Mylar, Estar, and Melinex. It comes in various thicknesses, but the best for our purposes is .005 of an inch, through which the print can be seen excellently. It is readily available in sheets or rolls from many art supply stores, or it can be ordered from sources listed at the end of this chapter.

Coverings and Envelopes

Matted prints can be protected with cellulose acetate coverings made in one of three ways. You may insert a sheet of cellulose acetate between the image and the window mat, or you may use a sheet of cellulose acetate a few

inches larger in each dimension than the matted print, place it over the face of the print, fold the acetate over the corners of the mat and tape it down—trimming any bulky excess—onto the back of the backboard. Or you may make a standard-size envelope of cellulose acetate that can be used again and again. Two sheets of acetate cut to dimensions only fractionally larger than the mat itself should be taped closed on three sides with 3M #810 nonstaining sealing tape. The print may be slid in and out easily.

If, however, you do not want to mat the print immediately—perhaps when a print is waiting its turn with the conservator or framer—or you want to keep the print safely in storage, you can make a variant of this envelope. The back of the envelope, for an unmatted print, can be made of two-ply 100% nonacidic matboard, and the front of .005 cellulose acetate. Cut these two to the same size, place one on top of the other, and tape them together with the same nonstaining tape along the edge of three sides so that prints can be removed without damage to the slipcase, which is also reusable. Two-ply board is recommended for storage because it reduces weight and bulk in Solander box or storage drawers. But do not store prints unprotected by matboard in drawers or boxes because soiling, tears, or wrinkles are certain to be the end result to at least some of them.

You have probably noticed prints protected in one of the ways described when looking through the racks of a dealer. Such protection is helpful, too, when preparing a print for mailing. But it should be understood that cellulose acetate is suitable for temporary storage only—say, for periods of less than a year.

Long-range Storage

For longer storage cellulose acetate has the defect of attracting static electricity and therefore dust, thus becoming more harmful than helpful. For permanent storage, acid-free lining papers, Permalife paper, and various Japanese vegetable papers may be considered for added protection, but matted prints kept in a Solander box, even when they are not wrapped in cellulose acetate, may be placed without any material between each print. The thickness of the mat itself will prevent the prints from coming into direct contact with each other.

Be sure that the Solander box containing your prints is placed in a healthy environment—avoid damp basements, attics that scorch in summer and freeze in winter, closets through which pipes rise, cupboards nestling near radiators, or spots exposed to excessive moisture. Very likely the most comfortable place for your prints is the room in which you are most comfortable yourself—and in that frequented room you have the added advantage of an easily and pleasantly accessible collection.

Storage Drawers and Cabinets

If your collection includes more prints than can be housed in a single Solander box, you will need wide shelves for them where the boxes can be arranged alphabetically, or you will need storage drawers, or closed, pull-out shelves. The most readily available drawers are metal architect's blueprint file drawers or map case drawers, usually five or six drawers high, that can be purchased from office supply distributors. These have the essentials —wide, shallow drawers with tight closures. Shallow drawers are far less wasteful than deep ones, for it will never do to pile too many prints on top of one another. Matted prints are surprisingly heavy, and too many in a stack can be harmful to the prints and troublesome for the collector. Architectural drawers can be bought in units with "open" tops that allow you to add sections as they are needed, stacking units as high as you find convenient. For some people the disadvantage of these storage drawers is their grey or tan enamel-clad, office-furniture appearance, especially if they are to be kept in living rooms. If this is important to you, consider having a wooden cabinet built to conceal them. Wherever you keep your storage drawers, however, line them with Permalife paper.

To our knowledge there are at present no commercial manufacturers who make wooden storage drawers suitable for fine prints. Therefore, if you would like to own them, you have few choices: search for old, second-hand, architect's blueprint drawers made of wood (very hard to come by); or have appropriate drawers made to order by a skilled carpenter or cabinetmaker. The latter is probably the preferable solution, since the size and proportions of the basic design can be adapted to your home and collection, and the details and trim can be made to conform to your decor. If you decide to have storage drawers made to order, you can buy a set of specifications from the Tamarind Institute in New Mexico, or you can use or adapt our plans for storage shelves on page 87. These are for storage cabinets we designed and had made in 1975, with shelves rather than drawers. We are able to store twenty to forty matted prints in each Solander box, and each shelf is designed to hold one box.

FRAMING

Backing

Prints that are not stored in Solander boxes or cabinets will go directly into frames after they are matted. Print conservation is an essential element in framing. To the backboard behind the matted print two additional layers of suitable material should be added to help protect the image from envi-

PRINT STORAGE UNIT*

Solander Box Size	Mat Size
12¼ x 15 x 3	11 x 14
15½ x 20¼ x 3	12 x 16
17¼ x 23 x 3*	16 x 20*
20¼ x 25 x 3	20 x 24
23¼ x 29 x 3	

ronmental vicissitudes. The first layer, immediately adjacent to the 100% acid-free backboard, may be either ragboard or a good quality rag-covered board. The second layer, which would normally be the outermost, can be made of any sturdy material.

Glazing

The front, or picture surface, of the print must be protected too. Although legitimate fault has been found with glass, and nonreflective glass as well as Plexiglas have been employed as substitutes, glass is preeminently the material of choice. There are even some prints by contemporary print-makers that look infinitely better without any glass at all, but if they are left without protection their life cannot be extended beyond ten years or so. Glass as a covering can be distracting because it is so reflective—there is nothing more irritating than having your own staring face reflected at you when what you want to peer at is the print image. And it can be discourag-ing when all you ever see of your favorite print from the chair at the other side of the room is the shape of the window behind you.

Nonreflective Glass

Nonreflective glass was for a time a widely hailed substitute, but it is not really satisfactory. Such glass does not reflect because it has millions of tiny lines that cut down its natural transmitting qualities, but these invis-ible incisions also cut its luminosity and thus cut into what viewers can see of the image. To us, graphics covered with nonreflective glass look as though they were printed on plastic—the kind kitchen place mats are made of.

Plexiglas

Clear glass of the kind used in framing is less than perfect for another reason—it does not protect prints from the hazards of sunlight. For this reason special Plexiglas, a clear, rigid plastic, is sometimes used. Plexiglas UF1 and UF3 filter the ultra-violet rays of direct and indirect sunlight, as well as the same rays emitted by fluorescent lights. The way to avoid problems with fluorescents is not to use them to light art objects, or to buy Plexiglas sleeves that fit over standard flourescent tubes to absorb damaging ultra-violet radiation. Plexiglas, however, is quite costly, and therefore is currently used mainly for very valuable or fragile prints. There is also the chance, as there is with any new material that has not been tested over the years, that unknown effects in its use may be known in the future.

Sheet Glass

So we're back to sheet glass, most of us, and despite its faults, it's an excellent, cheap, durable material that will protect most prints most of the time and allow us to look at them always. If you have been able to convince your framer to make nonacidic board mats to your specifications, you will surely have no trouble with the rest of your requirements.

Recess from Glass

Prints must be recessed from the glass in order to avoid the possibility that moisture condensing on the inside of the glass can come in contact with the print. If the print is matted, as it usually is, the thickness of the four-ply window mat will provide the necessary set-back. But if the print is not window-matted—that is, if it is attached to the backboard for framing without a mat, as described on page 82—strips of nonacidic board must be so placed along the edges of the backboard beneath the frame as to raise the glass, thus providing an air space in front of the image. Or the frame itself must be constructed so as to perform the function of lifting the glass.

Hanging Prints

Your properly matted, glazed, and framed prints are now ready for display on your walls. Enjoy them. There are Cassandras, to be sure, who warn against hanging valuable prints in sunny rooms or over radiators or in heavily polluted areas, but most of us live where we live, and there is not much we can do to make conditions better for our prints. If we survive, we guess they can too. When you have a choice, of course, it is well to be aware of the elements that are good and bad for your collection. If you are able to correct a situation where the humidity in your house is above 70% for extended periods, by all means do so. You will probably feel better too. Conversely, if you have been gasping in an excessively dry atmosphere, a humidifier will do wonders for you, your prints, and your houseplants. The walls above your sources of heat are best avoided for graphics if you have other spots, and likewise the wall that catches that glorious patch of sunlight every morning is not a good location for your most valuable impression. Be as careful as you can comfortably be, but don't allow yourself to be intimidated out of your joy in collecting. Prints, after all, are made by women and men for the pleasure of other human beings.

RESTORATION

All of these remarks on matting, storage, and framing—conservation—are based on the assumption that the print in question has been acquired in good condition. If it has not, you will need the services of a professional restorer. When you examine a print, especially one that has come from a source other than a dealer, any one of the following problems may necessitate consultation with a restorer.

Foxing

The kind of mildew action that is called foxing is caused by fungi or other organic matter. It results in stains and discoloration, usually brownish. This is the most common sort of stain on paper. Readily apparent, it is usually brought on by excessive humidity, and it is normally a reversible process.

Dirt

Another common stain is made by dirt, soot, or dust, the same kind that gets into your curtains or dims the luster of your carpet. It may be so evenly distributed that you may not even notice it at first. A degree more serious is chemical staining, which can be brought about by pollutants, insects, and by handling.

"Sunburn"

A third type of stain can be a "sunburn," with the exposed portion of the print—the part not protected by the window mat—stained from over-exposure to the ultra-violet portion of various light sources. Sunlight is the most destructive of these.

Acid Burn

A fourth kind of stain commonly seen occurs underneath the window mat, with the actual image unaffected. This discoloration can be caused by acidic matting materials that have given an acid burn to the paper on which the print was made. Conservators can usually work successfully with all these stain disfigurements.

Laid-down Prints

Problems that are solved with greater difficulty are those in which the print has been pasted on the verso to the backboard or by the margins of the recto to a window mat. Don't, for heaven's sake, attempt to peel the print

away if it has been glued down! Like all the other infirmities we are citing, this is a case for the professional, and you must resist the temptation to try out on your own just that corner bit. A friend of ours who began to peel a tiny corner—just to see how bad it was—was lured step by step into totally disfiguring a fine print.

Acidic prints

Or you may find, if you've been shopping in off-beat places, that when you remove the print from the frame that the back is stuffed with old newspaper, an acidic material if ever there was one. Such a circumstance may require the print to be de-acidified by a restorer. Or the print may have become creased from having been stored loose or having spent part of its life rolled in a tube.

Rolled Prints

This is as good a time as any to say loudly: never roll a print, never use a tube, not even for mailing, not even for a minute. We have received prints mailed in so-called mailing tubes a few times. They have either arrived damaged in bent and broken tubes, or we have found it impossible to remove them without doing them harm. Creasing and wrinkling is the least of what can happen when you are struggling with a stuck print.

Fold Marks, Tears

Or a print may actually have heavy fold marks, some of them even pressed down by a former owner to force it to fit into a frame. Or the paper on which the print was made may be very worn, or have actual holes, or even rips and tears. All of these varieties of damage are subject to restoration, although the problems are more difficult to correct.

Do-it-yourself Damage

You may wish to know enough about restoration to be able to discuss matters knowledgeably with a restorer. In that case, you will want to look through some of the books listed later, but you should not take this as a recommendation to attempt do-it-yourself repairs. Our aim is not to push business to restorers, who are usually overburdened with more assignments than they can get to anyway, but to make sure that you, a print lover, do not do further damage to a print already in danger of its life. You will find, as we have, that the hardest job for a conservator is the sick print that has been harried to its demise by loving hands at home. One man we know actually bleached away the image when he attempted to clean a print with a weak clorox bath!

Source of List of Restorers

The American Institute for the Conservation of Historic and Artistic Works, 1 East 78th Street, New York, N.Y. 10021 publishes a journal and an annual membership directory which lists members by their specialties. In order to find a print restorer, consult this list for one who specializes in works of art on paper. Since prints can be sent with ease through the mails if properly packed (see below), the restorers you use need not live within your immediate area—although it may be pleasant to know and talk to the person who restores your graphics. The museum or print room near you can also recommend restorers. Don't forget to ask for a *paper* specialist. A current list of paper restorers is also included on page 95.

Packing

To prepare your matted print for mailing, put it into a plastic bag or in clean wrapping paper. Then cut four pieces of corrugated cardboard two inches larger than the mat all around. (For oversize prints substitute either two pieces of masonite, beaverboard, or even plywood for corrugated cardboard.) Take the wrapped print, place it on one of the corrugated boards, and tape it down to the board on all four sides. Make the print the filling of a sandwich by first putting the taped print on another sheet of corrugated board. Then place the remaining two pieces on top. Now you have a sandwich between which your print is protected back and front, with two layers of corrugated board underneath and two on top.

 Now tape closed all four sides of the sandwich securely. (It is best to use ordinary masking tape, not the wire-impregnated kind.) It will thus be impossible for your print to slide around inside the sandwich, and neither the print nor the corners of the mat can be damaged.

Post Office or U.P.S. or Air Freight

Last, wrap your sandwiched print in heavyweight brown wrapping paper. Close all openings with masking or sealing tape. Tie the package with cord of an appropriate weight. Address it clearly and take it to the Post Office or United Parcel, depending on the package's size and your convenience. The Post Office has limitations on overall dimensions and will not accept packages larger than a certain size. This also varies according to the class of sending and receiving post office, and is subject to change. If your print is oversize, United Parcel or Air Freight are the alternates, and sometimes are considerably less expensive for certain kinds of packages.

Insurance

If the value of the print you are mailing at the Post Office is less than $200, it can be sent First Class, insured. If the value is more than that, it must be sent Registered in order to be insured. We think it is the best practice to insure prints for their full retail value. We do. Arrange for a return receipt (which naturally you will save), and the business is complete. We hope you'll never lose a print. We haven't ever lost one.

Cost

Once you mail or bring your damaged print to a restorer, you will be able to get a diagnosis of the problem and a prognosis for its repair. At this time a range of the possible cost to you will be stated. Since restoration is as much art as science, and the restorer cannot know how much time the job will take, the high figure suggested allows for every possible contingency, and, happily, it will rarely cost that much. But conservation is not cheap. Virtually nothing will cost less than $50, and charges can be many times that figure.

Sign a Contract

When a prognosis has been made and a maximum fee agreed upon, it is time to get a commitment from the restorer as to how long the task will take. Time is a problem for many of them, especially those with a backload of work. One conservator we know charges more for jobs done quickly than those that wait their turn. Most conservators will ask you to sign a contract that spells out the terms of the agreement.

Have Your Cake

If the cost is dismaying, keep in mind two things: you are saving an excellent print for future generations to enjoy as much as you do; and you are increasing the value of your heretofore damaged print—and how often in life can you opt for the ideal while making a good deal? Print collecting, as you must know by now, has *everything*.

The following suppliers are sources for the conservation materials suggested in this chapter. Write to them for catalogs and price lists.

Charles T. Bainbridge's Sons
20 Cumberland St.
Brooklyn, N.Y. 11205

Museum board
　(acid-free matboard)

Dennison Manufacturing Co.
Coated Paper Division
300 Howard St.
Framingham, Mass. 01701

Gummed cloth tape

The Mosette Co.
28 E. 22nd St.
New York, N.Y. 10010

Solander boxes

Process Materials Corporation
329 Veterans Blvd.
Carlstadt, N.J. 07072

Museum board
　(acid-free matboard)

Spink and Gaborc, Inc.
26 E. 15th St.
New York, N.Y. 10003

Solander boxes

Talas, Technical Library Service
104 5th Ave.
New York, N.Y. 10011

Archivist pens, linen tape, adhesives, acid-free glassine, cellulose acetate, Japanese papers, Permalife paper, ultra-violet ray absorbent shields

Specifications for storage drawers:

Tamarind Institute
The University of New Mexico
108 Cornell Ave., S.E.
Albuquerque, N.M. 87106

All those on the following list of paper conservators are members of The American Institute for Conservation of Historic and Artistic Works. All of them, at this writing, are doing at least some private work; almost all will accept work by mail.

Every conservator should be consulted—by phone or letter—before works are mailed or delivered.

CONSERVATORS

Mr. George Cunha, 33 High St., Topsfield, Mass. 01983

Mrs. Stephanie Ewing, P.O. Box 545, Sharon, Conn. 06069

Mrs. Christa M. Gaehde, 55 Falmouth Rd., Arlington, Mass. 02174

Mrs. Mary Todd Glaser, 73 East Linden Ave., Englewood, N.J. 07631

Mr. William Hanft, Technician, Department of Prints & Drawings, The Brooklyn Museum, 188 Eastern Pkwy., Brooklyn, N.Y. 11238

Mrs. Marie Kielmansegg Hitchings, 35 Paine Ave., New Rochelle, N.Y. 10804

Ms. Elizabeth Hollyday, 1122 Westover Ave., Norfolk, Va. 23507

Mrs. Carolyn Horton, 430 West 22nd St., New York, N.Y. 10011

Mr. Douglas Kenyon, Art Institute of Chicago, Michigan at Adams, Chicago, Ill. 60603

Mr. Roy L. Perkinson, California Palace of the Legion of Honor, Lincoln Park, San Francisco, Calif. 94121

Ms. Linda Shaffer, Los Angeles County Museum of Art, 5905 Wilshire Blvd., Los Angeles, Calif. 90036

Mrs. Martina Yamin, 206 East 30th St., New York, N.Y. 10016

GREETINGS·FROM·THE·HOUSE·OF·WEYHE – 1928

DWIGHT, MABEL (1876–1955) *Greetings from the House of Weyhe*
Lithograph. 1928. Signed. 7¼″ x 8¼″. Courtesy of Mason Fine Prints.

My library was dukedom large enough.
Shakespeare, *The Tempest*, 1611.

6. *Building a*
Print Reference Library

Any time anyone makes a list it is to some degree arbitrary. Our recom-
mendations represent a conscientious compilation of essential initial bib-
liographic material of interest to print lovers. We hope you'll take off on
your own from this launching.

The periodicals list includes gallery guides, a selection of general art
magazines, two publications oriented toward art as investment, and period-
icals—in and out of print—devoted only to fine prints. Except for the last
two categories, we could have included—literally—hundreds more titles.
We selected those we thought most useful to print people.

The list of books of particular value to those who want to know more
about the many aspects of prints is relatively brief and not specialized—
and omits, of course, the lengthy category of *catalogues raisonnés*. Almost
every one of the titles we have cited includes a bibliography, which can be
used as clues in your further researches.

Some of our titles are out of print; others are easily available. Some are
gorgeously printed and costly; others are inexpensive paperbacks. Many
are available in ordinary neighborhood libraries; others will be rare even in
specialized art libraries. In the same way their availability in bookstores
varies. You'll see both the easy-to-find and the elusive noted. Art books can
be found almost anywhere these days—but not always the ones you want
in the first place you look.

Many specialized art book dealers publish lists—erratically or regularly.
If you would like to examine a dealer's list, send for it. More and more
book dealers are beginning to charge for their mailings—like everything
else, their costs are rising—but the fee is normally applied toward your
first purchase. If you spot a title you particularly need on a specialized or
rare book list, order it—by telephone, if it's important. Remember: yes-

terday's "in-print" book is today's "out-of-print" title and tomorrow's "rare" book.

In addition to sending lists of desiderata to rare book dealers, in your search for specific titles, you may also find it worthwhile to attend antiquarian book fairs (contact the Antiquarian Booksellers Association of America, 630 Fifth Avenue, New York City for information on where and when), antique shows, and church fairs and such, where surprising items turn up. If you cannot find the works you want—or they are too costly— you'll discover that the next best thing to owning a book is knowing what library has a copy.

Since the money spent on books mounts up quickly, and values often multiply, keep records for insurance purposes. These can be filed as we suggested in our chapter on cataloging.

Print lovers are almost always book lovers too, so we're certain that every one of our readers will find some useful nuggets in the following pages.

PERIODICALS

Gallery
Guides

The Art Gallery Magazine, 1957. (Bimonthly, October through July.)
Ivoryton, Conn. 06442
Pull-out section, "The Artgallery Scene," gives excellent coverage to gallery and museum schedules in New York City, nationally, and internationally, although it is not as complete in the last two. Includes auctions. Main section features articles and reviews. Illustrated.

Art Now Gallery Guide. 1969. (Monthly, ten times annually.)
144 N. 14th St., Kenilworth, N.J. 07033
"A selected listing of current museum and gallery exhibitions," this guide is almost entirely devoted to New York City. Illustrated.

Artweek. 1969. (Weekly, 45 issues per year September through May, biweekly June, July, August.)
1305 Franklin St., Oakland, Calif. 94612
West coast art news is covered in depth with many articles and reviews. Includes photography, crafts. Calendar lists gallery and museum exhibits from British Columbia to Southern California. Illustrated.

Pictures on Exhibit. 1937. (Monthly, October through June.)

30 East 60th St., New York, N.Y. 10021

The oldest of the gallery guides, *Pictures on Exhibit* in-cludes world-wide reviews and coverage of art shows. Profusely illustrated.

West Art. 1962. (Biweekly.)

Box 1396, Auburn, Calif. 95603

Covering exhibitions in the western United States, espe-cially California, this newspaper-format guide includes crafts as well as fine arts. "Time to Show" section un-usually complete and of particular interest to artists. Illustrated.

*General Art
Magazines*

American Artist. 1937. (Monthly.)

165 West 46th St., New York, N.Y. 10036

Although directed toward artists—amateur and profes-sional, fine and commercial—its value to collectors ap-pears in the occasional article on printmakers and printmaking processes and in periodic special issues on graphic art. "Bulletin Board" lists exhibition informa-tion for artists. Illustrated.

American Art Journal. 1969. (Semi-annual.)

Kennedy Galleries, Inc., 40 West 57 St., New York, N.Y. 10022

This scholarly journal includes in almost every issue an in-depth essay on prints or printmakers. Reviews books and lists exhibition catalogs. Illustrated.

American Art Review. 1974. (6 issues annually.)

P.O. Box 65007, Los Angeles, Calif. 90065

Art historians are frequently the authors of scholarly ar-ticles on American art of the past in this lavishly pro-duced magazine. Prints included on occasion. Exhibition calendar. Profusely illustrated.

Art in America. 1913. (Bimonthly.)

150 East 58 St., New York, N.Y. 10022

Emphasizing contemporary art, this handsome magazine is international in scope. Some retrospective and histori-cal essays. Illustrated.

Artforum. 1962. (Monthly.)

667 Madison Ave., New York, N.Y. 10021

Thoughtful coverage of contemporary art. Features dis-cussions of esthetics and theory. Particular interest in experiment and the avant-garde. Illustrated.

ARTnews. 1909. (Monthly, except June, July, August, when quarterly.)

750 Third Ave., New York, N.Y. 10017

Excellent national coverage of major museum shows. Thorough national exhibition calendars; some international coverage. Periodic special print issues. Auction news. Reviews. Reportorial, straightforward approach. Illustrated.

Studio International. 1933. (*Studio*, 1893–1933.) (11 issues annually.)

14 West Central St., London WC1A IJH England

Semi-annual print supplement; quarterly supplement covers new art books, print editions, etc. Main concern contemporary art, especially experimental. International, good coverage England and United States. Illustrated.

Investment

The Art Investment Report. 1973. (Biweekly, every other Monday.)

120 Wall St., New York, N.Y. 10005

An investment-oriented evaluation of the art market edited by Richard H. Rush, author of *Art as an Investment.* Occasional analyses of print auctions and important print sales.

The Artnewsletter, 1976. (Biweekly.)

750 Third Ave., New York, N.Y. 10017

A division of *ARTnews.* Designed as "a confidential biweekly report on the art market." Frequent discussion of print market.

Buy-Sell Newsletter. 1973. (Quarterly.)

Art Appraisal & Information Service, Art Reference Gallery, Inc., 89 Park St., Montclair, N.J. 07042

Directed entirely toward the financial aspects of art, the *Newsletter* includes a buy-sell column and an appraisal service.

Print Periodicals

Newsletter on Contemporary Japanese Prints. 1970. (Issued periodically.)

The Helen and Felix Juda Foundation, 644 South June St., Los Angeles, Calif. 90005

"Purpose: to broaden the knowledge of art, particularly Japanese prints." One or two articles per issue. In English. Illustrated.

Nouvelles de l'estampe. 1963. (6 issues annually.)

Revue du Comité National de la Gravure Française, 58, rue de Richelieu, Paris 2ᵉ, France

Essays, research, *catalogues* primarily on European print-makers, Old Master to contemporary. (American dealers advertise, but virtually no editorial coverage of Americans.) Reviews of exhibitions. Print societies, dealer catalogs, auction prices, announcements of new editions covered. In French. Well illustrated.

Print Collector. 1972. (5 issues annually.)
Via Montenapoleone, 3, 20121 Milan, Italy

Articles frequently include original research and cataloging of Old Master and European prints. Up-to-date information on fakes and forgeries, book reviews, and selected auction prices included. In English, translated from the Italian *i quaderni del conoscitore di stampe.* Illustrated.

The Print Collector's Newsletter. 1970. (Bimonthly.)
205 East 78 St., New York, N.Y. 10021

Articles and interviews deal with prints and printmakers from all parts of the world and from all periods. Regular features include "News of the Print World," "Prints and Portfolios Published," "Multiples and Objects and Books," "Museum and Dealers' Catalogues," "International Auction Record," and the "PCN Directory," a classified section consisting almost entirely of dealers. Illustrated.

Print Review. 1973. (Issued twice annually by Pratt Graphics Center and Kennedy Galleries, Inc. Replacing *Artists's Proof.*)
Pratt Graphics Center, 831 Broadway, New York, N.Y. 10003

Contributors are printmakers, curators, critics, print connoisseurs; articles cover wide range of periods, styles, and countries, including Oriental. Museum news, book reviews. Profusely illustrated.

Prints. 1930–1938. 8 vols. (November 1930–February 1938. Bimonthly except July and August.) *Out-of-Print*

News and reviews of current print world; essays on contemporary artists. Valuable reference source on printmakers of the 1930s. Illustrated.

Impression. 1957–1958. (Four issues, beginning September 1957.)

"A magazine of the graphic arts," published in Los Angeles. Jules Heller, executive director.

Artist's Proof. 1961–1971. 4 vols. (vol. I–vol. IV, no. 1.)

Published twice annually by Pratt Graphics. International scope. Range from Old Masters to avant-garde. Includes coverage of individual artists, new techniques, book illustration, workshops. Illustrated.

Print Collector's Quarterly. 1911–1951. 30 vols. (vol. I, 5 issues; 4 issues per volume thereafter. Last issue vol. XXX, no. 2, March 1950. Vol. XXX, no. 3, Winter, combined with *Print*, a quarterly journal of the graphic arts. *Print* continues to be published, but does not cover fine prints.)

"The *Quarterly* will concern itself chiefly with the works of recognized great masters of engraving and etching, both old and modern." This early statement was adhered to, with essays by art historians and artists on individual printmakers, plus articles of general interest to collectors. Many descriptive *catalogues raisonnés*. Illustrated.

The Print Connoisseur. 1920–1932. 12 vols. (No issues published between October 1920 and January 1923.)

Coverage of fine prints similar to that of *Print Collector's Quarterly*, above, but also concerned with historical and popular prints. Frontispiece of each issue an original print. Illustrated.

BOOKS

About Prints Adhémar, Jean. *Graphic Art of the Eighteenth Century.* New York: McGraw-Hill, 1964.
Survey of continental printmaking.

Adhémar, Jean. *Twentieth-Century Graphics.* New York, Washington, D.C.: Praeger, 1971.
Combined with Roger-Marx's *Graphic Art of the Nineteenth Century*, a fairly comprehensive survey of European graphics.

Arms, John Taylor. *Handbook of Printmaking and Printmakers.* New York: Macmillan, 1934.
An informative well-rounded view of the field and its players by a master etcher.

Bailly-Herzberg, Janine. *L'eau-forte de Peintre au Dix-Neuvième Siècle: Le Société des Aquafortistes 1862–1867*. 2 vols. Paris: Leonce Laget, 1972.
A history of the French Society of Etchers. In French.

Beall, Karen F., ed. *American Prints in the Library of Congress: A Catalogue of the Collection*. Baltimore: Johns Hopkins Press, 1970.
Documentation of approximately 12,000 prints by 1250 American printmakers. Each printmaker illustrated once.

Binyon, Lawrence, and J. J. O'Brien Sexton. *Japanese Colour Prints*. London: E. Benn, 1923.
A standard on 18th-century printmakers, publishers, and printers' marks.

Castleman, Riva. *Contemporary Prints*. New York: Viking, 1973.
Reproductions of what is current.

Ebert, John and Katherine. *Old American Prints for Collectors*. New York: Scribner's, 1974.
Guide to "popular" prints.

Getlein, Frank and Dorothy. *The Bite of the Print*. New York: Crown, Bramhall House, 1963.
Satire and irony are the points of departure for discussion of many important prints.

Gilmour, Pat. *Modern Prints*. London: Studio Vista/Dutton, 1970. Paper.
Non-technical discussion (and defense) of radical innovations since 1960.

Haight, Anne Lyon, ed. *Portrait of Latin America*. New York: Hastings House, 1946.
Biographies in English and Spanish of the artists; illustrations of their work.

Hillier, Jack. *Japanese Colour Prints*. London and New York: Phaidon, 1966.
Origins of the color print, the Ukiyo-e style, and its techniques.

Hind, Arthur M. *A History of Engraving and Etching: From the Fifteenth Century to the Year 1914*. (3rd ed.: London, 1923.) Reprint, 3rd ed. New York: Dover, 1963. Paper.
"The standard work in English."

Ivins, William M., Jr. *How Prints Look*. Boston: Beacon Press, 1948.

An approach to developing connoisseurship by means of magnified details that clarify technical discussions.

Ivins, William M., Jr. *Notes on Prints. Being the Text of Labels Prepared for a Special Exhibition of Prints from the Museum Collection*. Boston: MIT Press, 1930.

Brilliant and provocative comments by the former curator of the Department of Prints at the Metropolitan Museum of Art.

Ivins, William M., Jr. *Prints and Visual Communication*. Cambridge, Mass.: Harvard University Press, 1953. Reprint. New York: Da Capo Press, 1969. Paper.

Socio-historical discussion of the history of Western prints, their functions, their use in the conveyance of ideas, and their role as a medium of personal expression.

Kainen, Jacob. "Prints of the Thirties: Reflections on the Federal Art Project," *Artists's Proof* II (1971): 34–41.

Kovler Gallery. *Forgotten Printmakers of the 19th Century*. Chicago: Kovler Gallery, 1967.

Annotated catalog of 843 prints, including lithographs by Calame, Charlet, Cheret, Deveria, Lunois, Raffet, Steinlen.

Laver, James. *A History of British and American Etching*. London: E. Benn, 1929.

The evolution of etching in England.

Lehrs, Max (Walter Strauss, ed.) *Late Gothic Engravings of Germany and the Netherlands*. New York: Dover, 1969.

All 682 illustrations from Lehrs' *catalogue raisonné* of copperplate engravings in Germany, the Netherlands, and France in the 15th century.

Leymarie, Jean. *The Graphic Works of the Impressionists: Monet, Pisarro, Renoir, Cézanne and Sisley. Catalogue by Michel Melot*. New York: Abrams, 1971.

Brief essay precedes the illustrations.

Lumsden, Ernest S. *The Art of Etching*. Philadelphia: Lippincott, 1925. Reprint. New York: Dover, 1962. Paper.

Observations on technique and artistic merit.

Man, Felix H. *Artists' Lithographs: A World History from Senefelder to the Present Day.* New York: Putnam, 1970.

Brief historical essays and notes on a selection of lithographs.

Mayor, A. Hyatt. *Prints and People.* New York: The Metropolitan Museum of Art, 1971.

The most readable book for print lovers. If you buy only one book on prints, make it this one.

Middendorf, J., and Wendy J. Shadwell. *American Printmaking: The First 150 Years.* Washington, D.C.: The Museum of Graphic Art, 1969.

Historical prints, 1670–1820.

Morse, John D., ed. *Prints in and of America to 1850.* Winterthur Conference Report. Charlottesville: University of Virginia, 1970. Paper.

Papers read by specialists in early American prints (including 16th-century Mexico, Colonial America, New England, scientific illustrations, etc.). Appendix with annotated list of early American print research resources in the United States.

Passeron, Roger. *French Prints of the Twentieth Century.* New York: Praeger, 1970.

Biographies and bibliographies of the artists.

Passeron, Roger. *Impressionist Prints.* New York: Dutton, 1974.

Readable and informative book begins by listing the relative ages of painter-printmakers at the time of the first group exhibition of the Impressionist painters in 1874.

Peterdi, Gabor. *Great Prints of the World.* London: Macmillan, 1969.

Contemporary printmaker illustrates the development of printmaking with examples and comments.

Roger-Marx, Claude. *Graphic Art of the Nineteenth Century.* New York, Toronto and London: McGraw-Hill, 1962.

A general history, with emphasis on developments in France. (See note on Adhémar.)

Sachs, Paul J. *Modern Prints and Drawings.* New York: Knopf, 1954.

From the early moderns through the Expressionists and Abstractionists. Chapters on Italy, England, Mexico.

Salamon, Ferdinando. *The History of Prints and Printmaking from Dürer to Picasso: A Guide to Collecting.* New York: American Heritage, McGraw-Hill, 1972. Sophisticated material requires some background.

Sotriffer, Kristian. *Expressionism and Fauvism.* New York and Toronto: McGraw-Hill, 1972. Annotated catalog of the works illustrated, a biography of each artist, and a fine bibliography.

Sotriffer, Kristian. *Printmaking History and Technique.* New York: McGraw-Hill, 1968. Survey of the major printmaking techniques and their historical development.

Statler, Oliver. *Modern Japanese Prints: An Art Reborn.* Rutland, Vt.: Tuttle, 1959. Discussion of the modern creative Japanese print, or Sosaku hanga.

Stein, Donna M., and Donald H. Karshan. *L'Estampe Originale: A Catalogue Raisonné.* New York: The Museum of Graphic Art, 1970. Definitive work on the French series of publications. Fully illustrated.

Stewart, Basil. *Subjects Portrayed in Japanese Colour Prints.* London: Kegan Paul, Trench, Trubner & Co. Ltd., 1922. Collectors' guide to all the print subjects illustrated.

Strauss, Walter L. *Chiaroscuro.* Greenwich, Conn.: New York Graphic Society, 1973. Comprehensive pictorial reference and *catalogue raisonné* of all the surviving chiaroscuro woodcuts of the German and Netherlandish masters.

Stubbe, Wolf. *Graphic Arts in the Twentieth Century.* New York: Praeger, 1963. Survey of the first half of the 20th century.

Weber, Wilhelm. *A History of Lithography.* New York, Toronto and London: McGraw-Hill, 1966. International, with chapters on von Mannlich, Géricault and Delacroix, Daumier, Goya, and Munch. Extensive discussions of changing techniques.

Zigrosser, Carl. *The Expressionists: A Survey of Their Graphic Art*. New York: Braziller, 1957.
Survey of the printmaking activities of those artists who rejected Impressionism for the expression of their own emotional experiences.

Zigrosser, Carl. *Prints and Their Creators: A World History (The Book of Fine Prints,* retitled). New York: Crown, 1975.
Study of the graphic arts in the East and West. Discusses 738 prints.

Zigrosser, Carl. *Six Centuries of Fine Prints*. New York: Covici-Friede, 1937.
Tour of the print world, Gothic through 20th century, with "A Note on Oriental Art."

Zigrosser, Carl, ed. *Prints: Thirteen Illustrated Essays on the Art of the Print*. New York: Holt, Rinehart, and Winston, 1962.
Scholarly essays selected for the Print Council of America.

Blodgett, Richard. *How to Make Money in the Art Market*. New York: Peter H. Wyden, 1975. *Buying Art*
"Art can be the most rewarding investment in the world."

Eagle, Joanna. *Buying Art on a Budget*. New York: Hawthorn Books, 1969.
On collecting art at reasonable prices while broadening one's appreciation.

International Directory of Arts. 12th ed., rev. 2 vols. Frankfurt: Art Address-Verlag Müller GmbH & Co. KG., 1974/75.
Geographically indexed guide. Volume I lists museums and institutional galleries, universities, academies and art schools, restorers and experts. Volume II lists art and antique dealers, art periodicals, antiquarian and art booksellers, artists, and private collectors.

Mayer, E. *International Auction Records*. New York: Editions Publisol. Published annually.
"Invaluable price guide."

Rush, Richard H. *Art as an Investment*. Englewood Cliffs, N.J.: Prentice-Hall, 1961.
A "practical" approach to collecting.

Cataloging Pink, Marilyn. *How to Catalogue Works of Art: A Guide
for the Private Collector*. Los Angeles: Museums Sys-
tems, 1972.
Booklet that tells exactly "how-to-do-it."

*Collecting
and
Connoisseur-
ship*

*Print Collecting Today: A Symposium Held in the Wiggin
Gallery, Boston Public Library*. Boston: Boston Public
Library, 1969.
The speakers were Arthur Vershow, a collector, Sinclair
Hitchings, a curator, and R. E. Lewis, a dealer.

Wilder, F. L. *How to Identify Old Prints*. London: G. Bell
and Sons Ltd., 1969.

The fine points of connoisseurship.

Zigrosser, Carl, and Christa M. Gaehde. *A Guide to the
Collecting and Care of Original Prints*. New York:
Crown, 1965.
An excellent small book.

Conservation Clapp, Anne F. *Curatorial Care of Works of Art on Paper*.
Oberlin, Ohio: The Intermuseum Laboratory, Allen Art
Building, 1973.
Useful information on hinging, matting, framing, and the
sophisticated techniques used by professional conserva-
tors.

Cunha, George Martin, and Dorothy Grant Cunha. *Con-
servation of Library Materials*. 2 vols. Metuchen, N.J.:
Scarecrow Press, 1972.
"A manual and bibliography on the care, repair, and resto-
ration of library materials." Vol. II is entirely bibli-
ography.

Dolloff, Francis W., and Roy L. Perkinson. *How to Care
for Works of Art on Paper*. Boston: Museum of Fine
Arts, 1971.
Basic introduction to paper conservation and restoration.

Plenderleith, H. J., and A. E. A. Werner. *The Conserva-
tion of Antiquities and Works of Art*. London: Oxford
University Press, 1971. 2nd ed., 1974.
All aspects of museum conservation, with excellent chap-
ters on paper.

Johnson, Kathryn. *Fakes and Forgeries*. Minneapolis: *Fakes and*
Minneapolis Institute of Arts, 1973. *Forgeries*

Brief section on prints illustrates a few examples of mechanical reproduction, forged signatures, and outright fakes.

Hodes, Scott. *What Every Artist and Collector Should* *Law*
Know about the Law. New York: Dutton, 1974.

Some information for the collector on tax problems, customs, and insurance.

Briquet, Charles M. *Las Filigranes: Dictionaire Histor-* *Paper and*
ique des Marques du Papier des Leur Apparition vers *Watermarks*
1282 Jusqu'en 1600. Paris: 1907. 4 vols. Reprint. New
York: Hacker, 1966.

Over 16,000 facsimiles of watermarks, plus text.

Heawood, Edward M. A. *Watermarks: Mainly of the*
Seventeenth and Eighteenth Centuries. Amsterdam:
The Paper Publication Society, 1969.

Corrected, not revised, edition of the 1950 edition with over 4000 watermarks.

Hunter, Dard. *Papermaking Through Eighteen Centuries*.
New York: William Edwin Rudge, 1930.

Methods used by papermakers.

Library of Congress. *Papermaking/Art and Craft*. Washington, D.C.: Library of Congress, 1968.

History of the craft of papermaking.

Lugt, Frits. *Les marques de collections de dessins et d'es-*
tampes; marques estampillées et écrites de collections
particulières et publiques. 2 vols. Amsterdam: Vereen-
igde Druk, 1921–1956.

A history of collectors by "the great amateur of prints."
The definitive work on the identification of collectors'
marks (including descriptions of the collections, and
their dates of sales when known). All scholarly catalogs
use "L" with the number from *Les marques* to identify
a collector's mark.

Lucas, E. Louise. *Art Books: A Basic Bibliography*. Green- *Reference*
wich, Conn.: New York Graphic Society, 1968.

Includes section on graphic arts.

Mason, Lauris, compiler (assisted by Joan Ludman). *Print*

Reference Sources: A Select Bibliography Eighteenth to Twentieth Centuries. Millwood, N.Y.: Kraus-Thomson, 1975.

"A catalogue of catalogues." A source list of *catalogues raisonnés* and museum and dealer catalogs on individual artists.

Technique

Antreasian, Garo, and Clinton Adams. *The Tamarind Book of Lithography: Art and Techniques.* New York: Abrams, 1971.

Definitive work on all aspects of contemporary lithographic technique.

Biegeleisen, J. I., and Max Arthur Cohen. *Silk Screen Techniques.* New York: Dover, 1958. Paper.

The earliest and still one of the best on silkscreen as a fine art. Revised from the 1942 edition.

Brunner, Felix. *A Handbook of Graphic Reproduction Processes.* 2nd ed. New York: Visual Communication Books, Hastings House, 1964.

Describes all printmaking processes.

Gross, Anthony. *Etching, Engraving and Intaglio Printing.* London: Oxford University Press, 1970.

Technique explicated by a leading English printmaker.

Hayter, S. W. *About Prints.* London: Oxford University Press, 1964.

Most aspects of contemporary printmaking by a noted artist.

Heller, Jules. *Printmaking Today: A Studio Handbook.* New York: Holt, Rinehart, and Winston, 1972.

Introduction to printmaking.

Peterdi, Gabor. *Printmaking.* New York: Macmillan, 1971.

An innovative artist and teacher writes on printmaking processes.

Ross, John, and Clare Romano. *The Complete New Techniques in Printmaking.* New York: Free Press, 1974. Paper.

Selected portions of the title below.

Ross, John, and Clare Romano. *The Complete Printmaker.* New York: Free Press-Macmillan, 1972.

Textbook on the print technology by a husband-and-wife team of printmakers.

Senefelder, Alois. A *Complete Course of Lithography*. London: Ackerman, 1819. New York: Da Capo Reprint, 1969.
A reprint of the 1819 classic supplemented with 31 plates from the first French and German editions.

CHAHINE, EDGAR (1874–1947) (*The Collector*)
Etching and drypoint. c. 1904. Signed. 8¾″ x 12½″. Courtesy of Mason
Fine Prints.

I do not know any reading more easy, more fascinating, more delightful than a catalogue.
 Anatole France, *The Crime of Sylvestre Bonnard,* 1881.

7. Cataloging a Private Collection

Why should you, as a private collector, catalog your prints? The reasons are many: So that you can know what you own at a glance. So that you can remember where you bought a print.

Does it matter? Well, for one thing the source of one print by a given artist—or period or style—is frequently the source of similar works the next time around. Your interests are likely to continue.

With a file-card catalog you'll be able to keep your record of each print's value up to date for insurance purposes. You'll have one easily accessible place to keep notes on the information you gather about each artist and each print; your clipping file can be keyed to your card catalog.

Keeping a catalog is a fairly simple matter, especially if you make entries as you go along, whether you buy one or two prints a year or dozens. Catalogs need not be restricted to museums or vast private collections because they are useful to everyone. This is the card we have devised. (see page 114). Its particular set of entries suits our needs. After we typed out a model on a standard 4″ × 6″ index card we had it reproduced by our local offset printers at a very reasonable cost. You can do the same, either using our card as your sample or making such changes as suit your predilections and your collection.

Artist: This first item in the upper left-hand corner is of course the most important. Last name first is the rule, since you will file cards alphabetically in file boxes available from any stationery store. If the print was done by two people—say, by an engraver or other crafts-person working from a painting or drawing by the artist—you will want to note the second name on the card and perhaps cross-index under the second name, although there is no need to complete a second card.

After the artist's name (and pseudonym, if there is one), enter the

Artist: Avery, Milton Date: (1894 -1965)
Title: Man With Pipe
Tech: Drypoint
Date: 1936
Signed: in pencil
Ed: 9/60
Paper: parchment-like
Ref: Lunn 14
Size: 6 3/8 × 5 13/16 (Sheet size 11 9/10 × 10")
Cond: fine
Comment: Portrait of Vincent Sprague, the artist

Date Purchased: 12/10/74
Source: Mason Fine Prints, Quaker Ridge Dr, Glen Head,
N.Y. 11545
Cost: $450.

DATE	PRICE	SOURCE OF INFO	COMMENT
Date:			
Sold to:			
Address:			
Price:			

country and year of birth on the same line. If the artist is no longer living, add the year of death. This information is almost always quickly available from standard art reference works. For contemporaries, your source of purchase will usually have the information, as will *Who's Who in Ameri-*

can Art for most living Americans. When in doubt, add a question mark after these or any other card entries. As your research adds reliable facts, cards can be revised.

Title: Enter the title as it appears in pencil on the print. If there is no title, use the one by which it was referred to in the auction catalog, dealer catalog, or other published material. If the artist calls it "untitled," you can too. You might add your own descriptive title, though, or even a brief description—"fields in foreground, figures in middle distance, hazy mountains beyond." The title may at times be one that has been applied through popular usage, such as Rembrandt's "Hundred Guilder Print," clearly not what the artist called it. In such cases you may wish to enter both the "official" name, if known, and the popular title of the print.

Technique: Note here everything you know about how the print was made. Usually a simple entry such as "etching," or "etching and drypoint," or "lithograph" is all that is called for. There are times, however, when you will be well enough informed to say "soft ground aquatint," or "lithograph with intaglio," or "hand-colored collograph." Any information you have and are sure about should be entered, even if such details were not included in the bill-of-sale or the catalog of the show, dealer, or auction from which you made the acquisition.

Date: Prints are generally dated in the year in which the stones or plates are made. Simple? No. Until recently printmakers rarely dated their prints at all, and a great many still do not.

Since there are printmakers, as we have noted, who print as they make sales, there may be twenty or more years between the first and last impression, even in a small edition. Or a plate may be executed and no edition made at all for many years. Picasso's "Pigeonneau" is noted in Bloch's *catalogue raisonné* as having been cut in linoleum "vers 1939." When the print came up at auction the date and later printing were indicated thus: "executed c. 1939, printed in sanguine, in 1957." The auction catalog date, giving the year the plate was executed as the date of the print, is the generally accepted and preferable practice. Yet artists from time to time have been known to think otherwise and date their impressions in the year of printing, as did Louis Lozowick when he reprinted some of his early works late in life.

Scholars catalog prints in the chronological sequence in which the plates were made, as Peter Morse writes in his *catalogue raisonné* of John Sloan's prints: "The chronology of Sloan's prints can be established with considerable accuracy. This entire *catalogue*, with only slight exceptions, is arranged in the order in which the prints were actually made. Where a print was finished long after it was begun, the starting date is used." You may learn the date—exact or approximate—from the *catalogue raisonné*; from the dealer, publisher, or artist if the printmaker is a contemporary; or

from the catalog of the print show, dealer, or auction at which it was purchased. Frequently the date you assign will have to be labeled "circa." When research does not reveal even an approximate date, use a question mark or "n.d." (no date).

Signed: If the print is signed in the plate or the margin, or both, note it. (Always be aware that pencil-signing is modern.) You might write on this line such specific information as "Signed 'Ben Shahn' lower right-hand corner of plate, signed in red conté crayon in margin lower left." A print may have a dedication—"To Kip with gratitude" or "Sally, it was beautiful!" If you know who Kip or Sally are, say so in writing; if you have discovered the occasion, so much the better; and if you think you can interpret any cryptic remarks, you've got it made, for you have added or at least annotated and documented something of unique value to the print. Some artists add "imp" after their signatures (abbreviation of "impressit" —"I printed it") when they have pulled their own impressions.

"Posthumous signatures" should be noted and identified—wife, son, museum, etc., and so too should estate stamps and other marks, authorized or unauthorized. And, of course, if the print is not signed in any fashion, you'll want to indicate that on this line too.

Keep in mind that artists often vary the way in which they sign their works at different points in their careers. Whistler used J.W., J.A.W., J.M.W., J. McN. W., Whistler, J. Whistler, James Whistler during his early years. Then he began to experiment with forming his initials into a pattern, either round or oblong designs, which eventually evolved into his famous butterfly. As Burns Stubbs points out,

> About 1873 Whistler reworked a number of his early etchings which had been signed and dated in the early sixties. Along with the changes in design or execution he added the butterfly without removing the original signature. Here, too, it might be well to note that many of his etchings and drypoints were unsigned; others were unsigned in their early stages but signed either with his name or the butterfly in later states, and, in a few rare instances, the signature or butterfly was removed entirely in the last state.

Pablo Picasso also varied his signatures between his first—P. Ruiz— and his last, Picasso. A few months ago we looked at very early etchings by an American who lived during the first half of this century; they are signed "Phillips," whereas all his paintings, done after 1920 when he had given up printmaking, are signed "Tromka."

Many print workshops, especially lithography workshops, use an un-inked embossed stamp called a "chop" on each impression of work printed on their premises. (See *Lithography Workshops Around the World* by Knigin and Zimeles for reproductions of many contemporary chops.) The signature entry is the place for a notation about blind stamps when there are any, and if the printers or engravers were notable in some way, indi-

cate their names. Or it might be that the designer of the blind stamp is worth recording, as would be the case for the stamp designed by Charpentier for L'Estampe Originale and used by them for 95 editions of 100 between 1893 and 1895.

Edition: How many prints are in the edition? We noticed a print in a catalog the other day that was labeled "one of one," although it was not a monotype. The technique by which a true monotype is made normally allows for only one impression, whereas "one of one" implies that the artist for some reason pulled only one proof, even when the medium—etching, lithography, or whatever—might have permitted many more.

Is your print from the first edition or the second or third? From what state is your impression? Write down each of these details as they apply. Nineteen of John H. Twachtman's etchings, for instance, were reprinted after his death by the firm of Frederick Keppel. Collectors want to know whether a given impression was made by the artist or were, as with these posthumous Twachtmans, printed later and signed by his son—"JHT per AT."

Sometimes a single edition has been printed by several hands over many years. Forty-five impressions of John Sloan's print, "Memory" (Morse 136), were printed originally; then the second printer, Platt, made 25; White printed 20; and finally Ernest Roth pulled 20 more. Exact dates for each printing have not been assigned, but it is known that Platt printed for Sloan during the years 1927 to 1933, White from 1931 to 1937, Roth from 1945 to 1951. However, this is considered one edition of 100, with an actual printing that numbers 110.

If your print is serially numbered (e.g., 29/30) by all means include that information, or if it is an "Artist's Proof" (A/P) or "Hors Commerce" (H/C), this is the place to jot the facts. You'll remember, of course, that print editions were not limited until well into this century, making it rare to know the size of the edition of earlier prints. Yet not long ago we came across a print by Jacques Villon, dating from the turn of the century, that was numbered.

Paper: Modern prints are sometimes documented very closely. (See reproduction of a Gemini G.E.L. documentation sheet, pages 72–73.) Paper is specifically noted in such documentation, so that collectors can state with authority that prints were made on "Rives BFK" or "Arches Cover." But other prints are pulled on papers that can be identified only as "thin mulberry" or "heavy ragpaper," and sometimes not that much is known.

Watermarks: The watermark, if there is one and you can find it, should be included in this Paper section. Some contemporary prints have documented watermarks, so that a recent SPB sale catalog noted "published by ULAE, 1969, signed and dated in pencil, numbered 2/2, H/C (*Hors Commerce*), on paper watermarked Angoumas A La Main, full sheet

printed to the edges." Most of the time, however, there will be very little you'll be able to say with certainty about the paper. Yet since paper and watermarks are studies that in themselves fascinate many people, we have included books in our bibliography that can be used to explore the subject in depth. There is also a pamphlet published by the Tamarind Institute about paper that can be ordered from them.

References: Mozart lovers refer to Köchel listings and print collectors look to Bartsch or Mellerio or Morse for, respectively, the *catalogues raisonnés* of the prints of Dürer, Redon, and Sloan. Sometimes a print will have more than one reference, and therefore reference numbers, having been cataloged by more than one person. Notation of the reference number facilitates any future search you make for information about the print, and it identifies the print even more explicitly than its title. It goes without saying, however, that many of the world's printmakers have not been cataloged.

Size: Height precedes width every time—10″ by 20″ always means that the print is ten inches high and twenty inches wide. There is no exception to this rule in recent catalogs.

The size of a print is almost always stated in terms of the *image* dimensions. Prints are normally matted, however, so that the 10″ by 20″ print (an unlikely shape) may become, in a mat, 15″ by 30″, and framed it will grow another few inches. But in your card catalog note the dimensions of the image only, not the paper, unless you have a particular reason for doing otherwise. Paper size might be recorded if it were unusual.

Condition: Look at your print with a cold, clear eye and honestly examine its condition—"two small pinholes on upper right, otherwise in good condition"; "soiled on margins"; "minor creases and staining," and so on. If you plan to have the print cleaned or repaired by a professional, fill out this section of your card in pencil, so that when the work is completed you can erase your first remarks, replacing them with "restored by _____" along with the date.

Comment: This is where you have a chance to make a note of all the extra things you know about the print, either at the time you make out the catalog card or as you learn new details over the years. Some matters are easily enough determined when the print is acquired: With modern prints the publisher, for instance, will usually be known to the buyer, if the print was published by someone other than the artist. As we've said, many publishers and printers currently use distinguishing chops. Sometimes you will find a collector's mark. If this is unknown to you and its origin is not explained in the bill of sale, you can look up many collectors' marks in *Les Marques de Collections de Dessins et d'Estampes* by Frits Lugt.

If your print was a deaccessioned duplicate of another impression in a museum, the fact is worth making a note of. Do you know when and

where this particular print has been exhibited? Or have you lent it for exhibition, or for reproduction in a book or catalog? If so, record it. You may indicate the printer here, too, if the name is known to you and has not been included elsewhere on the card. You might want to fill in on this line a matter so mundane as whether the print is framed, or one so valuable as its provenance.

These peripheral tidbits are not only fun to know, they can add to the desirability and worth of the print should you at some time decide to sell it. Add up this material, plus the preceding items, and you will find that they enhance your knowledge, increase your store of print scholarship and connoisseurship, and may at some time be important help to you as well as to fellow collectors.

The last three items are as easy as one, two, three: 1. *Date purchased:* When did you buy it? 2. *Source:* From whom did you buy it? 3. *Cost:* How much did you pay?

Now turn the card over. This side is devoted to money. Whenever you are aware that the print is changing hands—via a dealer's catalog, a priced auction catalog or yearbook, or auction news in a periodical—note the date, price, and source of your information. This is essential for insurance purposes in a volatile economy such as we have been experiencing. It will also save you time-consuming research should you ever decide to sell your print or to give it away and then take a tax deduction. If you sell, complete the information called for in the lower left-hand corner—the sale price.

We know every collector will not be as meticulous as this program suggests, but we do assure our readers of the rewards. Don't be afraid to vary our system according to your needs, but do try to keep some kind of ongoing record of your prints: it will add to the fun, value, and scholarliness of your collection.

ACQUISITIONS BOOK

In addition to the card-file catalog we suggest, there are collectors who keep an acquisitions record book or index sheets for their print collections. The headings for a sample page follow. Such pages are kept chronologically, unlike the alphabetical card catalog, and therefore can be read to show development and change in taste. Such a record allows for quick annual surveys of the sums spent on prints, and if the column for current values is kept up to date, the monetary worth of the entire collection can be calculated at any time.

Acquisitions Book or Collection Index Sheet

Date	Artist	Title	Cost	Value	Catalog Number
____	_____	_____	____	____	_____
____	_____	_____	____	____	_____
____	_____	_____	____	____	_____
____	_____	_____	____	____	_____

CATALOG NUMBERS

Collectors who wish to give their prints catalog numbers often use their chronological acquisitions pages for this purpose, since most catalog numbering systems incorporate the year of purchase. Cataloging may seem exotic to private collectors, but it is actually simple. Include the year of purchase in either full (1975) or abbreviated (75 or 975) form. Add a number to show the sequence within the year in which this print was purchased. The third print bought in 1975 could then be listed 3–75 or 31975. If the print is stored and the print storage drawers or Solander boxes are labeled with Roman numerals, this print—stored in drawer IV—might be cataloged IV-3-75; if your system of storage is alphabetical, the entry for the print could be M-3-975. In a similar fashion, you can code into your catalog numbers the technique, source of acquisition, or purchase price should you wish to do so.

CLIPPING FILES

Haven't you found that once you become aware of something new, you suddenly find it all around? And in the most unlikely places? Once you're convinced of how helpful it is to gather material on the printmakers in whom you are interested, you may become an obsessive clipping collector. Use heavy 12½ × 9½ manila envelopes to store your bits of paper. These close neatly, hold large amounts of material, and fit on standard bookshelves. Label each in an upper corner with the name of a printmaker you collect or the periods or subjects—all depending upon the point of view of your collection. Whenever you chance upon written material pertinent to your collection—a review of an exhibition; a discussion of the artist or the period; a note about a museum acquisition—cut it out or Xerox it and slip

it into the appropriate envelope in your file. Add such material as obituaries, small unbound exhibition catalogs that might slip behind more substantial books on your shelves, and even entire issues of magazines.

You'll be surprised at how quickly these items will broaden your knowledge of the works and the artists. Don't forget to date all this paper and note the source. Exhibition announcements can be added to your vertical file too, but notice that far too many of these state the day and month of the show and omit the year. This is something you should add to the announcement to give your collection the greatest accuracy.

CATALOGING BOOKS

We have evolved over the print-collecting years a homemade system for cataloging reference books and pamphlets about prints. It works for us, and perhaps it will for you. We arrange them in three separate categories, and we try to keep each type on its own set of shelves. We segregate them in the following way: *Catalogues raisonnés*, monographs, one-man show catalogs (when these are substantial and bound) are shelved alphabetically by the name of the artist, so that our shelves run from Albers, Appel, Archipenko, through to Wood, Zorach, Zorn.

The second set of books consists of general art reference works—all the books relating to print lore. Here we alphabetize by the author, so that our shelves read from Antreasian to Zigrosser.

Our third category is divided in two: Museum and exhibition catalogs are kept distinct from priced dealer and auction catalogs. The museum and exhibition catalogs are filed by state, although we have sometimes thought of rearranging them by institution. We have also thought about arranging them by topic or period, but where would one fit "Recent Acquisitions," or "Carl Zigrosser: Curatorial Retrospective, Philadelphia Museum of Art 1964"? The priced dealer and auction catalogs are shelved alphabetically by the name of the gallery or dealer, and in turn these are arranged chronologically.

Periodicals, too, are shelved. The *Print Collector's Newsletter*, happily, provides a binder that allows issues to be protected and referred to with ease. If you decide to save back issues of general art magazines you might want to place them in adjacent space, and whether you purchase the bindings sold for them depends upon your own needs and habits. Because most art magazines are large and well bound, however, special binding is not as much a necessity for them as it is for *PCN*. If you own runs of any of the out-of-print print periodicals they would of course be filed with *PCN*. Labeled file storage boxes can keep these clean.

REFERENCE FILE

Author:

Title:

Purchased: _____ _____ _____
 date from cost

Comments:

Card Catalog for Books

The aim of shelving written material in this way is so that it can be retrieved with ease. In order to know what you have, we suggest that you make out cards for your books. As you can see in the sample card reproduced, we include after author and title the date we purchased the book, the source of purchase, and the price we paid. We add these notes as much for insurance purposes as anything else, and since so many art books quickly rise in value and many are costly to begin with, we record on the back of our cards any changes in price we are aware of so that the reverse is modeled on the print cards discussed earlier.

More important, we make notations on the card of anything that seems pertinent to us. The most common cryptic scrawl is "Env," which means we have already set up an envelope for this artist—forestalling us from mistakenly readying a second when we come upon an item to clip. Another notation we make on book cards is one that reminds us of something we have read that might be forgotten when we are looking for information—a chapter in a general book on an artist in whom we are interested, for instance. Here, too, we make notes on such matters as a new catalog forthcoming, or the sale via auction of a large collection that includes artists we may at some time want to research. These notes remind us where we can find material when we need it.

All our information cards are filed together, alphabetically, so that au-

thors and artists are intermixed. The first items in our completed card catalog therefore reads:

Adhémar, Jean
Graphic Art of the 18th C.
3/70 Strand Book Store $5.00

Adhémar, Jean
Graphic Art of the 20th C.
5/72 Wittenborn $3.98

Albany Print Club
(envelope)

Albers, Josef
Miller, J. *Josef Albers: Prints 1915–1970*
2/70 Brooklyn Museum $3.50
see: Jane Haslem cat. "Innovators."

Alma-Tadema, Sir Lawrence 1836–1916
see Lott & Gerrish cat. 3/75

American Artists Group
(envelope)

Archipenko, Alexander
Karshan, D. A. *Archipenko:*
A Memorial Exhibition 1967–1969
UCLA Art Galleries
3/75 Wittenborn $22.50
 (He made 53 prints)

Arnold, Grant
Creative Lithography
2/73 Phil. Mus. Bk. Shop $2.50

A Print Sale.

ROWLANDSON, THOMAS (1756–1827) *A Print Sale*
Etching. 1788. Signed in plate. Ref: Grego 241. 6½″ x 10¼″. Courtesy of
Mason Fine Prints.

A feast is made for laughter, and wine maketh merry; but money answereth all things.
Ecclesiastes

8. Selling a Print: How to Price and Where to Sell

Selling to Improve Collections

"I never sell a print," asserts Lessing Rosenwald, who presides over the largest and most prestigious private collection of prints known. Yet even he has ways of winnowing his magnificent collection—he gives prints away on a princely scale—with a first gift in 1943 to the National Gallery in Washington consisting of 6500 impressions. The National Gallery, however, like virtually all other collections both public and private, has found itself disposing of certain prints from time to time. To guarantee the refinement of his gift rather than its dilution, therefore, Rosenwald stipulated that the National Gallery may sell prints "only if they are duplicates or lesser impressions of the same work. I permit them to sell the poorer," he explained, "but always retain the better one."

Even modest collectors parting with a single print are likely to be similarly motivated—their purpose is to upgrade or sharpen the collection. With their varied enthusiasms and interests collectors may decide to concentrate on a particular artist, a movement, a style, a period, a category of subject matter, or they may work toward improving the quality of each proof. For these and other reasons prints constantly appear on the market. Since you, as a collector, will occasionally be selling prints, you will want to learn how to realize the best price for those graphics you dispose of.

Prints for Investment

There are people who buy prints essentially for investment, for whom the enjoyment of graphic art is secondary. In fact, there are certain art investment services in which investors put up money for work they never see because the art is stashed away in vaults awaiting the best market. Two of

these are: Paul G. Dietrich of Jefferson City, Mo., who specializes in buying print portfolios; and Artemis, which holds a general art "portfolio." But this is a kind of buying and selling toward which we are not oriented in this book, although we have included periodicals concerned with art as investment in our list.

Indeed, the collector-for-investment may soon have to share the wealth. Many readers will recall that Robert Rauschenberg was widely reported to have exploded angrily at Robert Scull, after the latter sold a work he had purchased from Rauschenberg ten years before at a gain of $84,100, saying, "I've been working my tail off just for you to make a profit!"

Artists in the United States, spurred by such incidents, have been attempting for some years to have legislation enacted: *Droit de Suite*, or the right to art proceeds, as it is called in France, Italy, and Germany. Such a law would give the artist the right to a portion of any higher subsequent resale price. The argument is that whereas writers and composers can continue to earn income from early works that increase in value, the visual artist, by forfeiting all future interests or reward when the original is sold, is cheated. As recently as January 1975 the *Art Workers News* devoted an entire four-page issue to a proposed model "Artists Reserved Rights Contract." The November 1974 issue, too, is largely concerned with residual rights for artists. The heart of the proposed contract, signed by artist and collector, is the requirement that allows the former to receive "fifteen percent of the excess" on future sales. The agreement is to remain in force "until five years after the death of the artist." In the case of the two Roberts, then, if Scull's profit was $84,100, Rauschenberg's share would have been mandated at $12,615.

All this seems modest enough—copyrights on published works run for twenty-eight years and may be renewed by writers or their estates for a second equal period, and royalties rising to 15% are not uncommon. Even so, the millennium for printmakers and other visual artists is not likely to arrive tomorrow.

Prints as Gifts

The collector who would like to dispose of one or several prints should think about taking a leaf from Rosenwald's book—consider giving prints away. You may have a warm spot for a museum, library, or other institution—a school, college, or university—where you can be assured that the print will be displayed or available for viewing, and where it will be appreciated and preserved. Such a gift may offer the additional satisfaction of the opportunity to help complete or round out a collection—or to initiate a new one. Or you may be able to take the occasion to advance the reputation and widen the audience for a favorite artist, either a contemporary or one whose oeuvre you feel is under-appreciated. You may also,

as most collectors are aware, avail yourself of the added incentive of an income tax deduction.

Gift Tax Deductions

Most commonly, collectors who donate prints to museums and libraries are permitted to take advantage of a 100% tax deduction. If the print you are giving is now worth $1000, you may deduct that amount from your income as stated for tax purposes no matter whether you paid $100 or $500 or $2000. This is true for collectors, not artists, who since 1969 have been permitted to deduct only the cost of materials. The savings in taxes for collectors can be substantial. You may, on the other hand, wish to donate a print to a charitable foundation so that they, in turn, can sell it. In terms of taxes this procedure may be more advantageous than giving the proceeds of a sale to a charity, since normally you would pay a tax on any profit. But in such a case your print will not become part of a collection, and you will have no control over its ultimate home.

The foregoing is an extremely simplified—though workable, if you're not up to anything fancy—outline of income-tax deductions allowed at the present writing. The collector who is considering making a gift of graphic art should ascertain that the museum or charity that is to receive it has tax deductible status. Check the list in the Treasury Department's booklet, "Cumulative List, Organizations Described in Section 170 (C) of the Internal Revenue Code of 1954." Those who use accountants to compute their tax will want to check with them, too, and most collectors thinking about donating prints will learn some of the latest steps by reading the appropriate pages in *What Every Artist and Collector Should Know About the Law* by Scott Hodes (New York: Dutton, 1974), which gives the matter some attention.

Personal Gifts

Another suggestion for giving graphics away, though not a tax deductible one, can work out happily for donor and recipient. When substantial personal gifts are appropriate—weddings of relatives or close friends or their children, a graduation, an important birthday, an anniversary, a housewarming—we often puzzle at length over what to give, only to end up writing a check or buying something that is promptly returned to the store or spends the rest of its life languishing in a dark closet. Yet the more flattering gift, one that can be savored longer than almost anything else, might be a print from your collection. It may cost you no more—even substantially less—than the china or the check, but there's a great chance it will be welcomed more warmly than either of these. You may also be rewarded by the special pleasure, if you are lucky enough to match the picture and the person, of starting someone on the road to print collecting.

One thing is certain: you and your unique offering are sure to be remembered long after the recollection of other gifts has faded away.

Although the several ways suggested of divesting yourself of prints are usable from time to time, most often collectors have to go into the market and sell the prints they want to cull.

Seller Sets Price

The easiest way occurs when a fellow collector notices just that excess impression on the wall, declares "I love it!" and buys the print. Dream on. It happens once in a lifetime, but not more often. And even when it does, your friend's next words will be, "How much do you want?" The price is a decision *you* must make, for the seller must set the price. There is simply no way around this, even if you have no head for business, hate to get involved with money, feel awkward about naming prices—or any of the other excuses you may think up to avoid having to do the research and arrive at a price. Don't delude yourself by thinking, "Well, I'll see how much I'm offered for it." That would be asking for trouble. Consider for a moment. If you ask a dealer, "How much will you give me for . . . ?" you are immediately revealing that you do not know its worth on the current market. Most dealers will refuse your gambit, but some of those who do succumb and make an offer will be sorely tempted to "steal" the print— make an offer seriously below its current market value. This has happened so often to people we know that we repeat once again: The seller names the price.

There is nothing, of course, to prevent a prospective purchaser from making a counter offer, which you may be prepared to consider. But at the outset you are the only one who can announce the site of the ballpark.

Research Print's Value

The first hurdle, then, is to decide what the print is worth on the current market.

Keep Records

If you have followed our suggestions in the preceding chapter, you will have made out a catalog file card for the print when you bought it, with the price you paid, its source, and other pertinent information noted. The best procedure thereafter is to jot down the figure whenever you notice the print's sale price in an auction catalog or see it offered in a dealer's catalog. By keeping such a file up to date you will have a good idea of

the current value of your collection, a source of gratification to those who enjoy seeing their net worth grow. It is also the safest system for insurance purposes, especially when prices are volatile.

Print Library Catalogs

If, however, you are of the temperament that finds record keeping a drag, or you don't really care most of the time what your prints are worth—you just want to sell *this* one for a fair price—you can still find the facts you need by simple research. Look through your collection of catalogs. If it is inadequate to the task, look at our list of print rooms and libraries, find the nearest one that collects priced auction and dealer catalogs, and check for information on the print you want to sell. If you cannot find a recent sale price for that print, you will still have some idea of its range if you find another print by the same artist, especially if it is from the same period, the same medium, and of similar size. If there are auction catalogs available, but no list of prices achieved, use the estimates themselves as a guide. If necessary, and all else fails, write or phone the auction house to find out how much the print fetched.

Auction House Estimate and Appraisals

There are further ways of checking the worth of your print. When you are planning to sell a print at auction you can ask the auction house for an estimate. Their estimate, however, will be based mostly on the same catalogs you would use yourself. You can also ask a reputable dealer for an appraisal, the fee for which is usually about 1½% of its value. Or for a similar fee you can request a member of the Appraisers Association of America, Inc., 541 Lexington Ave., New York, N.Y. 10022, to set a price. Their members, who are self-selected and join by paying a fee, vary in their expertise. You are likely to be best served by selecting one whose specialty is wholly limited to prints.

Yet your own research is often more current and more accurate than any of these. For one thing, such estimates are based solely on auctions, omitting dealer sales entirely. Don't forget, though, that dealer prices are *asking* prices. Until a print is sold, the price the dealer sets in the catalog is not an established one. Once an impression has changed hands at the catalog price, however, that sum is as valid a statement of its current value as any other.

Newsletter

A quarterly "Buy-Sell Newsletter" concerned primarily with art prices is published by the Art Appraisal and Information Service, Art Reference Gallery, Inc., 89 Park St., Montclair, N.J. 07042. Readers will find infor-

mation about the prices of prints as well as those of other art objects in their brief articles and news items. This organization maintains a record of art sale prices, and for a fee, will appraise your print.

Investment Report

The "Art Investment Report," a "confidential biweekly survey designed and edited for the art connoisseur" is a stock-market-style tip sheet operating from an appropriate address: 120 Wall St., New York, N.Y. 10005. They, too, offer price information.

Condition Affects Price

Yet having said all this, we must point out that no two prints are absolutely identical, and the differences affect the sales price. First, the condition of a print affects its value. If yours needs restoration, have the work done. (Names and addresses of restorers are included in Chapter 5, "Preserving Prints.") More often than not you will be well rewarded for your added investment. Even if the print itself required no aid, replace faded or dusty mats and renew weak hinges. When you present an impression in the most attractive way you are enhancing both the print and its value.

Provenance Affects Price

The provenance of a print can raise its worth too. Does yours have a collector's mark, especially one from a respected collection? The reasoning that "if so-and-so thought the print was good or ABC museum thought it worth purchasing then it must be an outstanding impression" is a price levitator. Or perhaps the print's past history can be deduced from a dedication penciled in the margin by the artist to a friend, relative, fellow artist, collector—you name it. Understandably, many collectors are happy to pay a premium for this additional interest. When artists do their own printing the value may be enhanced. Unusual paper can make an impression special too. In fact, anything that makes an impression unique adds to its monetary worth. The more you know about a print the better.

State and Edition Price Factors

The state of a print—whether it is the first, second, or third state (as explained in Chapter 2) as well as the edition of the impression—are factors in the price collectors are prepared to pay. Rare states, by virtue of their rarity, usually command bonus rewards. Late editions, on the other hand, often have a fraction of the value of earlier ones.

Prices Fluctuate

All sorts of other matters, related and unrelated to the print world, cause fluctuations in the value of graphics. In 1973, for instance, when the

American artist of Japanese descent, the late Yasuo Kuniyoshi, was being bought heavily by the then newly prosperous Japanese, prices for all his work jumped enormously. Since then they have leveled downward. The point in this as in many other examples we might mention is that the price variations for Kuniyoshi had little to do with his work and everything to do with affairs extrinsic to it. If you are interested in charting prices of prints as you would stocks, the technique is taught in *Art as an Investment* by Richard H. Rush (Englewood Cliffs, N.J., Prentice-Hall, 1961).

WHERE TO SELL A PRINT

Once you have set a price on your print, the next decision you must make is where to sell it. In order to find the best market with the least possible delay, we suggest a second cardinal rule: Know Your Market. If you are approaching dealers, for instance, there is simply no point in offering a contemporary American to one who specializes in French Impressionists, or a 19th-century etching to a dealer in Old Masters, or popular prints such as Currier and Ives to anyone who sells fine prints only.

Trades and Swaps

It is likely that the market you know best is composed of your fellow collectors. A trade can be a good bet if you each covet something belonging to the other. Although we are not uncomfortable with this method, many people are, and as long as both parties are satisfied, trades can work. Swaps are part of a long tradition, as can be seen by looking through the classified section of any small town newspaper. Yet even as we make that somewhat condescending statement we notice that trading can occur at the loftiest levels, as a recent *New York Times* item reports: "A rare painting by the 17th-century French artist Georges de la Tour has been acquired by Walter Chrysler, Jr., for donation to the Chrysler Museum of Art at Norfolk, Va. Although the museum, in a press release, put the price of the painting at $1.4 million, it has been learned that the work was actually acquired from a private collector through the trade of several paintings in Mr. Chrysler's possession."

Specialized Collections

The more you know about the print proclivities of your fellow collectors, institutional or private, the simpler it will be to focus quickly on your potential market. Subject matter, for example, can be the thematic basis of a collection. Most representational prints can be subsumed under a subject category—Western scenes, English landscapes, sporting events (e.g., Bellows' prizefights), views of cities, images relating to the visual arts (artists,

self-portraits, patrons or dealers in galleries), set pieces involving any of the other arts (musicians, dancers, clowns), and so on.

A collector somewhere concentrates on each of these categories; find the collection that matches your print and it is sold. Do not hesitate to write a letter offering what you have to any public or private collection. At one time we had a lithograph by the contemporary American, Carroll Cloar, called "Brother Hinson's Encounter with Death," that we found hard to live with because of its subject matter, a death-bed scene. We sold it to a dealer in Washington and were surprised and pleased to see it turn up shortly thereafter in the Prints and Photographs Collection of the United States Department of Health, Education and Welfare. The Washington dealer to whom we had sold it clearly knew about that excellent collection which logically centers on pictures relating to health, education, and welfare. On another occasion we sold a print called "No. 1 Wall Street," by Kerr Eby, the American etcher, to a man who used it to decorate his office at No. 1 Wall Street.

Individual Printmakers

In the same way, if you note the point of view of a museum or private collector you may be able to sell your print. Often their aim is to complete a collection of the graphic work of a particular artist or group of artists. If you come up with a missing print, it can be sold in a moment.

Individual artists have their avid collectors. Rockwell Kent, a prolific printmaker, has attracted since his death in 1971 what might almost be called a cult, with an organization of collectors that publishes a newsletter which includes a buy-sell column exclusively for Kent prints and memorabilia. (*The Kent Collector*, George Spector, 34–10 94th St., Apt. 1–B, Jackson Heights, N.Y. 11372.)

On the other hand, although there is no permanent claque cheering for him, the graphic work of such an artist as the American Ivan Albright, who has made few prints, is very much in demand, in part because of its scarcity. There are enough artists and prints of this kind to form a category, and if you wish to dispose of one of them it's worth knowing which artists these are.

Fill in Omissions

Or you may have noted, on visits to collections and from examining catalogs, specific lacunae in a collection—be they of a style or historical era. You may be able to fill the gap with your print simply by writing a letter offering it. Sometimes collectors search out all the existing states of a print they are interested in, or they hope to find all the material related to it or supportive of it. We sold "Two Boys on the Beach No. 2" by Paul Cadmus to the University of Vermont. Their art gallery wanted it, we found, be-

cause they had already been the pleased recipients of the drawing from which the print evolved.

Sell Through Dealers

You may find, however, that the print you want to sell does not fit into any of these many special niches. In that case you may decide to sell through a reliable dealer.

Two Kinds of Dealers

You can work with one of two types and in one of two ways. Some of those who deal in prints have galleries where at least a portion of their clientele just walks in and buys from the walls or the bins. Such public galleries, when they are active, can normally sell a print more quickly than can the many dealers who do business through the mails. Dealers for whom the catalog is the principal means of offering graphics must wait for photographs taken and a brochure printed, addressed, and mailed before the first prospective customer is aware that the print is being offered for sale. Furthermore, such catalogs may be prepared and mailed at intervals of two, three, four, or six months, with an inevitable built-in delay. Yet catalogs often reach a far wider range of collectors than some of the busiest street-level galleries.

Selling Outright

Whichever type of dealer you decide to do business with, you have a second choice to make: sell outright or sell on consignment. If you sell outright you will be paid promptly and have no further responsibility for the print. Lest you stop reading here because the choice seems so obvious, let us warn immediately that you will get less money for your print with this arrangement. Naive collectors sometimes expect dealers to pay them the retail value of a print or close to it, but the fact is that they cannot, no matter how valued you are as a client. Dealer profit lies in the difference in price between wholesale and retail. When dealers invest their own money in your print by buying it outright, their usual practice is to pay from 50 percent to 70 percent of the retail value. But there is no doubt that selling outright to a dealer is the easiest, simplest, speediest method available to collectors for divesting themselves of prints.

If you decide to sell on consignment, you can realize a higher return. Sometimes a dealer selling for you on consignment will charge as little as 10% for turning a print over. But you will wait longer for your money.

Selling on Consignment

Your first step in selling on consignment is to come to an agreement with the dealer as to what both of you consider a fair price. Agree to the

percentage you pay the dealer for selling your print. Discuss and agree to the manner in which a reduction in the price affects your net. (We are not hinting at dickering, merely to the traditional dealer practice of allowing museums and other dealers a 10% discount.) Agree to the length of time you will wait for the print to be sold, after which it will be returned to you. Make certain of the insurance arrangements. When you are selling on consignment to a gallery dealer, the print is physically out of your hands and must be insured. When you are selling on consignment through a catalog dealer, you usually retain physical possession of the print after photographs, if any, have been taken.

You are morally bound, when you enter into a consignment agreement, not to sell the print by yourself during a specified period, usually two or three months, since the dealer will have gone to certain expense on your account. Whichever of the two kinds of dealer you decide on to sell on consignment for you, make certain that your print will not be released from the dealer to the purchaser until the dealer has been paid in full.

Written Agreement

Each item in the preceding paragraph should be agreed to in writing. Make certain that you have a valid receipt for your property. When you can, work with an experienced dealer whose reputation backs up the written agreement. Do nothing in "good faith." It is not businesslike and it is not necessary. If your dealer does not have a standard receipt form that embodies the recommendations outlined, then make your own, modeled on the sample that follows. Keep a copy for yourself and give a copy to the dealer.

AUCTIONS

The other major way of selling graphics is via auction. So many collectors are aware of this today that at Sotheby Parke Bernet in New York about half the print consignments come from private individuals, the other half from dealers. The price your print achieves at auction may be higher than that which a dealer can offer you, but there are risks and delays, as we'll explain, and there are also costs.

Commission

In the United States and England the seller pays the auctioneer a commission on the sale price, whereas both the buyer and seller pay at the important Kornfeld and Klipstein auctions in Switzerland, although K&K prefer to buy prints outright for their annual auction. In most other countries it is the buyer who pays the commission, at rates noted in Chapter 3, "Buying a Print."

Your name
Your address

September 10, 1976

Consigned to: Mason Fine Prints
Quaker Ridge Drive
Glen Head, N.Y. 11545

Wood, Grant

"January"

Lithograph, 1938

Signed in pencil by the artist

Edition: 250

9″ by 11¾″

Selling price:	$725.
20% Commission:	155.
Net to Owner:	$570.

Payment in full or return of print due 90 days from above
date

Dealer's Signature

Minimum Consignments

All auction houses set a minimum sum on the valuation of print consignments they will accept. The amount is $500 at SPB in New York at the current writing, although the total sum may be made up by several prints, and the minimum commission on an individual lot is $35. In addition, sellers in all cases pay the cost of packing and shipping their prints *to* the auction, although the buyer is responsible for these once the print has been sold.

Insurance

Insurance costs from the home of the seller to the place of auction are also paid by the consignor, as are any premiums that are to be paid on insurance at the auction house itself. Owners with fine arts insurance policies may not need to take the additional coverage necessary for those with only the usual homeowners' policies.

Locale of Auction

Not every auction house will do equally well for every print. Each house has its own market and its own clientele, although the print market is truly international, with dealers traveling all over the world for prints that inter-

est them. It is for this reason that international auction schedules are arranged so that no one auction conflicts with another. Even so there is a better market, say, for German Expressionists at the Munich houses than there is in New York, or for English sporting prints in London than in Los Angeles, and the prices achieved attest to the greater appreciation.

Major and Minor Sales

Similar reasoning has led SPB New York to divide its five annual auctions among major and minor sales. They find that prints selling for one or two hundred dollars slow the pace of the major auctions, that the buyers of prints selling for thousands of dollars are consistently uninterested in those of much lower price. The pace at print auctions is swift, with 150 lots changing hands at two-hour SPB sessions. If you (or your letter describing them) arrive at SPB with one or two prints of small value that you wish to dispose of, they may direct you to PB84, which sells lower priced lots. The risk at PB84, because they sell estates with their necessarily miscellaneous merchandise, is that the prints may not attract knowledgeable bidders. Yet according to Ruth Ziegler, of the SPB print department, good prints buried under stacks of dross usually find a respectable market. She pointed out, however, that at estate auctions especially people buy visually—that is, for decorative value, and the framed, attractive print is most likely to do well.

Estimates

If you decide on one of the American auction houses you can write or telephone the information about your print: tell them the name of the artist, the signature, title, medium, size, condition, and ask for the date of the next auction for which your print will be eligible. Ask for an estimate. This may turn out to be an estimate of an estimate, since your print will be carefully examined before a final estimate is decided upon. The only exception occurs with framed, inexpensive prints (those selling for less than $100 or so) which might not be removed from the frame and may be sold "as is."

If you decide that one of the European houses is suitable, the procedure is the same, except that you would be unlikely to telephone. If the response to your letter of inquiry is agreeable to you, you will have to mail your print directly; at times, however, a representative arrives in New York and will accept delivery of your print.

Conditions of Sale

Whatever auction house you select, you will in every case receive with the estimate a receipt and a copy of the Conditions of Sale—a written statement of the terms of your contract with the auctioneer. These include the

percentage of payment required and from whom; the waiting time for money due you; the grace interval during which you may withdraw a print; the dates when your print should arrive—all the responsibilities and liabilities are spelled out.

Auction Delays

There are built-in delays in selling at auction. First of all, your print must arrive well ahead of the sale. At SPB New York the print must arrive two months before the sale—a few of the reasons being that the house must allow four weeks for the catalog to be printed, time for its mailing to go out to subscribers, and a week for an exhibition prior to the sale. Even if your timing is perfect, and you decide early enough in December to sell at the February auction, you will not be paid the moment the sale ends, since for various reasons they may have to delay sending a check for up to a maximum of 35 days.

More likely your timing won't be perfect, and the print you decide to sell in June has to wait for the November auction, a wait of six months before the sale, plus a month thereafter for payment. Or you may decide early enough, only to find that the auction house is accepting no more prints because they have too many lots already. Or they may accept your print only to change their minds when they discover they have another impression of the same print scheduled for the same sale. Since SPB believes that duplication often reduces price potential, they may in this case ask you to postpone selling till the next auction. In all, you should probably estimate a minimum of three months and a maximum of six between the time you decide to sell a print and the moment you have the cash in hand.

Should you decide to withdraw your print from sale, however, better decide early on that, too. Generally two months in advance of the sale is required; thereafter you would be liable for the commission even if you decide to keep the print (or find another buyer on your own).

Positive Descriptions

One of your responsibilities, when you deliver the print, is a written description. As with all sales of graphics (or of anything else, for that matter), the more positive information you can provide, the better appreciated your print will be. Whatever you know about the provenance is valid and valuable (a matter that encourages us to cite our suggestions once again for maintaining a running record as outlined in "Cataloging a Collection"). If you have studied auctionese, you have noticed that whenever possible the facts are stated either in positive form or in such a way that they sound minimally threatening. "Third state" will be transformed into "third and final state"; "damage to paper" may become "small tear in margin outside

image"; "trial proof" is invariably followed by "rare"—usually a tautology, but one that makes things sound better.

Framed or Unframed?

Your print will of course be examined by experts before being listed and finally estimated, but the phrases you use—if they are accurate—are likely to be retained. Framed prints, as we have said, will almost always be removed from the frame for examination, but then they will be returned to the frame for exhibition before the sale. Whether to send a print framed or unframed is a moot point. According to Ms. Ziegler, framing means not a particle of difference in the sale price of Old Masters, but it can affect other prices, especially those of contemporary prints. She pointed out that very large modern prints, particularly those priced under a few hundred dollars, can be costly to frame, and buyers seem ready to pay something extra not to have the bother or expense. Even with modern masters, such as Picasso or Braque, she said, frames might put the selling price up a hundred dollars or two on a print valued at a thousand or two. This is not solely because the cost of framing is a factor but because buyers are attracted to a handsome image well set-off on the wall, and they can even be tempted, by an attractive picture in a frame, into bidding on a print that interested them not at all when they were reading the catalog at home.

No doubt, too, frames protect prints during the handling they are subjected to as they make their way from your collection through the mails to the auction house, where they will first be examined, then displayed, then have their moment on the easel on the dais the day of sale, and then are repacked and mailed to the new owners. Yet glass is very much more difficult to package safely than a matted print, unless you deliver by hand. Furthermore, if you have standardized your mat sizes as we suggested earlier, you can re-use every frame with ease. We believe, too, that serious collectors always go through the unframed prints carefully at auctions, and they always discover the choicest morsels tucked away in an unprepossessing stack of paper. The decision, then, is up to you, and perhaps can be made individually each time you prepare to sell at auction.

Auction Estimates

The auction house will arrive at its final estimate in a manner very similar to that described earlier except that auction estimates are based almost entirely on prices achieved at other auctions in every part of the world. Although auctioneers are very much aware of dealer prices, those sales do not normally enter into their figuring. According to Ms. Ziegler, dealer prices are about 40% higher than auction prices, and it takes the latter "a few years to catch up with the retail market." These percentages and time spans are not entirely true to our experience but they do represent the way

things frequently turn out. For the collector who now asks, "But why should I ever buy from a dealer if auction prices are so much lower?" we have a ready answer. At a reliable dealer you can find the exact print you want by the artist you are looking for; it will be in good condition; there will be no question as to its authenticity and provenance; you will have a wide range of selection from well-selected stock; you will not have to arrive in a particular place at a particular time as you do at auction, nor will you have to waste hours sifting through prints that hold no interest for you. Dealers earn their mark-up because they have invested in stock, paid the overhead for running their establishments, and have the expertise that is a guarantee to the customer. Furthermore, although the preceding remarks apply to both old and new prints, a great many prints by living print-makers rarely, if ever, come up at auction.

Speculating

Can you make a killing by selling at auction? Possibly you have the same chance there as you do in the stock market, real estate, or anything else you choose to speculate in, and your success or failure depends on some of the same factors—your luck, expertise, daring. During one period of a few years auction prices doubled on Old Master sales at SPB. On contemporaries it is unlikely to make a noticeable profit in less than ten years—and this year's hotshot may be forgotten before the decade is over. Or you may choose the wrong contemporaries. Yet the Carter Burden collection, which consisted mainly of prints published by Gemini, some of them only a couple of years old at the time of sale, realized handsome profits for the owner. For one thing, Burden had been a subscriber to Gemini, which means he purchased his prints at a discount and owned some that were coveted and printed in small editions. It's hardly likely that any of these profitable auction sales could have been forecast even five years ahead, or that Burden or the buyers of the Old Masters were speculating on quick, highly profitable turnover. Prints as investment—yes; as speculation—be careful.

Auction Bargains

Can you get a bargain at auction? Sometimes. At prestigious print auctions the bargain is rarely found because the crowd is in a depressed mood and bidding slowly, or the sale poorly attended, or any of the other sorts of things that can affect estate auctions, country auctions, and the like. You can find a bargain, however, if the reserve price has been set low or there is no reserve price at all. (Reserves are explained in Chapter 3, "Buying a Print." They represent a percentage of the estimate, a sum beneath which the seller will not part with the print. At this writing reserves are not announced in the catalog—neither the dollar amount nor the fact that a

reserve has or has not been set, but since from time to time there is agitation on this matter, the rules controlling reserves are subject to change.) This can and does happen—a print coming up without a reserve—when a seller wants to get rid of it quickly rather than for the best price, and surprisingly low bids have more than once won the prize.

Price Manipulation

But can you do anything about it if you see your print lagging along slowly, not reaching the estimate? Can you bid up your own print? It's illegal. You are not permitted by law to buy-in your own property at auction. But everyone has a friend. Dealers have been known to maintain the price of prints by artists whose work they stock by bidding them up to the estimate either directly or by proxy. Since the price achieved becomes part of the record and their stock could be reduced a quarter, a third, a half in value—by whatever percentage the sale price fails to reach the estimate—their incentive for supporting a sale price is strong. The best protection you as seller have at auction is the reserve price agreed upon by you and the auction house. You may do better than the reserve, but you cannot do worse. If the auction house must buy-in for you at the reserve price, you will pay only a small percentage as agreed upon in the Conditions of Sale and your print will be returned to you.

Can the price of prints at auction be manipulated downward? Inevitably it is possible for two or more individuals to agree not to bid against each other on lots that both want. They may agree to divide and share after the sale. This is what is known as a ring, and it is illegal—but very difficult to prove. It is a case where both want the print, but don't want to pay the price. What frustrates such efforts more often than not is the collector—or two or three, like you—who comes along and bids the print up and away from those attempting to keep it for themselves at a low price. As a buyer, such rings are no threat to you—your course is to bid what you think a fair price based on research no matter who tries to manipulate it up or down. As a seller your best course is to select the auction and auction house most compatible with your print, set a reserve you can live with, and relax. You can't really lose if you are still with us this far along.

<div align="center">OTHER SALE CHANNELS</div>

Advertise

Collectors who choose not to sell through dealers or auctions and have not located a collection to which they can sell directly may opt for advertising their prints. The classified columns of major city newspapers, especially those which carry art columns, are an obvious choice. Not so obvious, though frequently more effective, are business, professional, and organiza-

tional journals. Such space is often free or the charge is nominal. Other good bets sometimes overlooked are the college bulletin, the house organ, the club newspaper, and specialized periodicals—such as those for antiques. You'll soon learn not to scatter your shot, for results will narrow trial and error the next time around.

Native Sons

One last spur to sales. Favorite sons and daughters, as well as local-boys-who-make-good continue to this day to have appeal. This response can hold true for an artist long dead as well as for a newcomer just surfacing. We were once astonished to see a minor Samuel Palmer print that we had bought in this country for $40 sell almost simultaneously at an English auction for several hundred. We would no longer be surprised, for Palmer was English, and far better known and admired in Britain than here. American artists command better prices in the United States, Canadians in Canada, the English in England, the French in France, and the Italians in Italy. One could go on. Many print lovers, in fact, may not even have heard the names of excellent favorites outside their own national boundaries. When you are traveling, then, the trick would be to bring along prints by *their* natives you would like to dispose of and bring back home prints originating in your country that nobody elsewhere appreciates.

What is true for nations is also true for cities and states within the United States and within many other countries as well. If you own a print that includes the Golden Gate Bridge and you want to sell, by all means take it with you to San Francisco, and if you expect to visit the Midwest, bring along your excess Regionalists.

Capital Gains Tax on Profit

Once your print is sold for more than you originally paid, you are liable for a tax on the profit. Fortunately for collectors, you pay a capital gains tax only, since your print was not purchased primarily as an investment. This is the ruling if you have owned the print for six months or more, you are not a dealer, and the sale was not made in the ordinary course of business. If you bought your print, for example, for $200 and sold it a few years later for $1000, your profit would have been $800, less whatever your selling costs were. You are liable for additional income tax on only 50 percent of your profit, in this case, $400—if you had no expenses in selling. The matter of tax liability, too, is one of the factors collectors need to weigh when they make decisions about how or whether to sell, retain, or give away prints from their collections.

LABOUREUR, JEAN-ÉMILE (1877–1943) *Les Amateurs d'Estampes*
Etching. 1925. Ref: Godefroy 319. 3″ x 4¼″. Courtesy of Mason Fine Prints.

Art is a human activity having for its purpose the transmission to others of the highest and best feelings to which men have risen.
Count Leo Tolstoi, *What Is Art*, 1896.

9. *Seeing Prints: Museums, Print Clubs, Print Dealers*

INTERNATIONAL MUSEUM LIST

We are proud of the following annotated list of prints in public collections. In order to compile it we sent close to 600 questionnaires to selected museums throughout the world. After examining their answers to our survey, we culled the entries to those collections with the most validity for print connoisseurs. To our knowledge no similar compendium of this print information has existed heretofore.

Unlike painting or sculpture collections, where a large portion of an institution's holdings are regularly kept on view, most print collections are submerged like the proverbial iceberg in Solander boxes and storage cabinets. To see the prints you must have some idea what is comprised in a given collection.

Our entries are annotated with as full information as the responses to our survey allow. Many of these were a delight to read and deserve more extensive quotation than we have space to give them. We have deliberately omitted the days and hours when collections are open because these often change, and the schedules of print rooms are frequently different from those of the parent museum. In addition, we think you should always write or telephone ahead for an appointment to see prints in a collection, even to those few print rooms that do not make advance notice mandatory.

Before you request an appointment decide what prints you want to see. Although most collections are open to any member of the public with a legitimate interest in seeing prints—by no means do you have to be a recognized scholar or connected with a museum or university—few are staffed sufficiently to accommodate idle browsers. We hope that the information

in the next pages will allow you to know what is accessible where, enabling you to study the works you want and need to become familiar with at first hand.

Alabama **Birmingham**
Birmingham Museum of Art, 2000 8th Ave. North, 35203.
 Tel: (205) 259-2565
Collection: 400 prints—all periods; Old Master; modern;
 Japanese
Library: 4,000 volumes

Arizona **Flagstaff**
Northern Arizona Art University Gallery, Box 5801, 86001.
 Tel: (602) 526-3471
Collection: 157 Old Master to contemporary prints—19th-
 century English and French; German Expressionist;
 Spanish Surrealist
Library: 2,000 volumes in another building
Phoenix
Phoenix Art Museum, 1625 N. Central Ave., 85004. Tel:
 (602) 258-6164
Collection: 1,700 prints—encyclopedic collection; German
 Expressionist; 20th century
Library: 3,000 volumes
Tempe
University Art Collections, Matthews Center, Arizona
 State University, 85281. Tel: (602) 965-2874
Collection: 1,028 prints—Old Master through 19th-cen-
 tury European; 19th and 20th-century American
Library: Print reference books housed in the university
 library

Arkansas **Little Rock**
The Arkansas Arts Center, MacArthur Park, 72203. Tel:
 (501) 376-3671
Collection: 200 Old Master to contemporary prints; some
 Oriental prints
Library: 5,500 volumes

California **Berkeley**
University Art Museum, University of California, 94720.
 Tel: (415) 642-1395

Collection: 1,000 prints—all periods; 19th and 20th century; large collection of Japanese woodblock prints

Library: General art reference library

Davis

The Permanent Collection of the Department of Art, University of California, 95616. Tel: (916) 752-0105

Collection: 1,000 prints—15th through the 20th centuries, European and American

Library: 1,750 volumes

La Jolla

La Jolla Museum of Contemporary Art, 700 Prospect, 92034. Tel: (714) 454-0183

Collection: 1,500 prints—Contemporary American and European; Tamarind Workshop lithographs; Gemini Workshop lithographs; some contemporary Oriental

Library: General art reference library

Long Beach

California State University—Print Room, 6101 E. Seventh St., 90801. Tel: (213) 498-4023

Collection: 500 prints—Old Master; 19th-century French; American; Japanese Ukiyo-e

Library: University library

Los Angeles

Grunwald Center for the Graphic Arts, University of California, 405 Hilgard Ave., 90024. Tel: (213) 825-3783

Collection: 25,000 prints—15th century to the present; German Expressionist; Japanese woodblock; complete oeuvre of Tamarind Lithography Workshop; comprehensive holdings of Picasso, Matisse, Rouault, Renoir

Library: Extensive general art reference library

Los Angeles County Museum of Art, 5905 Wilshire Blvd., 90036. Tel: (213) 937-4250

Collection: General collection—15th century to the present; Dürer; 16th and 17th-century Dutch and Flemish; Rembrandt; German Expressionist; American modern and contemporary prints

Library: 50,000 volumes

Los Angeles Municipal Art Gallery, 4804 Hollywood Blvd., 90027. Tel: (213) 660-2200

Collection: 300 to 400 prints—mostly 19th-century Japanese

Library: General art reference library

Los Angeles Public Library, 630 W. 5th St., 90017. Tel: (213) 626-7555

Collection: Prints by California artists of the 1920s, 1930s, 1940s; Japanese prints

Library: General art reference

Monterey

Monterey Peninsula Museum of Art—Armin Hansen Room, 599 Pacific St., 93940. Tel: (408) 372-5477

Collection: 150 prints—mostly 20th century; Armin Hansen; J. Walter Tittle; regional artists; some English and some 18th-century and 20th-century Japanese

Library: 450 volumes

Oakland

Oakland Museum—Oakes Gallery, 10th and Fallon Sts., 94607. Tel: (415) 273-3931

Collection: Focuses on the art of California: California artists, or works of art concerning themselves with California, of the 19th and 20th centuries

Library: 2,000 volumes

Sacramento

E. B. Crocker Art Gallery, 216 O St., 95814. Tel: (916) 446-4677

Collection: 300 prints—17th through 20th-century American; 19th-century English; Western European; Oriental

Library: 1,100 volumes

San Diego

Fine Arts Gallery of San Diego, P.O. Box 2107, Balboa Park, 92112. Tel: (714) 232-7931

Collection: 2,000 prints—15th-century German; early to late Japanese woodblocks; 20th-century American; Tamarind lithographs

Library: 7,500 volumes housed in another building

San Francisco

Achenbach Foundation for the Graphic Arts, California Palace of the Legion of Honor, Lincoln Park, 94121. Tel: (415) 558-2881

Collection: 100,000 prints and 2,000 drawings—European, American, and Oriental dating from 1500 A.D. to the present; German Old Master; German Expressionist; Japanese Ukiyo-e, and Japanese contemporary

Library: 3,500 volumes limited to prints and drawings

Archives of American Art, Smithsonian Institution, West

Coast Area Office, M. H. De Young Memorial Museum, Golden Gate Park, 94121. Tel: (415) 668-1880

Collection: Research collection of documentary material on American art, either in original manuscript or printed form or microfilm (5,000 rolls, containing five million items). Covers American painters, sculptors, printmakers; art collectors; dealers; critics and historians; museums, societies and institutions

San Francisco Museum of Art—Moses Lasky Graphics Room, McAllister St. at Van Ness Ave., 94102. Tel: (415) 863-8800

Collection: 1,400 prints—late 19th century and 20th century, European, North and South American; good Matisse representation; German Expressionist; American printmaking of the 1930s; European Expressionist

Library: General art reference library includes 4,000 monographs, 40,000 exhibition catalogs

San Marino

Henry E. Huntington Library and Art Gallery, 1151 Oxford Rd., 91108. Tel: (213) 792-6141

Collection: 500 prints—European 15th to 19th centuries; Rembrandt: 18th to 20th-century English, including 18th century mezzotints; American prints from Colonial period to Revolutionary War period; Civil War period; California prints from Gold Rush to c. 1900

Library: Private research library

Santa Barbara

Ala Story Graphic Arts Gallery, University of California, 93106. Tel: (805) 961-2951

Collection: 950 prints—late 15th-century European to mid-20th-century European, Japanese, and American

Library: 50,000 volume Arts Library is a branch of the University of California at Santa Barbara Library, and is housed in a separate building

Santa Barbara Museum of Art, Print Room, 1130 State St., 93101. Tel: (805) 963-4364

Collection: 2,000 prints—various periods, European and American

Library: General art reference

Santa Clara

de Saisset Art Gallery and Museum, University of Santa Clara, 95053. Tel: (408) 984-4528

Collection: 300 prints—17th and 18th-century European; Engelbrecht; Bertolocci; Jakob Steinhardt; Grégoire Huret

Library: General art reference housed in university library

Stanford

Stanford University Museum of Art—Print and Drawing Study Room, Stanford University, 94301. Tel: (415) 497-4177

Collection: 2,500 prints from Schongauer to present—late 18th, early 19th-century French and English

Library: Library housed in separate building

Colorado **Denver**

Denver Art Museum, 100 W. 14th Ave., Parkway, 80204. Tel: (303) 297-5114

Collection: 350 prints—17th century (Callot); 19th-century and early 20th-century French (Rouault, Braque, Matisse); 20th century (Picasso, Lars Bo, Archipenko, Matta)

Library: 200 volume departmental library

Connecticut **Farmington**

Hill-Stead Museum, 671 Farmington Ave., 06032. Tel: (203) 677-9064

Collection: 100 prints—Dürer; Piranesi; 18th-century English engravings; Meryon; Whistler; Japanese prints

Hartford

Wadsworth Atheneum, 25 Atheneum Sq. N., 06103. Tel: (203) 278-2670

Collection: About 4,000 to 6,000 prints—Wickes Collection of 18th-century French portraits; Gay Collection of European prints—primarily 19th-century French; some contemporary prints; Morse Collection of 50 Japanese prints

Library: 10,000 volumes

Middletown

Davison Art Center—Wesleyan University, 301 High St., 06457. Tel: (203) 347-9411, ext. 401

Collection: 10,000 prints—covers the entire field of printmaking: strongest in Old Master and 19th-century European prints; particularly strong in Goya, J. F. Millet, Manet, Joseph Pennell, and the 16th-century Northern Mannerists

Library: Print reference library

New Britain

The New Britain Museum of American Art, 56 Lexington St., 06052. Tel: (203) 229-0257

Collection: 400 prints by American artists—Milton Avery, Thomas Hart Benton, Arthur B. Davies, Lauren Ford, Gordon Grant, Sante Graziani, Childe Hassam, Arthur Heintzelman, Eugene Higgins, Max Kahn, Philip Kappel, Corita Kent, Clare Leighton, Luigi Lucioni, Reginald Marsh, Thomas Nason, Louis Orr, Philip Pearlstein, Joseph Pennell, Abraham Rattner, Ben Shahn, John Sloan, Stow Wengenroth, Grant Wood

Library: Reference works on American art

New Haven

Yale University Art Gallery, 1111 Chapel St., 06520. Tel: (203) 432-4055

Collection: 20,000 prints—Dutch and German prints of late 15th to 17th centuries; Japanese prints of the 18th and early 19th centuries; French prints of the 19th and early 20th centuries; German Expressionist; American prints from 18th century to the present

Library: In print room

Storrs

The William Benton Museum of Art, The University of Connecticut, 06268. Tel: (203) 486-4520

Collection: 400 prints, 16th to 20th centuries—German prints 1880 to 1920; Walter Landauer Collection of 104 Käthe Kollwitz prints, all series complete

Library: 50 volumes, limited to prints

Wilmington *Delaware*

Delaware Art Museum, 2301 Kentmere Pkwy., 19806. Tel: (302) 655-6288

Collection: 1,500 prints—19th and 20th-century American; complete set of all of John Sloan's graphic work; complete uncut first folio of Audubon's *Birds of America*

Library: 20,000 volumes

Winterthur

The Henry Francis du Pont Winterthur Museum, Winterthur, 19735. Tel: (302) 656-8591

Collection: Mainly American prints before 1900—period of colonization; the republic to 1840; British mezzotints

Library: 40,000 volumes on American decorative arts

Washington

Archives of American Art, Smithsonian Institution, Archives Center, Eighth and G Sts., N.W. 20560. Tel: (202) 381-6174

Collection: Research collection of documentary material on American art, either in original manuscript or printed form or microfilm (5,000 rolls, containing five million items). Covers American painters, sculptors, printmakers; art collectors; dealers; critics and historians; museums, societies, and institutions.

The Corcoran Gallery of Art, 17th St. and New York Ave., N.W. 20006. Tel: (202) 638-3211

Collection: 3,000 prints—some Old Master European prints; 18th century to contemporary American prints

Library: Art reference library concentrated principally on American art of all media

Freer Gallery of Art, 12th St. and Jefferson Drive, S.W., 20560. Tel: (202) 381-5332

Collection: Comprehensive collection of prints by James McNeill Whistler; several hundred Japanese prints

Library: General art reference library relating to cultural and historical background of collection; extensive files on Whistler—catalogs, articles from newspapers and magazines, 270 Whistler letters, books related to Japanese prints

Library of Congress—Prints and Photographs Division, 2nd St. at Independence, S.E., 20540. Tel: (202) 426-5836

Collection: 65,000 prints covering all periods and all countries; Rembrandt; 15th to 20th-century European; Oriental; American prints, popular prints, posters; self-portraits

Library: General art reference housed in Library of Congress

National Collection of Fine Arts, Smithsonian Institution, 8th and G Sts., N.W., 20560. Tel: (202) 381-5984

Collection: 6,000 18th to 20th-century American prints—strong in New Deal Art Projects and 20th-century American

Library: 16,000 volumes pertaining to American art

National Gallery of Art—Department of Graphic Arts, 6th

St. and Constitution Ave., N.W., 20565. Tel: (202) 737-4215

Collection: 50,000 prints—15th through 20th centuries, European and American; Old Master (Rembrandt, etc.); 15th-century German woodcuts and German and Italian engravings; 16th-century German and Dutch; 17th-century Dutch and French; 18th-century English, French and Italian; 19th-century French; Whistler; 20th-century School of Paris

Library: 60,000 volumes

Comment: The Rosenwald Collection of the National Gallery is presently at the Alverthorpe Gallery

Smithsonian Institution—Division of Graphic Arts, National Museum of History and Technology, 20560. Tel: (202) 381-5480

Collection: 20,000 etchings, engravings, and lithographs—European and American artists from the 16th century to the present, collected with regard to the history of printing techniques

Library: 1,000 volumes partially housed in same building

Comment: The 45,000 prints in the Division of Graphic Arts include 25,000 photomechanical reproductions which date from 1850 and which document the history of photomechanical printing techniques.

Coral Gables *Florida*

Lowe Art Museum, University of Miami, 1301 Miller Dr., 33146. Tel: (305) 284-3535

Collection: 3,000 prints—Old Master; English; French; German; American contemporary

Library: 3,000 volumes

St. Petersburg

Museum of Fine Arts, 255 Beach Drive North, 33701. Tel: (813) 896-2667

Collection: 300 prints and photographs; Old Master (Rembrandt, Dürer, Goltzius); 18th-century mezzotints; 19th-century Japanese prints; 20th-century American prints

Library: 4,000 volumes

Tampa

University Galleries, Florida Center for the Arts, University of South Florida, 4202 E. Fowler Ave., 33620. Tel: (813) 974-2375

Collection: 660 prints—from 1900 to contemporary European and American (Kollwitz to Rauschenberg)
Library: 16,550 volumes

Georgia **Athens**
Georgia Museum of Art, The University of Georgia, Jackson St., 30602. Tel: (404) 542-3254
Collection: 2,000 prints from all periods and nationalities —Old Master; American; European; some Japanese
Library: University library art reference division, housed in separate buildings
Atlanta
The High Museum of Art, Ralph K. Uhry Print Room, 1280 Peachtree St., N.E., 30309. Tel: (404) 892-3600
Collection: 800 prints—early European and late 16th to 18th centuries; French and American, 1860s to 1920s
Library: 5,000 volumes
Savannah
Telfair Academy of Arts and Sciences, Print Gallery, 121 Barnard St., 31401. Tel: (912) 232-1177
Collection: 360 prints, 15th century to the present—English, German, Italian, Spanish; American; Hogarth collection
Library: 2,000 volumes

Hawaii **Honolulu**
Honolulu Academy of Arts, Graphic Art Center, 900 South Beretania St., 96814. Tel: (808) 538-3693
Collection: 12,000 prints—15th century through contemporary—European and American
Library: 300 volumes print reference

Idaho **Boise**
Boise Gallery of Art, Box 1505, Julia Davis Park, 83701. Tel: (208) 345-8330
Collection: 100 varied prints
Library: 1,000 volumes

Illinois **Carbondale**
University Galleries, Southern Illinois University, 62901. Tel: (618) 453-3493
Collection: 300 prints in general collection, mostly contemporary American
Library: Print reference books are part of general university library, housed in separate building

Champaign

Krannert Art Museum, 500 Peabody Drive, University of Illinois, 61820. Tel: (217) 338-1860

Collection: 1,000 prints—20th-century American and various other periods

Library: General art reference library is part of large university library

Chicago

Art Institute of Chicago, Department of Prints and Drawings, Michigan Ave. at Adams St., 60603. Tel: (312) 443-3600

Collection: Illustrates the history of printmaking from the 15th century to the present with important examples in all periods; Gauguin; Redon; Toulouse-Lautrec; Millet; Degas; Whistler; Meryon; Daumier; Klee; Corinth; Picasso

Library: 91,000 volumes

Comment: A description of the reconstruction of the Department of Prints and Drawings, written by Mr. Joachim, can be found in the *Print Collector's Newsletter*, V, 1 (March/April 1974).

Peoria

Lakeview Center for the Arts and Sciences, 1125 W. Lake Ave., 61614. Tel: (309) 685-4028

Collection: About 100 prints—20th-century American and a few 19th-century European

Library: 5,000 volumes

Anderson

Indiana

Alford House, Anderson Fine Arts Center, 226 West Historical Eighth St., 46016. Tel: (317) 649-1248

Collection: 75 prints by contemporary Midwestern printmakers

Library: 200 volumes

Bloomington

Indiana University Art Museum, 47401. Tel: (812) 337-5445 or 337-4833

Collection: 1,000 prints—Dürer; Italian Renaissance; Northern Renaissance; late 19th-century European; early 20th-century European; major holdings in Japanese prints

Library: General art reference library is part of Fine Arts Department

Muncie

Art Gallery, Ball State University, 47306. Tel: (317) 285-5242

Collection: 600 prints—19th and 20th-century American and European; about 35 range from the 15th to the 18th centuries

South Bend

Art Gallery, University of Notre Dame, 46556. Tel: (219) 283-7361 and 283-6261

Collection: 2,000 prints—15th through 20th centuries

Library: 5,000 volumes

Iowa

Davenport

Davenport Municipal Art Gallery, 1737 West Twelfth St., 52804. Tel: (319) 326-7804

Collection: 700 prints—Japanese, European, and American—15th to 20th centuries but predominantly 19th-century American and 19th-century Expressionist

Library: 5,000 volumes

Des Moines

Des Moines Art Center, Greenwood Park, 50312. Tel: (515) 277-4405

Collection: 700 prints—15th to 20th centuries: Austrian; Flemish; Spanish; Bohemian; Swiss; Belgian; Swedish; Scottish; Russian; Mexican; Canadian; Japanese; American; German Expressionist; Dutch 17th century; Italian 17th-18th centuries; English 19th century; French 19th-20th centuries

Library: 6,000 volumes

Fort Dodge

Blanden Art Gallery, 920 3rd Ave. South, 50501. Tel: (515) 573-2316

Collection: 75 prints—European and American 19th and 20th century; Japanese Ukiyo-e and 20th century

Library: 625 volumes

Iowa City

University of Iowa Museum of Art, Riverside Drive, 52242. Tel: (319) 353-3266

Collection: 1,000 prints—19th-century French and Spanish (principally Goya); 13th-century European; 20th-century American; some Japanese 19th century

Library: General art reference housed in separate building

Mason City

Charles H. MacNider Museum, 303 Second St., S.E., 50401. Tel: (515) 423-9563

Collection: 25 prints—American 20th century

Library: 500 volumes of reference on American art

Lindsborg *Kansas*

Birger Sandzen Memorial Gallery, P.O. Box 348, 67456. Tel: (913) 227-2220

Collection: 200 prints including Sandzen lithographs, woodcuts, drypoints and a small group of 15th, 16th and 17th-century engravings

Library: 200 volumes

Wichita

Wichita Art Museum, 619 Stackman Drive, 67203. Tel: (316) 264-0324

Collection: 260 Old Master through 19th-century English and continental prints

Library: 1,200 volumes

Berea *Kentucky*

Berea College—Art Department, 40403. Tel: (606) 986-9341, ext. 292

Collection: 1,000 prints—Old Master, French 19th century; American to 1940

Library: 3,000 volumes

Lexington

University Art Gallery, University of Kentucky, Fine Arts Building, Rose St., 40506. Tel: (606) 258-2808

Collection: 200 prints—16-17th-century European (German woodcuts, etc.); contemporary—Spanish, German, American, Japanese

Library: Separate part of university system

Louisville

The J. B. Speed Art Museum, 2035 South Third St., 40208. Tel: (502) 636-2893

Collection: 750 16th through 20th-century prints—Old Master; 18th-19th-century English; American and European; Japanese

Library: 9,000 volumes, housed in adjoining facilities

New Orleans *Louisiana*

The New Orleans Museum of Art, P.O. Box 19123, City Park, 70179. Tel: (504) 488-2631

Collection: 200 Old Master to contemporary prints, mostly European, some American and a few Louisiana artists
Library: 5,300 volumes
Shreveport
The R. W. Norton Art Gallery, 4747 Creswell Ave., 71106. Tel: (318) 865-4201
Collection: 1,000 18th to 20th-century American and European prints; large collection of prints by Frederic Remington and Charles M. Russell
Library: 6,000 volumes

Maine **Brunswick**
Bowdoin College Museum of Art, Walker Art Building, 04011. Tel: (207) 725-8731, ext. 275
Collection: 3,000 prints—Old Master; 17th to 20th-century European (French, English, Italian, etc.); 19th to 20th-century American; German Expressionist; over 200 Winslow Homer; 220 John Sloan; 150 Ernest Haskell
Library: 4,000 volumes
Orono
University of Maine Art Gallery, Carnegie Hall, 04473. Tel: (207) 581-7165
Collection: 1,000 prints—Old Master; 18th to 20th-century European and American; Hogarth, Goya, Picasso
Library: University library in separate building
Rockland
William A. Farnsworth Library and Art Museum, Box 466, 04841. Tel: (207) 596-6457
Collection: 800 prints—15th and 16th-century European; 19th and 20th-century American
Library: 3,500 volumes

Maryland **Baltimore**
Baltimore Museum of Art, Art Museum Drive, 21218. Tel: (301) 396-6345
Collection: 55,000 prints—Dürer to the present; 19th-century French; 20th-century European (Picasso, Matisse)
Library: 16,000 volumes
College Park
Art Gallery, University of Maryland, 20742. Tel: (301) 454-2717
Collection: 200 prints—mainly 20th-century American works from the thirties
Library: University library housed in separate building

Hagerstown

Washington County Museum of Fine Arts, City Park,
21740. Tel: (301) 739-5727

Collection: 350 prints—18th to 20th-century American,
English, Italian, and French; American prints represent-
ing a large collection of W.P.A. lithographs; Charles
Dahlgreen etchings

Library: 1,000 volumes

Amherst *Massachusetts*

Mead Art Gallery—William W. Collins '53 Print Room
and Edward W. Crossett '05 Print Collection and Li-
brary, Amherst College, 01002. Tel: (413) 542-2335

Collection: 5,000 prints—Old Master; 19th-century French;
Goya; 19th-century Japanese; 19th and 20th-century
English and American; some contemporary prints;
Whistler; Hassam; Zorn; Bellows

Library: 50,000 volumes

Andover

Addison Gallery of American Art, Phillips Academy, 01810.
Tel: (617) 475-6507

Collection: 1,000 American prints—1775 to the present

Library: 7,000 volumes

Boston

Archives of American Art, Smithsonian Institution, North
East Area Office, 87 Mt. Vernon St., 02108. Tel: (617)
523-2460

Collection: Research collection of documentary material
on American art, either in original manuscript or printed
form or microfilm (5,000 rolls, containing five million
items). Covers American painters, sculptors, printmak-
ers; art collectors; dealers; critics and historians; mu-
seums, societies, and institutions.

Boston Public Library—Print Department, Copley Square,
P.O. Box 286, 02117. Tel: (617) 536-5400, ext. 311

Collection: 60,000 prints—Old Master; 19th and 20th-
century French, British and American (including con-
temporary New England area); Italian; Israeli; Latin
American; major collections of Rowlandson, Goya,
Daumier, Toulouse-Lautrec; almost complete graphic
work of Fantin-Latour, Forain, Bellows; large collections
of Charlot, Gavarni, Meryon, Jacques Villon, Charles
Shannon, John Copley; many works of American print-

makers (Whistler, Pennell, Hassam); small collection of
Expressionist prints (Kollwitz); large collection of early
Parisian lithographs

Library: 1,500 volume print reference library

Comment: An article describing the collection's scope appeared in *Artists' Proof* XI, pp. 63–65.

Museum of Fine Arts—Department of Prints and Drawings, 479 Huntington Ave., 02115. Tel: (617) 267-9300

Collection: Half a million prints, drawings, watercolors,
illustrated books and photographs—American and European, 15th century to the present; Italian 15th-century
engravings; comparative impressions of Dürer; Duvet's
"Apocalypse"; chiaroscuro woodcuts; Goya (mostly odd
trial proofs, "Caprichios"); 19th-century French lithographs; Picasso; Matisse; Villon; Munch; German Expressionist; Dine; Johns; Rauschenberg

Library: Departmental reference library

Cambridge

Busch-Reisinger Museum, 29 Kirkland St., 02138. Tel:
(617) 495-2317

Collection: 300 prints—primarily German; German Expressionist; Bauhaus and Feininger archives

Fogg Art Museum—Department of Prints and Photographs, Harvard University, 02138. Tel: (617) 495-2393

Collection: 51,000 prints—15th century to present; 15th
to 16th-century Northern European; 16th-century German; 17th-century Dutch; 18th to 20th-century French;
20th-century American

Library: 145,000 volumes

Houghton Library—Department of Printing and Graphic
Arts, Harvard University, 02138. Tel: (617) 495-2444

Collection: About 20,000 illustrated books and manuscripts
from incunabula to 20th-century books—15th-century
French and Italian illustrated books; 17th-century baroque books; 18th-century Italian books; 20th-century
livres de peintres; calligraphy; type specimens; William
Blake

Library: For staff use

Holyoke

Holyoke Museum—Wistariahurst, 238 Cabot St., 01040.
Tel: (413) 536-6771

Collection: 65 prints—19th and 20th-century American; 20th-century European and Oriental

Library: 100 volumes

Lincoln

De Cordova Museum and Park, Sandy Pond Road, 01773. Tel: (617) 259-8355

Collection: 131 prints—European and American, 1900 to the present

Library: 1,200 volumes

Northampton

Smith College Museum of Art—Eleanor Lamont Cunningham Print Room, Smith College, 01060. Tel: (413) 584-2700, ext. 236

Collection: 5,000 prints—Western European 15th to 20th centuries; 19th-century French; German Expressionist; Japanese; Hogarth, Piranesi, Turner

Library: 28,000 volumes, housed elsewhere on the campus

Springfield

Springfield City Library—Wellman Hall Art Department, 220 State St., 01103. Tel: (413) 739-3871

Collection: Over 3,000 prints—mainly 19th-century American; some English (late 18th, early 19th century); contemporary

Library: 33,000 volumes in Art and Music Department

Williamstown

Sterling and Francine Clark Art Institute, South Street, 01257. Tel: (413) 458-8109

Collection: Covers Renaissance to late 19th-century Western art; Dürer; 18th-century illustrators (Gavarni, etc.); late 19th-century French (Bonnard, Degas, Gauguin, Toulouse-Lautrec); Winslow Homer

Library: 15,000 volumes

Worcester

Worcester Art Museum, 55 Salisbury St., 01608. Tel: (617) 799-4406

Collection: 10,000 prints—European and American prints, 15th to 20th centuries; Japanese prints, 17th to 20th centuries; contemporary American; chiaroscuro; 18th-century color prints; prints by Francisco Goya; caricatures by George Cruikshank

Library: 35,000 volumes

Michigan **Albion**

Albion College Department of Visual Arts, Print Gallery, Albion College, 49224. Tel: (517) 629-5511

Collection: 1,500 prints—encyclopedic collection, 15th century to present; all periods, all nationalities, including Oriental

Library: General art reference library is part of college library about a block away

Ann Arbor

University of Michigan Museum of Art, Alumni Memorial Hall, 48104. Tel: (313) 764-0395

Collection: 3,500 prints—15th-century European to contemporary; 19th-century French; German Expressionist; special collection of Whistler prints; Japanese

Library: 43,000 volumes in University Fine Arts Library

Detroit

Archives of American Art, Smithsonian Institution, Mid West Area Office, 5200 Woodward Ave., 48202. Tel: (313) 833-2199

Collection: Research collection of documentary material on American art, either in original manuscript or printed form or microfilm (5,000 rolls, containing five million items). Covers American painters, sculptors, printmakers; art collectors; dealers; critics and historians; museums, societies, and institutions.

Detroit Institute of Arts, 5200 Woodward Ave., 48202. Tel: (313) 833-7900

Collection: 15,000 prints—European and Oriental 15th to 20th centuries; Italian chiaroscuro; German Expressionist; French 19th century; American 20th century

Library: 50,000 volumes

Grand Rapids

Grand Rapids Art Museum, Print Room—In Honor of Mrs. Cyrus Edward Perkins, 230 East Fulton, 49502. Tel: (616) 459-4676

Collection: 800 prints—16th-20th-century European, American, and Japanese; 19th-century French; German Expressionist

Library: 1,300 volumes

Kalamazoo

Kalamazoo Institute of Arts, 314 South Park St., 49006. Tel: (616) 349-7775

Collection: 1,000 prints—19th and 20th-century European and 20th-century American

Library: 4,300 volumes

Muskegon

Hackley Art Gallery, 296 West Webster, 49440. Tel: (616) 722-6954

Collection: 550 prints—Old Master through present; 20th-century American

Library: Small reference library for staff use

Olivet

Armstrong Museum of Art and Archeology, Olivet College, 49076. Tel: (616) 749-7000

Collection: 150 prints—Old Master; 20th-century European and American prints; including Dürer; Kollwitz; Barlach; Matisse; Toulouse-Lautrec; Rouault; Piranesi; Goya; Japanese pillow prints; WPA prints

Library: 2,500 volumes

Minneapolis *Minnesota*

The Minneapolis Institute of Arts, The Jones Print Study Room, 2400 Third Ave. South, 55404. Tel: (612) 874-0200

Collection: 40,000 prints—Old Master to present; important examples by major printmakers of all periods and nationalities

Library: 1,000 volumes in print reference library

University Gallery, University of Minnesota, 110 Northrop Auditorium, 55455. Tel: (612) 373-3424

Collection: 3,500 prints (plus 750 on extended loan from Mr. and Mrs. Hudson Walker)—Old Master to contemporary; 19th and 20th-century European; 20th-century American

Library: 40,000 volumes housed in separate buildings

St. Paul

Minnesota Museum of Art, Permanent Collection Prints, 305 St. Peter St., 55102. Tel: (612) 224-9472, 9471

Collection: 500 prints—16th century to the present; 20th-century American; Japanese; Kollwitz

Library: 1,500 volumes

Laurel *Mississippi*

Lauren Rogers Library and Museum of Art, P.O. Box 1108, 39440. (Corner 5th Ave. and 7th St.). Tel: (601) 428-4875

Collection: 300 prints—Japanese and contemporary American

Library: 16,000 volumes

Missouri **Columbia**

Museum of Art and Archeology, Ellis Library 4 D11; University of Missouri, 65201. Tel: (314) 882-8363

Collection: 350 prints—all periods and nationalities; 17th-century Netherlandish to 20th century and contemporary; Japanese color prints

Library: 60,000 volumes

Kansas City

Nelson Gallery—Atkins Museum, Print Study Room, 4525 Oak St., 64111. Tel: (816) 561-4000

Collection: 4,000 prints—1450 to present; Old Master; 15th-century German woodcuts; 19th-century French; German Expressionist; Dürer; Rembrandt; Goya; Blake; Daumier

Library: Special library devoted entirely to prints and drawings

St. Louis

The St. Louis Art Museum, Forest Park, 63110. Tel: (314) 721-0067, ext. 32

Collection: 5,000 prints—from late 15th century to present; 16th-century German; 17th-century French (portraits); 19th-century French; early 20th-century English and 20th-century American

Library: 20,000 volumes

Washington University Gallery of Art, Steinberg Hall, 63130. Tel: (314) 863-0100

Collection: 400 prints—Old Master through 20th-century European and American

Library: Art reference library

Nebraska **Lincoln**

Art Galleries, University of Nebraska, 68508. Tel: (402) 472-2461

Collection: 1,600 prints—16th-century European to contemporary American and European; 19th and 20th-century European; German Expressionist; 20th-century American

Library: Some general reference books in print room; university library is main source for specialized books

Omaha

Joslyn Art Museum, 2200 Dodge St., 68102. Tel: (402) 342-3996

Collection: 4,000 prints—German 16th-20th century; French 17th-20th century; Italian 19th-20th century; American 19th-20th century; Japanese 19th-20th century

Library: 10,000 volumes

Exeter *New Hampshire*

Lamont Gallery, The Phillips Exeter Academy, 03833. Tel: (603) 772-4311

Collection: 750 prints—19th-century English; American 19th and 20th century; Daumier

Library: In separate building

Hanover

Hopkins Center Art Galleries, Dartmouth College, Barrows Print Room, West Wheelock St., 03755. Tel: (603) 646-2808

Collection: 6,000 prints—15th to 20th-century European; 19th and 20th-century American; 19th and 20th-century American and European posters; 19th century Japanese

Library: University library, housed in separate building

Clinton *New Jersey*

Hunterdon Art Center, The Print Room, 7 Center St., 08809. Tel: (201) 735-8415

Collection: 90 prints—contemporary American

Library: 200 volumes

Madison

Friendship Library, Fairleigh Dickinson University, Special Collections and Art Properties, 07940. Tel: (201) 377-4700, ext. 408, 234

Collection: 200 prints—19th-century English; first 30 years of 20th-century German and American

Library: 2,600 volumes art library

Newark

Newark Public Library, Art and Music Department, Fine Print Collection, 5 Washington St., 07101. Tel: (201) 733-7828

Collection: 10,000 prints—various periods; American; late 19th and early 20th-century; 2,000 Japanese prints; New Jersey artists; New Jersey iconography; bank notes; trade cards; serigraphs; historic maps

Library: General art reference material

New Brunswick

Rutgers University Fine Arts Collection, 08903. Tel: (201) 932-7237

Collection: 1,800 prints—15th-century to 20th-century German; 17th-century Dutch; 19th-century French; English; 19th-century to mid-20th-century American

Library: General art reference library

Princeton

The Art Museum, Princeton University, 08540. Tel: (609) 452-3787 or 3764

Collection: 10,000 prints—European and American; nearly complete specialized collection of Callot; Goltzius; Dürer; Rembrandt

Library: Marquand Art Library, a branch of the university library, is in a contiguous building

New Mexico **Albuquerque**

University Art Museum, University of New Mexico, Print and Photograph Study Room, Fine Arts Center, 87131. Tel: (505) 277-4001

Collection: 4,000-5,000 prints—survey of styles; 15th-century German through the 19th and 20th-centuries European and American; 19th-century French; lithography from its inception to the present; contemporary American lithographs; all prints produced by the Tamarind Lithography Workshop

Library: General art reference library

Santa Fe

Archives of American Art, Smithsonian Institution, South West Field Office, 545 Canyon Rd. Tel: (505) 982-1242

Collection: Research collection of documentary material on American art, either in original manuscript or printed form or microfilm (5,000 rolls, containing five million items). Covers American painters, sculptors, printmakers; art collectors; dealers; critics and historians; museums, societies, and institutions.

New York **Brooklyn (New York City)**

The Brooklyn Museum, William A. Putnam Memorial Print Room, 200 Eastern Pkwy., 11238. Tel: (212) NE 8-5000, ext. 205, 206, 207

Collection: 25,000 prints—broad general collection; Jacobus de Voragine's *Legenda Sanctorum* (1474); 45 woodcuts

and engravings by Dürer including *The Small Passion*; 53 etchings by Rembrandt; complete set of Goya's *Los Caprichos*; complete 1st edition of Piranesi's *Invenzioni Capric di Carceri*; 19th and 20th-century French; German Expressionist; 20th-century American

Library: 80,000 volume museum library

Buffalo

Albright-Knox Art Gallery, 1285 Elmwood Ave., 14222. Tel: (716) 882-8700

Collection: 1,700 prints—Old Master through American and European contemporary; Callot; Daumier; Toulouse-Lautrec; Haden (215 prints, making it one of the three best collections of this artist's graphic work)

Library: 13,000 books, 2,000 periodicals

Charles Burchfield Center, 1300 Elmwood Ave. 14222. Tel: (716) 862-6011

Collection: Permanent exhibition of the work of Charles Burchfield (1893–1967)

Corning

The Corning Museum of Glass, Corning Glass Center, 14830. Tel: (607) 937-5371

Collection: 500 prints—all periods and nationalities, pertaining to glass technology and history

Library: 15,000 volume library of record for glass history—general reference material

East Hampton

Guild Hall, 158 Main St., 11937. Tel: (516) 324-0806, 324-5171

Collection: 200 prints—American area artists; 12 etchings —Thomas Moran; 12 etchings—Childe Hassam; 145 drypoints—Peggy Bacon

Flushing (New York City)

Queens College, Paul Klapper Library, Art Library, 11367. Tel: (212) 520-7243

Collection: 500 prints—Old Master; German Expressionist; 20th-century American; WPA prints

Library: 20,000 volumes

Ithaca

Herbert F. Johnson Museum of Art, Print Room, Cornell University, 14850. Tel: (607) 256-6464

Collection: 8,000 prints—Old Master through 20th century; late 19th and early 20th-century American and

British prints; Dürer; Callot; Goya; Canaletto; Piranesi; Whistler; Ensor; Delacroix; Hiroshige

Library: 400-500 volumes in print library

Manhattan (New York City)

Archives of American Art, Smithsonian Institution, Administrative Headquarters, New York Area Office, 41 E. 65th St., 10021. Tel: (212) 628-1251

Collection: Research collection of documentary material on American art, either in original manuscript or printed form or microfilm (5,000 rolls, containing five million items). Covers American painters, sculptors, printmakers; art collectors; dealers; critics and historians; museums, societies, and institutions.

Grey Art Gallery and Study Center, New York University Art Collection, 100 Washington Square East, 10003. Tel: (212) 598-3479, 598-3483

Collection: 600 prints—19th-century French; 20th-century American and European; 20th-century Middle Eastern, Japanese, Indian; WPA

Library: General art reference

Hispanic Society of America, Broadway at 155th St., 10032. Tel: (212) 926-2234

Collection: Prints by Hispanic artists and Hispanic scenes and subjects by other artists; complete set of Goya etchings

Library: 350,000 volumes—related to literature and language, history and the arts of the Iberian Peninsula

Lovis Corinth Memorial Foundation, Inc., 55 Liberty St., 10005. Tel: (212) 964-4424

Comment: Established 1969–1970 as a tax-exempt, nonprofit educational membership corporation to exhibit works by Lovis Corinth and Charlotte Berend in American museums, to dispense educational information about German art as represented by Lovis Corinth, and to provide access to educational material relating to the lives and works of said artists, to researchers; supported by members.

The Metropolitan Museum of Art, Department of Prints and Photographs, Fifth Ave. at 82nd St., 10028. Tel: (212) TR 9-5500, ext. 254

Collection: 500,000-1,000,000 graphics—extraordinary range, from major prints by major artists to reproductive

engravings after paintings, 15th century to the present; photographs, illustrated books; drawings; posters; silhouettes and trade cards

Library: The Print Department has its own reference library, composed chiefly of *catalogues raisonnés* of print-makers and photographers and other books essential to cataloging the collection

The Museum of Modern Art, Abby Aldrich Rockefeller Print Room, 11 West 53rd St., 10019. Tel: (212) 956-2676

Collection: 30,000 prints—1885 to the present, international; 20th century (Munch, Picasso, Beckmann, Chagall, Redon, Rouault, Klee, Villon, Matisse, Dubuffet, Rauschenberg, Johns, Kuniyoshi, Sloan, Toulouse-Lautrec); illustrated books—20th century (Picasso, Miro, Chagall, Braque); artists' books—(1960 to the present); complete production of the Tamarind Lithography Workshop from 1960 to 1970 and all published editions of Universal Limited Art Editions

Library: Reference works on prints in both Print Room and museum library

The New-York Historical Society, Print Room, 170 Central Park West, 10024. Tel: (212) 873-3400

Collection: 500,000 pieces—fine prints, photographs, maps; advertising posters, etc.; 18th-century American; 19th and early 20th-century New York; political caricatures of the 19th century; late 19th-century circus and theatrical posters; American ship prints; engraved and lithographic portraits; book plates; Currier and Ives

Library: Print Room is a part of the library; contains general reference material

The New York Public Library, Prints Division, Fifth Ave. and 42nd St., 10018. Tel: (212) 790-6207

Collection: 160,000 prints and drawings—from 15th century to the present; European; North and South American; 19th-century French; Japanese early lithographs; portraits; I. N. Phelps Stokes Collection of American Historical Views; Eno New York City Views; Mary Cassatt; Edouard Manet; Kitagawa Utamaro

Library: Print Division Library—reference books; extensive clipping file on printmakers

The Pierpont Morgan Library, 29 East 36th St., 10016. Tel: (212) MU 5-0008
Collection: Most distinguished collection of Rembrandt prints in America
Library: General art reference—illuminated manuscripts; incunabula; old printed books; music manuscripts; and reference music library

The Solomon R. Guggenheim Museum, 1071 Fifth Ave., 10028. Tel: (212) 360-3000
Collection: 500 prints—only 20th century; Kandinsky; Klee
Library: 10,000 volumes

Whitney Museum of American Art, 945 Madison Ave., 10021. Tel: (212) 249-4100
Collection: 1,300 prints—20th-century American (includes 1920s, 1930s, and contemporary)
Library: 7,000 volumes

Mountainville

Storm King Art Center, Walter S. Orr Graphics Collection, Old Pleasant Hill Road, 10953. Tel: (914) 534-3115
Collection: 300 prints—19th-century Hudson River prints; 19th and 20th-century American; Currier and Ives; Davies; Hart; Marsh; Sloan; Nevelson; Johns; Kelly; Oldenburg
Library: 1,000 volumes

Purchase

Neuberger Museum, S.U.N.Y. at Purchase, 10577. Tel: (914) 253-5132-33
Collection: 300 prints—Constructivist, contemporary American
Library: General art reference library housed in separate building

Rochester

Memorial Art Gallery of the University of Rochester, 490 University Ave., 14607. Tel: (716) 275-3081
Collection: 2,500-3,000 prints—Old Master; European; early 20th-century American (1920s–1930s), contemporary; Japanese
Library: 10,000 volumes

Southampton

Parrish Art Museum, 25 Jobs Lane, 11968. Tel: (516) 283-2118

Collection: 300-350 prints—19th century through early 20th-century American

Library: 6,000 volumes

Utica

Munson-Williams-Proctor Institute, 310 Genesee St., 13502. Tel: (315) 797-0000

Collection: 1,200 prints—Old Master through contemporary; 19th and 20th-century American; Japanese woodcuts; Currier and Ives; British mezzotints

Library: 55,000 volumes

Chapel Hill *North*

The William Hayes Ackland Memorial Art Center, Ack- *Carolina*
land Building, University of North Carolina, 27514. Tel: (919) 933-3039

Collection: 5,000 prints—15th-20th centuries; German Renaissance; German Expressionist

Library: 28,000 volumes

Charlotte

Mint Museum of Art, 501 Hempstead Place, P.O. Box 6011, 28207. Tel: (704) 334-9723

Collection: 500 prints—Renaissance through contemporary; 20th-century American (especially regional); Western art; Oriental

Library: 2,400 volumes (13,500 including exhibition catalogs and periodicals)

Raleigh

North Carolina Museum of Art, 107 East Morgan St., 27611. Tel: (919) 829-7568

Collection: 700 prints—American; Spanish (Goya, Picasso); French (Callot, Corot, Chagall, Rouault); Italian (Piranesi); elephant folio of the *Audubon Birds of America*

Library: 11,000 volumes

Akron *Ohio*

Akron Art Institute, 60 E. Market St., 44308. Tel: (216) 376-9185

Collection: 500 varied prints—contemporary, American

Library: 2,000 volumes

Cincinnati

Cincinnati Art Museum—Department of Prints, Drawings

and Photographs, Eden Park, 45202. Tel: (513) 721-5204, ext. 44

Collection: 12,500 prints, drawings and photographs—11th and 12th-century Japanese; Old Master; collection of 19th and 20th-century French color lithographs; 20th-century Biblical and religious prints; a playing card collection important for its accompanying bibliography

Library: Split between print department and main museum library

Cleveland

The Cleveland Museum of Art, 11150 East Blvd., 44106. Tel: (216) 421-7340

Collection: 12,100 prints—15th-century Italian (E series Tarocchi, Pollaiuolo, Mantegna school); 15th-century German, Netherlands (Master E. S. Schongauer); 16th century (Altdorfer, Burgkmair, Dürer, Lucas van Leyden, Jean Duvet); 18th-century Italian, French decorative; 19th century (Blake, Palmer, Calvert, Delacroix, Géricault, etc.; Impressionists, Post-Impressionists); lithography, from incunabula to the present; large collections of Meryon, Legros, Lepère, Renoir, Redon, Haden, Bone, Homer, Whistler, Pennell (lithographs), Bellows, Hassam, Otto H. Bacher, Henry G. Keller

Library: Over 80,000 volumes, in general art reference library, books on prints are housed in the Department of Prints and Drawings

Dali Museum, 24050 Commerce Park Road, 44122. Tel: (216) 464-0400, ext. 10

Collection: Salvador Dali paintings and graphics exclusively

Library: 500 volumes—written or illustrated by Dali, or about him

Columbus

Columbus Gallery of Fine Arts, Print Room and Print Study Room, 480 E. Broad St., 43215. Tel: (614) 221-6801

Collection: 3,500 prints—16th-20th century, European, American, Japanese; American 20th century; Czechoslovakian moderns; book plates (Thomas Ewing French Collection)

Library: Print library begun in 1972

Dayton

Dayton Art Institute, Forest and Riverview Aves., 45401.
Tel: (513) 223-5277

Collection: 1,500 prints—15th to 20th century

Library: 20,000 volumes

Granville

Denison University Gallery, Broadway at Cherry, 43023.
Tel: (614) 581-0810, ext. 371 or 255

Collection: 500 prints—Old Master through 20th century;
French, Italian, American

Library: University library housed in separate building

Oberlin

Allen Memorial Art Museum, Wolfgang Stechow Print
Study Room, Oberlin College, 44074. Tel: (216) 447-
1221, ext. 3117

Collection: 3,000 prints—16th-century German (Dürer);
17th-century Dutch (Rembrandt); 18th and 19th-cen-
tury English and French (Hogarth, Blake, Whistler,
Daumier); 20th-century European (Picasso and Ger-
man Expressionist); 20th-century American; Oriental

Library: 28,000 volumes

Toledo

The Toledo Museum of Art, The Grace J. Hitchcock Print
Study Room, P.O. Box 1013, 43697. Tel: (419) 255-8000

Collection: 2,200 prints—15th through 20th-century Eu-
ropean and American; 19th and 20th-century Japanese;
Meryon; La Farge; Mauve; Israels; Jacquemart; major
works by Rembrandt, Piranesi, Dürer, Whistler, Ho-
garth, Daumier

Library: 700 volumes

Wooster

College of Wooster Art Museum, 44691. Tel: (216) 264-
1234, ext. 425

Collection: 5,000 prints—late 19th century, early 20th-
century French, English, American

Library: 80 volumes

Youngstown

The Butler Institute of American Art, 524 Wick Ave.,
44502. Tel: (216) 743-1711

Collection: 800 prints—American only; nearly complete
collection of Winslow Homer wood engravings

Library: 1,000 volume general American art reference li-
brary

Oregon **Eugene**
Museum of Art, University of Oregon, 97403. Tel: (503)
686-3027
Collection: 1,600 prints—Japanese woodblock prints; Chi-
nese woodblock prints; Pacific Northwest contemporary
artists; 20th-century American and British
Library: University libraries housed in separate building
Portland
Portland Art Museum, 1219 S.W. Park, 97205. Tel: (503)
226-2811
Collection: 2,000 prints—American and European; Jap-
anese woodcuts (some 700 examples); German Ex-
pressionist; Piranesi; WPA prints; Northwest artists
through early 1960s
Library: 6,200 volumes

Pennsylvania **Allentown**
Allentown Art Museum, Box 117, 5th and Court Sts.,
18105. Tel: (215) 432-4333
Collection: 360 prints—reflecting the dates of Samuel H.
Kress Memorial Collection of European Paintings and
Sculpture, 1350 to 1750 A.D.; some 19th and 20th-century
prints; 94 etchings and lithographs by Thomas Schofield
Handforth; two engravings by Jan Muller (1571–1628);
Will Barnet; Mortimer Menpes; Thomas Hart Benton
Library: 6,000 volumes
Bethlehem
Lehigh University Permanent Collection Fine Arts De-
partment, Lehigh University, 18105. Tel: (215) 691-
7000, ext. 525
Collection: 1,200 prints—Old Master; 19th-century En-
glish; 19th and 20th-century American; some European
continental masters
Library: University library; Fine Arts Department library
Greensburg
The Westmoreland County Museum of Art, 221 North
Main St., 15601. Tel: (412) 837-1501 or 1500
Collection: 200 prints—18th, 19th, and 20th centuries,
American and modern European
Library: 5,000 volumes
Jenkintown
Alverthorpe Gallery, 511 Meetinghouse Rd., 19406. Tel:
(215) TU 4-0466

Collection: 25,000 prints—15th through 20th centuries; touching all nationalities; 15th-century anonymous woodcuts; Rembrandt; Callot; Whistler; Blake; German Expressionist; master prints; modern prints; Ms. miniatures

Library: 5,000 volume print reference library—500 bound periodical volumes

Comment: The Rosenwald Collection, Alverthorpe Gallery, is part of collections of National Gallery of Art and Library of Congress.

Philadelphia

Drexel Museum Collection, Drexel University, 32nd and Chestnut Sts., 19104. Tel: (215) 895-2424

Collection: 350 prints—about 200 19th-century Japanese prints; about 130 Hogarth prints; some modern prints

Library: University library

Free Library of Philadelphia, Logan Square, 19103. Tel: (215) MU 6-5405

Collection: 8,000 prints—international collection, 1493 to present; Wohlgemuth, Dürer; Rembrandt; Goya; Rouault; Dali; August Koellner (350 prints and drawings); James McBey (110 prints and drawings); Joseph Pennell (100 prints); Thomas Handforth (168 prints); Benton Spruance (325 prints); W.P.A. collection of prints and drawings

Library: General art reference library

Comment: "Picture archives on specific subjects—Lewis Portrait Collection; Jackson Collection of American Lithography; Carson Collection of Napoleonic Prints; Castner Collection of Philadelphiana; Americana; Philadelphia street cars; greeting cards, postcards and tradesmens' cards; History of the Law; angling."

Pennsylvania Academy of the Fine Arts Museum Print Room, Broad and Cherry Sts., 19102. Tel: (215) 299-5060

Collection: 3,000 American prints of 1800 to 1950

Library: 5,000 volumes

Philadelphia Museum of Art—Department of Prints, Drawings and Photographs, P.O. Box 7646, 19101. Tel: (215) PO 3-8100

Collection: 120,000 prints—Western and Oriental prints from beginning to present; French 18th century; Ameri-

can 20th century; near-complete sets of work of Marin, Sloan, Hopper

Library: 6,000 volumes, limited to prints, drawings, and photographs

Pittsburgh

Museum of Art, Carnegie Institute, 4400 Forbes Ave., 15213. Tel: (412) 622-3200

Collection: 4,500 prints—Old Master; late Medievals to late 20th-century European; 18th to 20th-century American and Japanese

Library: Print room library—limited to print references

University Art Gallery, University of Pittsburgh, 104 Frick Fine Arts Bldg., 15260. Tel: (412) 624-4116

Collection: 650 prints—19th-20th-century English and American; nearly complete edition of Callot's prints (lacking the Commedia dell'Arte); Hogarth; Stubbs

Library: 46,000 volumes

Reading

Reading Public Museum and Art Gallery, 500 Museum Rd., 19611. Tel: (215) 373-1525

Collection: 1,500 prints—European Baroque; 19th-century Japanese, European and American; World War I and World War II European and American posters

Library: 2,000 volumes

Rhode Island **Providence**

Museum of Art, Rhode Island School of Design, Department of Prints and Drawings, 224 Benefit St., 02903. Tel: (401) 331-3507

Collection: 8,000 prints, Old Master to contemporary—19th-century French; 19th and early 20th-century British; Northern Mannerist works; contemporary American; chiaroscuro woodcuts, cartouches and designs

Library: 40,000 volume school library—general art reference; Print Room library—limited to print references

South **Charleston**
Carolina

Carolina Art Association—Gibbes Art Gallery, Dunkin Print Room; Japanese Print Room, 135 Meeting St., 29401. Tel: (803) 722-2706, 2707

Collection: 6,000 prints in Dunkin Print Room—American 17th through 20th century; South Caroliniana; 20th-century Carolina artists; European 16th through 20th

century; 600 prints in Japanese Print Room—color wood-blocks; 17th through 19th-century Ukiyo-e, including Harunobu, Kiyonaga, Utamaro, Sharaku, Hokusai, Hiro-shige

Library: 3,000 volumes

Chattanooga *Tennessee*

Hunter Museum of Art, 10 Bluff View, 37403. Tel: (615) 267-0968

Collection: 50 prints—19th and 20th-century American; some Europeans; 20 Currier and Ives

Library: 400 volumes

Sewanee

The University of the South, Gallery of Fine Arts; Museum Chambers, Guggry Hall, 37375. Tel: (615) 598-5719

Collection: 250 prints—primarily post-1890; Impressionist and German Expressionist; 20th-century American; Rouault "Miserere" series

Library: General art reference material housed in university library

Dallas *Texas*

Dallas Museum of Fine Arts, Fair Park, 75226. Tel: (214) 421-4187

Collection: 19th-century French; 20th-century American and European

Fine Arts Division, Dallas Public Library, 1954 Commerce St. 75201. Tel: (214) 748-9071

Collection: 60 prints—a few 18th-century Japanese woodcuts; contemporary French, Spanish, European and American

Library: 25,000 volumes

El Paso

El Paso Museum of Art, 1211 Montana, 79902. Tel: (915) 584-9716

Collection: 200 prints—1800 to 1975; French Impressionist and Post-Impressionist; Ash Can School

Library: 5,000 volumes

Fort Worth

The Fort Worth Art Museum, 1309 Montgomery St., 76107. Tel: (817) 738-9215

Collection: 600 prints—20th century

Library: 5,000 volumes—limited to 20th-century art references

Kimbell Art Museum, Will Rogers Road West, 76107. Tel: (817) 332-8451
Collection: Small, select collection of less than 100 prints
—Old Master; 17th to early 20th centuries; European
Library: 15,000 volumes
Houston
Menil Foundation, Inc., 3363 San Felipe Rd., 77019. Tel: (713) 622-5651
Collection: 4,000 prints—15th through 20th-century European; 19th and 20th-century American; Braque, Ernst, Léger, Matisse, Picasso, Rouault; black iconography; gardens through the ages
Library: Rare books library is housed in same building; general art reference library is situated in separate building

The Museum of Fine Arts, Houston, The Alvin S. Romansky Print Room, 1001 Bissonet (P.O. Box 6826), 77005. Tel: (713) 526-1361
Collection: 600 prints, Old Master (Dürer, Goltzius, Rembrandt); 19th-century American and European (Daumier, Manet, Hassam); 20th-century American
Library: 18,000 volumes
Midland
Museum of the Southwest, 1705 West Missouri, 70701. Tel: (915) 683-2882
Collection: 400 prints, Old Master through contemporary; 19th and 20th-century American
Library: 300 volumes
San Antonio
Marion Koogler McNay Art Institute, 6000 North New Braunfels, 78209. Tel: (512) 824-5368
Collection: 250 prints, from 1800 to the present—19th and 20th-century European; 20th-century American and Mexican; German Expressionist
Library: 5,000 volumes

Utah **Provo**
Brigham Young University, B. F. Larsen Galleries, 84602. Tel: (801) 374-1211, ext. 2881
Collection: 1,500 prints—Old Master (Rembrandt); Eu-

ropean; early 20th-century American through contemporary; J. Alden Weir (estate); Mahonri Young
Library: University library in next building

Burlington *Vermont*

Robert Hull Fleming Museum, The University of Vermont, 05401. Tel: (802) 656-2090
Collection: 500 prints—from Schongauer to contemporary; American early 20th century
Library: Library holdings mostly housed in University of Vermont library; books in museum are very basic tools and a growing research file primarily of artists represented in the collection

Norfolk *Virginia*

Chrysler Museum at Norfolk, Olney Rd. and Mowbray Arch, 23510. Tel: (804) 622-1211
Collection: 5,000 prints—Old Master; 18th through 20th-century French; 19th and 20th-century American (including photographs); 19th and 20th-century German; Oriental
Library: 30,000 volumes

Richmond

Virginia Museum of Fine Arts, Boulevard and Grove Ave., 23221. Tel: (804) 770-6320
Collection: 1,000 prints—Old Master; contemporary American
Library: 30,000 volumes

Roanoke

Roanoke Fine Arts Center—Print Room, 301 23rd St., S.W., 24014. Tel: (703) 342-8945
Collection: 300 prints—20th-century American
Library: General art reference library

Seattle *Washington*

Henry Art Gallery, PF-30 University of Washington, 98195. Tel: (206) 543-2280
Collection: 500 prints—19th and 20th-century American, Japanese, and European; 20th-century Americans of the Northwest region
Library: 18,000 volume general art reference library is part of university library housed in a separate building

Seattle Art Museum, Volunteer Park, 98112. Tel: (206)
447-4785
Collection: 2,000 prints—Western European countries be-
fore and after 1900; 18th and 19th-century British,
French and German; American contemporary and North-
west particularly; Chinese/Japanese prints and stencils
Library: 9,500 volumes

Seattle Public Library, Art Department, 4th and Spring
Sts., 98104. Tel: (206) 624-3800
Collection: 477 prints—19th and 20th-century American,
European and Oriental; Seattle and Northwest
Library: 66,388 volume general art reference library in
the art department

Wisconsin **Appleton**
The Institute of Paper Chemistry, 54911. Tel: (414)
734-9251
Comment: "The Museum materials here consist of items
acquired by the Institute of Paper Chemistry over the
years, and the formal Hunter collection set up originally
as the Dard Hunter Paper Museum at the Massachu-
setts Institute of Technology in 1939 and moved here for
a permanent home in 1954. Materials include a consider-
able amount of literature, artifacts, paper and associated
materials."

Madison
Elvehjem Art Center, University of Wisconsin, Oscar F.
and Louise Greiner Mayer Print Center, 800 University
Avenue, 53706. Tel: (308) 263-2246
Collection: 1,000 prints—Old Master through contempo-
rary American
Library: 60,000 volumes

Madison Art Center—Langer Print Study Room, 720 E.
Gorham St., 53793. Tel: (608) 257-0158
Collection: 1,450 prints—Old Master; Japanese 18th and
19th century; Mexican 20th century; American 20th cen-
tury; contemporary European; 23 Piranesi; 33 Käthe
Kollwitz; 12 Rouault; French painter–printmakers
Library: 200 volumes

Milwaukee
University of Wisconsin, Milwaukee Art Department Gal-
lery, School of Fine Arts, 53211. Tel: (414) 963-4200

Collection: 400 prints—1450 to present day; European and American; German Expressionists; contemporary American; Oriental

Library: University library in separate building

FOREIGN PRINT COLLECTIONS

Adelaide *Australia*

The Art Gallery of South Australia, Department of Prints and Drawings, North Terrace, 5000. Tel: 223-8485

Collection: 10,000 prints—general; 18th-20th-century British; 19th and 20th-century Australian; European; contemporary

Library: General art reference library

Melbourne

National Gallery of Victoria, Department of Prints and Drawings, 180 St. Kilda Road, 3004. Tel: 62-7411

Collection: 16,600 prints—Old Master; Australian; Japanese; modern American; 15th-century Italian Renaissance engravings by Pollaiuolo and Mantegna; early and excellent impressions of the near-complete graphic oeuvre of Albrecht Dürer (1471–1528); about 133 of the 300 etchings by Rembrandt in fine, early impressions; complete set of van Dyck's collection of portrait etchings and engravings (c. 1626–1632) known as the *Iconography*; complete set of Turner's *Liber Studiorum* with proof prints and all states; Piranesi's *Carceri* series editions of 1745 and 1761; Goya's *Tauromachia* (1816) and the *Disasters of War* (1810–1813); Blake's *Book of Job* engravings (1820–1826); aquatints, etchings and lithographs by Picasso, Toulouse-Lautrec, Munch, Chagall, Matisse, Heckel, Lichtenstein, Appel, Corneille, Jasper Johns, Oldenburg, Olitski, Dine; *Twelve Great Disciples of Buddha* by Munakata; color woodcuts by Utamaro, Hokusai, Hiroshige and all the best-known masters of this art

Library: 1,000 volumes

Perth

Western Australian Art Gallery, Beaufort St. Tel: 28-7233

Collection: 2,500 prints—15th to 20th centuries; 19th and 20th-century Australian and English

Library: 3,000 volumes

Sydney

Art Gallery of New South Wales, Department of Prints and Drawings, Art Gallery Road, Domain 2000. Tel: (02) 221-2100

Collection: 3,000 to 5,000 prints—predominantly Australian (all periods); Old Master; European and American; 19th-century French; 19th-20th-century English; Ukiyo-e woodcuts; Turner *Liber Studiorum*; modern Japanese

Library: 9,000 volumes

Austria **Linz**

Neue Galerie der Stadt Linz, Wolfgang—Gurlitt Museum (New City Gallery), Hauptplatz 8. Tel: 24104

Collection: 2,450 prints—19th century-20th-century Middle European; international contemporary; important Kubin collection

Library: 6,500 volumes

Vienna

Graphische Sammlung Albertina (Albertina Graphic Art Collection), 1 Augustinerstrasse, A-1010. Tel: (0222) 52-4232

Collection: Nearly two million prints—Old Master (Dürer, Rembrandt, Goya) up to modern master; all schools, all periods

Library: Over 40,000 volumes—predominantly graphic art reference

Belgium **Antwerp**

Stedelijk Prentenkabinet (Municipal Gallery of Graphic Arts), Vrigdagmarkt 23. Tel: 031-32.24.55 or 031.33.06. 88

Collection: 20,000 old prints, 30,000 modern prints—works of all periods; Flemish, especially Antwerp

Library: About 10,000 volumes mainly on prints, but also general works on art

Canada *Alberta*

Edmonton

University of Alberta Art Gallery and Museum, Ring House #1, University of Alberta, T6G ZEZ. Tel: (403) 432-5818

Collection: 110 prints—20th-century Canadian and American

Library: 100 volumes—housed in separate building

British Columbia

Vancouver

The Vancouver Art Gallery, 1145 West Georgia St., V6E 3H2. Tel: (604) 682-5621

Collection: 650 prints—contemporary international; 20th-century Canadian and American

Library: 8,500 volumes

Victoria

Art Gallery of Greater Victoria, 1040 Moss St., V8V 4P1. Tel: (604) 384-4101

Collection: 600 prints—Old Master; 19th century-20th-century international; Japanese (300 Sosaku Hanga, 100 Ukiyo-e); Canadian; Eskimo

Library: 2,500 volumes housed in separate building

New Brunswick

Fredericton

Beaverbrook Art Gallery, Queen St., P.O. Box 605. Tel: (506) 455-6551

Collection: 400 prints—18th and 19th-century British; 19th and 20th-century Canadian

Ontario

Hamilton

Art Gallery of Hamilton, Main St. West at Forsyth, P.O. Box 68, Station E, L8S 4K9. Tel: (416) 527-6619, 527-6610

Collection: 1,000 prints—Canadian; American and British; European

Library: General art reference

Kingston

Agnes Etherington Art Centre, Queen's University, K7L 3N6. Tel: (613) 547-5747 or 547-6170

Collection: 900 prints—15th century to contemporary; Italian; French; Flemish; Dutch; British; German; Canadian contemporary

Library: 16,000 to 17,000 volumes in adjoining building

Quebec

Montreal

The Montreal Museum of Fine Arts, Department of Prints and Drawings/Cabinet des Dessins et Estampes, 1379 Sherbrooke St. West, H3G 1K3. Tel: (514) 842-8091

Collection: 2,400 prints—Middle Ages to contemporary;

Old Master; 19th and 20th-century international; Eskimo; contemporary Canadian

Library: 53,000 volumes

Saskatchewan

Saskatoon

The Saskatoon Gallery and Conservatory Corporation, P.O. Box 569, S7K 3L6. Tel: (306) 652-8355

Collection: 580 prints—Eskimo; 20th-century Canadian

Library: 3,000 volumes

Denmark **Copenhagen**

Statens Museum for Kunst (The Royal Museum of Fine Arts), Department of Prints and Drawings, Sølvgade, 1307. Tel: (01) 11 21 26

Collection: 250,000 prints and drawings—complete engravings and many woodcuts by Dürer in superb impressions; almost complete and very good set of Rembrandt's etchings; some 200 "éditions de luxe" books, illustrated with original prints by artists of the École de Paris from Toulouse-Lautrec and onwards; one block-book (*The Seven Planets*); lithographs by Toulouse-Lautrec almost complete, 20th-century French prints

Library: 36,000 volumes—limited to prints and drawings

Comment: "Originally the collections of the Royal House of Denmark and as such dating back to the 16th century —thus one of the oldest collections of the world. Since 1843 a Public Collection under state administration."

France **Biot**

Musée Fernand Léger

Collection: Art museum; works of Fernand Léger (1881–1955)

Paris

Bibliothèque Nationale—Cabinet des Estampes (National Library—Print Department), 58 Rue de Richelieu, 2e

Collection: 12,000,000 prints—foremost collection in the world; all periods from the 15th century to the 20th century

Library: General art reference library in adjoining facilities of the Bibliothèque Nationale

Comment: The *dépôt légal des estampes* . . . instituted by Louis XIV in 1690 makes it obligatory that two copies of any print or image on sale to the public must

be sent to the Cabinet. Between three and four thousand prints are added each year.

The prints are grouped under double headings: one of the artist and the other of the subject.

The Cabinet's catalog is formulated on a clear and rather simple basis. It contains 391 volumes that run the length of the Work Room and are arranged in alphabetical order, containing the classification according to artist, subject, topographical and chronological order. Portraits cataloged separately in ninety-five volumes.

The most important publication under way is the *Inventaire de la Gravure Française,* classified according to centuries, of which twenty-five out of a total of fifty have been published.

See also: "Cabinet des Estampes" by Marina Kolasinki in *Print Collector* 6 (1974): 42–45.

Musée du Louvre (The Louvre Museum), Print Room, Edmond de Rothschild Collection, Palais du Louvre. Tel: 231-59-40

Collection: 40,000 prints—15th-century woodcuts; German school (almost everything by Dürer); Dutch school (almost everything by Rembrandt); Italian Quattrocento; French 17th and 18th centuries, works inspired by the French Revolution

Library: Sale catalogs 1666–1935; texts relative to the artists and works in the collection pertaining to the period from 1880–1910; catalogs of the exhibitions that the print department of the Louvre has organized

Comment: Baron Edmond de Rothschild's collection was given to the Louvre in 1935. Strict instructions were given as to how the prints were to be conserved and presented to the public. The rooms attempt to recreate the atmosphere of the collector's study.

See also: "The Edmond de Rothschild Collection" by Marina Kolasinki in *Print Collector* 10 (1974): 34–38.

Musée du Petit Palais (Municipal Museum), 1 Ave. Dutuit—75008. Tel: 265-99-21, 265-12-73

Collection: 13,000 prints—Dutch 17th century; French 16th to 19th centuries; Italian 15th through 19th centuries; German 15th through 16th centuries; Flemish 16th through 17th centuries

Berlin

Brücke-Museum, Bussardstcig 9. Tcl: 030-831-2029

Collection: About 1,900 prints of the "Brücke" group of German Expressionists

Library: Small reference library limited to the "Brücke"

Staatliche Museen Preussischer Kulturbesitz, Kupferstich-kabinett (State Museum, Institute of Prussian Culture), Arnimalle 23/27. Tel: 830-1228, 830-1219

Collection: 400,000 Old Master drawings and prints; European prints from the beginning of printing until the present day

Library: 5,000 to 7,000 volumes

Comment: "The Kupferstichkabinett contains European drawings from the 14th to the end of the 18th centuries, prints from the beginning of printmaking until the present day, a very refined collection of illuminated manuscripts from the 10th century until the 17th century as well as a splendid collection of incunabula and illustrated books through all centuries."

Bremen

Kunsthalle Bremen, Kupferstichkabinett (Bremen Art Gallery—Print Department), Am Wall 207. Tel: (0421) 34-1468

Collection: 220,000 prints and drawings

Library: 38,000 volume general art reference library

Cologne

Wallrat-Richartz-Museum, Graphische Sammlung (Print Collection), An der Rechtschule. Tel: (0221) 221-2395

Collection: 50,000 prints—German, Netherlandish, and French masters, 15th through 18th centuries; German and French 19th century; European 20th century

Library: 100,000 volumes

Comment: "Good collection of American prints (Pop Art) lent by the collector Peter Ludwig."

Duisburg

Wilhelm-Lehmbruck-Museum, Dusseldorfer Street 51

Collection: 20th-century German graphics; complete works of Wilhelm Lehmbruck (1881–1919)

Library: 5,000 volumes

Hamburg

Hamburger Kunsthalle, Kupferstichkabinett (Hamburg

Hall of Arts—Print Department), Glockengiesserwall.
Tel: 248 252 616 or 248 252 604

Collection: 50,000 prints—early Italian to Castiglione and
Tiepolo; Netherlandish 16th through 19th centuries;
French 16th through 19th centuries; German through all
centuries; British 19th century; 20th-century interna-
tional; Goya

Library: 50,000 volumes

Munich

Staatliche Graphische Sammlung München (National
Graphic Arts Collection, Munich), Meiserstrasse 10.
Tel: 089-5591-341

Collection: 250,000 European drawings and prints from
the 14th to 20th centuries—early German woodcuts of
the 15th century; German prints of the 15th and 16th
centuries; Dutch drawings and prints of the 15th and
16th centuries; German drawings of the 19th century

Library: About 20,000 volumes, mainly encompassing
drawings and prints

Naumburg-Grossjena

Klinger-Gedenkstätte, DDR 4801

Comment: Memorial museum; life and work of artist Max
Klinger (1857–1920) in his summer home

Nuremberg

Germanisches Nationalmuseum, Kupferstichkabinett (Ger-
manic National Museum—Print Department), Korn-
markt 1. Tel: 0911-203971

Collection: 300,000 prints—15th through 19th-century
German; historical prints; city plans and prospectuses;
maps; portrait prints

Library: 400,000 volumes

London *Great Britain*

British Museum, Department of Prints and Drawings,
Great Russell St., WC1 3DG. Tel: 01-636-1555

Collection: Vast general collection of prints from c. 1400
onwards, Western European and American

Library: Vast general art reference library

Tate Gallery, Print Department, Millbank, SW1. Tel:
(01) 828-1212

Collection: 3,500 prints—post-1945 British

Library: General art reference library—12,000 bound vol-
umes, 46,000 exhibition catalogs

Comment: "The new Print Department was only officially launched in 1974 and is based on huge gifts of prints from various sources, all post-1945 and chiefly British. It is now functioning as a kind of voluntary depot and participating British publishers donate one of every edition they make."

Victoria and Albert Museum, Department of Prints and Drawings, South Kensington, London SW7 2RL. Tel: 01-589-6371

Collection: 400,000 prints—Old Master to 20th century, all periods and nationalities; engraved ornament; prints related to the decorative arts; topographical; portraits; caricature; fine art engraving

Library: 750,000 volumes

Comment: The library is the National Art Library and covers all fields.

Manchester

Whitworth Art Gallery, University of Manchester, Whitworth Park, M15 6ER. Tel: 061-273-1880

Collection: 10,000 prints, 300 books and folios—mid-15th century to present, Old Masters, especially Italian and Northern European, 15th through 16th centuries; 18th through early 20th-century British, especially Hogarth; social satire; mezzotint portraits; Turner; topographical; Edwardian etchings; 20th-century woodcuts

Library: General art reference library

Oxford

The Ashmolean Museum, Beaumont St. Tel: 57522

Collection: Old Master; late 19th century to early 20th-century English; Pissarro family; Hope Collection of engraved portraits

Library: General art reference library

Hungary **Budapest**

Magyar Nemzeti Galeria (Hungarian National Gallery), Graphic Art Department, Budávari Palota, H-1250. P.O.B./Postafiók 31. Tel: 160-806, 160-961

Collection: 5,000 pieces—Hungarian works only

Library: 16,000 books, 25,000 journals and catalogs—general art reference

Israel **Haifa**

The Municipal Museum of Modern Art—Print Cabinet, 4 Bialik St., P.O. Box 4811. Tel: 64-07-75; p.m.-64-07-84

Collection: 3,000 prints—18th through 20th centuries;
mostly European; German 20th century
Library: 7,500 volume general art reference library
Jerusalem
Israel Museum Bezalel National Art Museum—The Israel
Feinberg Graphic Study Room, P.O. Box 1299, Hakiria.
Tel: 02-36-231, ext. 253
Collection: 50,000 prints, drawings and books—15th cen-
tury to 20th century; Israeli; European; American; Jap-
anese; French 19th century; Picasso
Library: There is a small reference library limited to prints
and drawings in the Print Room, in addition to the
45,000 volume general art library of the museum
Tel Aviv
Tel Aviv Museum—Graphic Cabinet, 27-20 Shaul Hame-
lech Blvd.
Collection: 10,000 prints—19th and 20th-century Jewish;
Israeli; early 20th-century German; German Expression-
ist
Library: 18,500 volume general art reference library

Amsterdam *Netherlands*
Rijksmuseum, Rijksprentenkabinet (State Museum—
Print Department), Jan Luykenstraat 1A. Tel: 020-732-
121
Collection: About one million prints and drawings—Old
Master through 1940; European; Japanese; Rembrandt;
Seghers; Dürer
Library: General art reference library

Stedelijk Museum (Municipal Museum), Paulus Potter-
straat 13. Tel: (020) 73.21.66
Collection: 15,000 prints and drawings from 1850 to the
present
Library: 12,000 volumes
Eindhoven
Municipal Van Abbemuseum (Eindhoven Municipal Mu-
seum), Bilderdijklaan 10. Tel: (040) 68811
Collection: 200 prints—20th-century Dutch; 80 works by
El Lissitsky
Library: 25,000 volumes—housed in adjoining building
The Hague
Haags Gemeentemuseum—Prentenkabinet (Municipal

Museum of The Hague—Print Department), Stad-
houderslaan 41, P.O. Box 72. Tel: 070-51.41.81
Collection: 20,000 prints—European 19th and 20th cen-
turies; 19th and 20th-century Dutch; 19th-century
French; German Expressionist; typography 1920–1940;
posters 1890 to present
Library: 20,000 art books

Otterlo

State Museum Kröller-Müller, Nationale Park de Hoge
Veluwe. Tel: 08382-241
Collection: About 2,000 prints—Old Master; 16th to 19th-
century international; 19th and 20th-century interna-
tional; Van Gogh
Library: A relatively small library

Rotterdam

Museum Boymans Van Beuningen, Mathenesserlaan 18-
20, Postbox 2277. Tel: 010-360500
Collection: 85,000 prints—European; minor Dutch and
Flemish Masters 16th-18th century; Dutch 19th cen-
tury; Italian; French; English; contemporary interna-
tional
Library: 125,000 volumes

New Zealand **Dunedin**

Dunedin Public Art Gallery, Logan Park, P.O. Box 566.
Tel: Dunedin 78-770
Collection: 350 prints—Old Master, German, Dutch; 18th-
century French
Library: 2,000 volumes plus catalogs

Wellington

National Art Gallery of New Zealand, Buckle St. Tel:
59-703
Collection: 5,000 prints—15th century to the present;
Dutch; French; German; Italian; Spanish; English; Eu-
ropean Old Masters, Rembrandt, Dürer
Library: 3,000 volumes

Norway **Oslo**

Nasjonalgalleriet, Kobberstikk OG Håndtegningsamlingen
(National Gallery—Print Collection), Universitetsgaten
13. Tel: (02) 200404
Collection: 22,000 foreign prints; 5,000 Norwegian prints
—from late 19th century to today; Dürer; Goya; 19th-
century French; German, Dutch, Italian, French and

English of all important periods; Danish; Swedish; some Japanese woodcuts

Library: 45,000 volumes including 18,000 catalogs and pamphlets

Cape Town *South Africa*

South African National Gallery, P.O. Box 2420, Government Ave. Tel: 45-1628

Collection: 2,000 prints—Old Master, 16th to 20th-century European; 19th-century English; 150 Daumier prints; 19th-20th-century South African

Library: 4,700 volumes (excluding catalogs)

Durban

Durban Art Gallery, City Hall, Smith St. Tel: 27535, ext. 351

Collection: 400 prints—17th-century Dutch; 19th and 20th-century English and French; German Expressionist; 20th-century South African

Library: 5,000 volumes

Johannesburg

Johannesburg Art Gallery, Print Room, Joubert Park, 2001. Tel: 725-3130, 725-3180-81

Collection: 2,050 prints—Old Master through 20th-century international, 16th-century German, 17th-century Dutch, 18th-century French; 19th-century French and English

Library: 2,800 volumes

Barcelona *Spain*

Museo de Arte Moderno—Seccion de Grabados (Museum of Modern Art—Print Department), Palacio de la Ciudadcla. Tel: 319 5729

Collection: 60,000 prints—16th through 20th centuries; Low Countries, Spain, Europe

Library: 50,000 volumes

Basel *Switzerland*

Öffentliche Kunstsammlung—Kupferstichkabinett (Museum of Fine Arts—Print Department), St. Albangraben 16, CH-4010. Tel: (061) 23.18.55

Collection: 120,000 prints and drawings—Old Master through contemporaries; illustrated books

Library: 48,000 volumes

Berne

Kunstmuseum Bern, Graphische Sammlung und Paul Klee-

Stiftung (Berne Museum of Fine Arts—Graphics Collection and Paul Klee Foundation), Hodlerstrasse 12, CH-3011. Tel: (031) 22.09.44

Collection: Old Master, Swiss drawings and etchings 16th through 20th centuries; Paul Klee, about 3,000 drawings, watercolors and nearly all his prints

Library: 35,000 volumes

Zurich

Schweizerisches Landesmuseum—Graphische Sammlung (Swiss National Museum—Graphics Collection), Museumstrasse 2, CH-8023. Tel: (051) 25.79.35

Collection: 50,000 prints and drawings—only Swiss, all periods

Library: 1,000 volume special library for prints and drawings

Zentralbibliothek Zürich, Graphische Sammlung (Zurich Central Library—Print Collection), Zahringerplatz 6, CH-8025. Tel: 01-47-72-72

Collection: 100,000 prints—topographical views (especially Swiss) 16th through 19th century; portraits and broadsheets 16th through 19th century

Library: Limited to print references; catalogs collected are only of works by publishers and galleries in Zurich (Canton)

Yugoslavia **Ljubljana**

Narodna Galerija, Grafični Kabinet (National Art Gallery —Print Department), Prežihova ulica 1. Tel: 21-249; 21-765; 21-570

Collection: 4,000 prints—18th, 19th, and early 20th-century Slovenian, Austrian, and Italian masters

Library: 10,387 volumes

PRINT CLUBS

The print clubs listed below are open to collectors, and membership often includes all those concerned with the art of the print—artists and museum professionals, as well as the interested public. Some clubs meet from time to time to discuss prints. Contact your local group for further information, or form a new club if there is none in your locality.

Other clubs (not included in this list) are composed entirely of printmakers, such as the Society of American Graphic Artists. Frequently these open some form of associate membership to print lovers. Usually a fee is

charged, in return for which associate members annually receive a print specially created by one of the artist-members.

Baltimore Print Club
Baltimore Museum of Art
Charles and 31st Sts.
Baltimore, Md. 21206

Fine Prints Society
4310 Stanford St.
Chevy Chase, Md. 20015

Print Club of Albany
125 Washington Ave.
Albany, N.Y. 12210

The Print Club of Cleveland
11150 East Blvd.
Cleveland, Ohio 44106

The Print Club
1614 Latimer St.
Philadelphia, Pa. 19103

Print Club of Rochester
Memorial Art Gallery
490 University Ave.
Rochester, N.Y. 14607

The Washington Print Club
3812 Windon Place N.W.
Washington, D.C. 20016

A third type of "club" offers contemporary prints to members by mail on a subscription basis.

Associated American Artists, 663 Fifth Avenue, New York, N.Y. 10022

The Collectors Guild, Ltd., 185 Madison Avenue, New York, N.Y. 10016

Fine Arts 260, A Division of the Book of the Month Club, 280 Park Avenue, New York, N.Y. 10017

Original Print Collectors Group, Ltd., 120 East 56th Street, New York, N.Y. 10022

PRINT DEALERS—UNITED STATES, CANADA, AND MEXICO

You are always welcome to visit the showrooms of print dealers, except for those very few who work by appointment or catalog only. Galleries are open to all members of the public during regular business hours, and in them you can enjoy the whole wide world of prints. Unlike so many museums these days, there is never any charge for admission (except during a benefit show), and you will never be pressured to become a customer. But you'll be strongly tempted—which is exactly the reason so many excellent print shows are mounted by private galleries.

Our list of dealers cannot begin to include more than a small fraction of the many fine print galleries throughout this country, Canada, and Mexico. We have selected those that seemed of greatest interest to collectors. Most of them specialize in prints, although we have included a few that carry work in other media as well as a full line of graphics by the artists in their

stables. We have tried to arrive at a representative sampling so that collectors of all print media and periods will be served.

Once you have arrived in a new place, it's easy enough to find the names of more dealers in your specialties. Local newspapers, art magazines, city guides, and gallery guides carry art show information, and almost every art dealer will be happy to give you the names and addresses of other local fine print dealers. Our aim in the following list is to get you off to a good start.

PRINT DEALERS (U.S.)

Abbreviations:
O.M. Old Master (1450–1700)
Mod. Modern (1700–c. 1945)
Contemp. Contemporary (c. 1945–)
Cat. Catalogs issued
Appt. Appointment necessary

Arizona
Phoenix
Art Consultants Ltd., 1846 E. Roosevelt St., 85006. Tel: (602) 271-9801. Contemp.
Scottsdale
RST Gallery, 7120 E. Indian School Rd., 85251. Tel: (602) 945-4557. Mod., Contemp.

California
Berkeley
Eurographics, 729 Spruce St., 94707. Tel: (415) 525-9089. O.M., Mod., Contemp.
Carmel
Art and Designs of Japan, P.O. Box 998, 93921. Tel: (408) 624-0820. Japanese, Appt.
Los Angeles
Victoria Keilus Dailey, 303 N. Sweetzer, 90069. Tel: (213) 658-8515. O.M., Mod., Cat., Appt.
DeVorzon Gallery, 744½ N. La Cienga Blvd., 90069. Tel: (213) 659-0555. Contemp.
Gemini G.E.L., 8365 Melrose Ave., 90069. Tel: (213) 651-0513. Contemp.
Betty Gold, 723½ N. La Cienga Blvd., 90069. Tel: (213) 657-1705. Mod.
Jeffrey Horvitz, Ltd., 1115 N. La Cienga Blvd., 90069. Tel: (213) 652-3296. Mod.
Margo Leavin Gallery, 812 N. Robertson Blvd., 90069. Tel: (213) 273-0603. Contemp.

Zeitlin & Ver Brugge, 815 N. La Cienga Blvd., 90069. Tel: (213) 652-0784. O.M., Mod., Cat.

Los Gatos

L'Estampe Originale, P.O. Box 926, 95030. Tel: (408) 356-1726. Mod., Cat.

Nicasio

R. E. Lewis, Inc., P.O. Box 72, 94946. Tel: (415) 924-4080. Mod., Appt.

Palm Desert

Horizon Graphics, 73-350 El Paseo, 92260. Tel: (714) 346-3975. Contemp.

San Francisco

Allrich Gallery, 2 Embarcadaro Center, 94111; Tel: (451) 398-8896. Mod., Contemp.

John Berggruen Gallery, 28 Grant Ave., 3rd floor, 94108. Tel: (415) 781-4629. Contemp.

Connoisseur's Gallery, 1 Embarcadero Centre, 94111. Tel: (415) 989-6189. O.M., Mod., Japanese

The Graphics Gallery, 1 Embarcadero Centre, 94111. Tel: (415) 989-7676. Contemp.

Hansen Fuller Gallery, 228 Grant Ave., 94108. Tel: (415) 982-6177. Contemp.

Pasquale Iannetti Associates, 680 Beach St., Suite 479, 94109. Tel: (415) 673-4027. O.M., Mod., Contemp., Cat.

Maxwell Graphics, Ltd., 551 Sutter St., 94102. Tel: (415) 421-5193. Mod., Contemp.

Phoenix Gallery, 257 Grant Ave., 94123. Tel. (415) 982-2171. Contemp.

Thackrey & Robertson, 2266 Union St., 94123. Tel: (415) 567-4842. Mod., Contemp.

Walton Galleries Inc., 577 Sutter St., 94102. Tel: (415) 391-8185. O.M., Mod., Contemp.

San Jose

The Ages Fine Arts, 4797 Raspberry Pl., 95129. Tel: (408) 247-4646. Mod., Contemp., Appt.

Santa Monica

La Tortue Galeria, 2917 Santa Monica Blvd., 90404. Tel: (213) 828-8878. Mod., Contemp.

Bethlehem *Connecticut*

June 1 Gallery, Bellamy La., 06751. Tel: (203) 266-7191. Mod., Cat., Appt.

Wilton

The Print Cabinet, Tiny House, Cannon Crossing, 06897. Tel: (203) 762-9893. O.M., Mod., Contemp.

District of **Washington**
Columbia Franz Bader Gallery, 2124 Pennsylvania Ave., N.W., 20037. Tel: (202) 337-5400. Mod., Contemp.

Fendrick Gallery, 3059 M Street, N.W., 20007. Tel: (202) 338-4544. Contemp.

Georgetown Graphics, 3209 O St., N.W., 20007. Tel: (202) 333-6307. Contemp.

Jane Haslem Gallery, 2121 P St., N.W., 20037. Tel: (202) 338-3014. Mod., Contemp., Cat.

Lunn Gallery/Graphics International Ltd., 3243 P St., N.W., 20007. Tel: (202) 338-5792. Mod., Contemp., Cat.

Mickelson Gallery, 707 G St., N.W., 20001. Tel: (202) 628-1735. Mod., Contemp.

Middendorf Gallery, 2014 P St., N.W., 20036. Tel: (202) 785-3750.

Florida **Captiva Island**

Untitled Press, 33924. Tel: (813) 472-1265. Contemp.

Jacksonville

Art Sources, 2101 Gulf Life Tower, 32207. Tel: (904) 396-5473. Contemp.

Miami

Gala Gallery, 2333 Biscayne Blvd., 33137. Tel: (305) 576-5885. Contemp.

Gloria Luria Gallery, 14700 Biscayne Blvd., 33137. Tel: (305) 949-3494.

Madden and Wechsler Galleries, 3490 Main Highway, 33133. Tel: (305) 445-7333.

Medici II Gallery, 1052 Kane Concourse, 33154. Tel: (305) 866-7016. Contemp.

Palm Beach

Hokin Gallery, 245 Worth Ave., 33480. Tel: (305) 665-5177. Contemp.

Georgia **Atlanta**

Mint Graphics, Inc., 229 Peachtree St., N.E., 30303. Tel: (404) 659-3770. Contemp., Appt.

Heath Gallery, 34 Lombardy Way, N.E., 30309. Tel: (404) 892-2277.

Honolulu *Hawaii*

Limited Edition Gallery, 1765 Ala Moana Blvd., 96814.
Tel: (808) 941-4522.

Chicago *Illinois*

Allan Frumkin Gallery, 620 N. Michigan Ave., 60611. Tel:
(312) 787-0563. Mod., Contemp., Cat.

Richard Gray Gallery, 620 N. Michigan Ave., 60611. Tel:
(312) 642-8877. Mod., Contemp.

R. S. Johnson-International Gallery, 645 N. Michigan Ave.,
60611. Tel: (312) 943-1661.

Douglas Kenyon, Inc., 230 E. Ohio Ave., 60611. Tel: (312)
642-5300. Mod., Contemp.

Marshall Field & Co., Antiquarian Book, Map and Print
Dept., 111 N. State St., 60602. Tel: (312) 781-4281.
O.M., Mod., Contemp.

Dorothy Rosenthal, 233 E. Ontario St., 60611. Tel: (312)
644-3224. Mod., Contemp.

Samuel Stein Fine Arts., Ltd., 620 N. Michigan Ave.,
Suite 340, 60611. Tel: (312) 337-1782. Mod., Contemp.

Van Straaten Gallery, 646 N. Michigan Ave., 60611. Tel:
(312) 642-2900. Contemp.

Oakbrook

Merrill Chase Galleries, Oakbrook Center, 60521. Tel:
(312) 654-0225. Mod., Contemp.

Riceville *Iowa*

Waverly Multiples, Box 118, 50466. Tel: (515) 985-2560.
Contemp.

Shawnee Mission *Kansas*

Morgan Art Gallery, 5006 State Line, 66205. Tel: (913)
236-7796. Contemp.

New Orleans *Louisiana*

Ronnie R. Brenner, 1213 Fourth St., 70130. Tel: (504)
899-6236. Mod., Contemp., Appt.

Tahir Gallery, 823 Chartres St., 70116. Tel: (504) 525-
3095. Mod., Contemp., Cat.

Baltimore *Maryland*

Ferdinand Roten Galleries, Inc., 123 W. Mulberry St.,
21201. Tel: (301) 837-7723. O.M., Mod., Contemp.,
Cat.

The Tomlinson Collection, Inc., 711 W. 40th St., 21211.
Tel: (301) 338-1555. O.M., Mod., Contemp., Cat.

Bethesda

Bethesda Art Gallery, 7950 Norfolk Ave., 20014. Tel: (301) 656-6665. Mod.

Capricorn Gallery, 8004 Norfolk Ave., 20014. Tel: (301) 657-3477. Mod.

Towson

Erikson Fine Prints, 8415 Bellona La., Suite 313, 21204. Tel: (301) 828-1131. O.M., Mod., Cat., Appt.

Belmont

Massachusetts Lee Gallery, 94 Juniper Rd., 02178. Tel: (617) 484-6481. Contemp.

Boston

Childs Gallery, P.O. Box P, 169 Newbury St., 02116. Tel: (617) 266-1108. Mod., Cat.

Graphics 1 and Graphics 2, 168 Newbury St., 02116. Tel: (617) 266-2475. Mod., Contemp., Cat.

Harcus-Krakow-Sonnabend-Rosen, 7 Newbury St., 02116. Tel: (617) 262-4483.

Impressions Workshop, 29 Stanhope St., 02116. Tel: (617) 262-0783. Contemp.

R. M. Light, 190 Marlborough St., 02116. Tel: (617) CO 7-6642. O.M., Mod., Appt.

Nielsen Gallery, 179 Newbury St., 02116. Tel: (617) 266-4835. Mod., Contemp.

Angus Whyte Gallery, 121 Pinckney St., 02114. Tel: (617) 723-9607. Mod., Contemp., Cat., Appt.

Cambridge

DG Editions, 2325 Massachusetts Ave., 02140. Tel: (617) 868-5404. Mod., Contemp.

Newton Centre

Horizon Gallery, 43 Glendale Rd., 02159. Contemp.

West Somerville

Gropper Art Gallery, 58 Day St., P.O. Box 326, 02144. Tel: (617) 666-5644. Mod., Cat., Appt.

Michigan **Ann Arbor**

Michael S. Sachs, Inc., 216 N. State St., 48108. Tel: (313) 665-9388. Mod., Cat., Appt.

Alice Simsar Gallery, 301 N. Main St., 48104. Tel: (313) 761-0707. Contemp.

Detroit

Gertrude Kasle Gallery, 310 Fischer Bldg., 48202. Tel: (313) 875-9006.

London Arts Inc., 321 Bldg., 48202. Tel: (313) 871-3606. Mod., Contemp.

Lakeside

Lakeside Studio, 150 S. Lakeshore Rd., 49116. Tel: (616) 469-1377. O.M., Mod., Contemp., Cat.

Royal Oak

Klein-Vogel, 4520 N. Woodward Ave., 48072. Tel: (313) 647-7709. Mod.

Minneapolis *Minnesota*

Peter M. David Gallery Inc., 920 Nicolet Mall, 430 Oak Grove St., Suite 216101, 55402. Tel: (612) 870-7344. Contemp.

Dayton's Gallery 12, 700 On the Mall, 55402. Tel: (612) 375-2465. Contemp.

Glen Hanson Fine Arts, 2440 Girard Ave. S., 55405. Tel: (612) 377-4386. Contemp.

St. Paul

Richard Doth Fine Arts, 3134 N. Victoria St., 55112. Tel: (612) 484-9483. Contemp., Appt.

Jefferson City *Missouri*

Art Investment Advisors, Inc., 2251 West McCarty, 65101. Tel: (314) 634 3546, Mod., Contemp.

Kansas City

Galerie Spielhagen, 825 Westport Rd., 64111. Tel: (816) 531-2588. Mod., Contemp.

St. Louis

Nancy Singer Gallery, 31 Crestwood Dr., 63105. Tel: (314) 727-1830. Contemp.

Santa Fe *New Mexico*

Janus Gallery, 16½ East Palace Ave., 87501. Tel: (505) 983-1590. Contemp.

Bayshore *New York*

Huntington Gallery, Box 430, 11706. Tel: (516) 587-7847. Mod., Appt.

Brooklyn

Paul McCarron, P.O. Box 735, 11202. Tel: (212) 858-5024. O.M., Mod., Appt.

Cold Spring Harbor

Harbor Gallery, 43 Main St., 11724. Tel: (516) 692-9526. Mod., Contemp., Cat.

Glen Head

Mason Fine Prints, Quaker Ridge Dr., 11545. Tel: (516) 681-4284. Mod., Cat., Appt.

Larchmont

Art Fair, 126 Larchmont Ave., 10538. Tel: (914) 834-9474. Mod., Contemp., Japanese

New York City

Aberbach Fine Art, 988 Madison Ave., 10021. Tel: (212) 988-1100. Contemp.

Brooke Alexander Inc., 26 E. 78 St., 10021. Tel: (212) 988-2056. Contemp., Cat.

Associated American Artists, 663 Fifth Ave., 10022. Tel: (212) 755-4211. O.M., Mod., Contemp., Cat.

La Boetie, Inc., 9 E. 82nd St., 10028. Tel: (212) 535-4865. Mod.

Bogart Gallery, 32 E. 58th St., 10022. Tel: (212) 628-1735. Mod., Contemp.

Brentano's, 586 Fifth Ave., 10036. Tel: (212) 757-8600. Mod., Contemp.

Brewster Gallery, 1018 Madison Ave., 10028. Tel: (212) 472-9481. Mod., Contemp.

Aldis Browne Fine Arts Ltd., 20 E. 53rd St., 10022. Tel: (212) 593-3560. Mod., Cat., Appt.

Cass Canfield Collection, FAR Gallery, 746 Madison Ave., 10021. Tel: (212) 288-5493. Mod., Contemp., Appt.

Carus Gallery, 1044 Madison Ave., 10028. Tel: (212) 879-4660. Mod., Cat.

Castelli Graphics, 4 E. 77th St., 10021. Tel: (212) 288-4601. Contemp.

Richard A. Cohn Fine Arts, 41 Central Park W., 10023. Tel: (212) 799-6675. O.M., Mod., Appt.

Martin Diamond Fine Arts, Inc., 16 E. 79 St., 10021. Tel: (212) 988-3600. Mod., Contemp.

Terry Dintenfass, Inc., 50 W. 57 St., 10019. Tel: (212) 744-1580. Contemp.

Lynn G. Epsteen, 219 E. 69th St., 10021. Tel: (212) 753-2408. Mod., Contemp., Appt.

FAR Gallery, 746 Madison Ave., 10021. Tel: (212) 734-7287. Contemp.

Margo Feiden Galleries, 51 E. 10th St., 10003. Tel: (212) 677-5330. Mod., Contemp.

Ronald Feldman Fine Arts, Inc., 33 E. 74th St., 10021. Tel: (212) 249-4050. Contemp.

Fitch-Febvrel, 601 W. 115th St., 10025. Tel: (212) 666-0550. Mod., Contemp.

Fourcade Droll, Inc., 36 E. 75th St., 10021. Tel: (212) 535-3980. Contemp., Appt.

Allan Frumkin Gallery, 41 E. 57th St., 10021. Tel: (212) 752-0122. Mod., Contemp.

Galerie St. Etienne, 24 W. 57th St., 10019. Tel: (212) 245-6734. Mod.

Getler/Pall, P.O. Box 580, Lenox Hill Station, 10021. Tel: (212) 371-5424. Mod., Contemp., Cat., Appt.

Gimpel & Weitzenhoffer Graphics, 1040 Madison Ave., 10021. Tel: (212) 628-1897. Mod., Contemp.

Golden Lion Gallery, 1437 First Ave., 10021. Tel: (212) 861-0270. Contemp., Appt.

Lucien Goldschmidt Inc., 1117 Madison Ave., 10028. Tel: (212) 879-0070. O.M., Mod., Cat.

C. & J. Goodfriend, 309 W. 104th St., 10025. Tel: (212) 663-7095. O.M., Mod., Appt.

James Goodman Gallery/Goff Fine Arts, Inc., 55 E. 86th St., 10028. Tel: (212) 427-8383. Contemp.

Martin Gordon, P.O. Box 517, Gracie Station, 10028. Tel: (212) 249-7350. Mod., Appt.

Graham Gallery, 1014 Madison Ave., 10021. Tel: (212) 535-5767. Mod.

Juliette Halioua, 37 E. 67th St., 10021. Tel: (212) 794-2757. Contemp.

Hirschl & Adler Galleries, Inc., 21 E. 67th St., 10021. Tel: (212) 535-8810. Mod.

Hundred Acres Gallery, 456 West Broadway, 10012. Tel: (212) 533-2250. Contemp.

Isselbacher Gallery, 1225 Madison Ave., 10028. Tel: (212) 831-4741. Mod.

Martha Jackson Gallery, 32 E. 69th St., 10021. Tel: (212) 988-1800. Contemp., Appt.

Japan Gallery, 1210 Lexington Ave., 10028. Tel: (212) 288-2241. Japanese

Kahan/Esikoff Fine Arts Ltd., 922 Madison Ave., 10021. Tel: (212) 744-1490. Mod., Contemp.

Kennedy Galleries, Inc., 40 W. 57th St., 5th floor, 10019. Tel: (212) 541-9600. O.M., Mod., Cat.

Knoedler and Co. Inc., 21 E. 70th St., 10021. Tel: (212) 628-0400. Contemp.

Kraushaar Galleries, 1055 Madison Ave., 10028. Tel: (212) 535-9888. Mod., Contemp.

Kathryn Markel Fine Arts, 72 E. 79th St., 10021. Tel: (212) 744-3325. Contemp., Appt.

Marlborough Graphics, 40 W. 57th St., 10019. Tel: (212) 541-4900. Mod., Contemp.

Midtown Galleries, 11 E. 57th St., 10022. Tel: (212) PL 8-1900. Mod.

Morris Gallery, 174 Waverly Pl., 10014. Tel: (212) 929-5425.

Multiples, Inc., 927 Madison Ave., 10021. Tel: (212) 249-3250. Contemp.

The Pace Gallery, 32 E. 57th St., 10022. Tel: (212) 421-3237. Contemp., Cat.

Parasol Press Ltd., 126 E. 79th St., 10021. Tel: (212) 249-0051. Contemp.

Petersburg Press Inc., 18 E. 81st St., 10028. Tel: (212) 249-4400. Contemp.

Prints on Prince Street, 29 Prince St., 10012. Tel: (212) 966-6403. Contemp.

Raydon Gallery, 1091 Madison Ave., 10028. Tel: (212) 535-4300. Mod.

Reiss-Cohen Inc., 982 Madison Ave., 10028. Tel: (212) 628-2496. Mod.

Ferdinand Roten Galleries, 20 University Place, 10003. Tel: (212) 260-4280. O.M., Mod., Contemp., Cat.

Saidenberg Galleries, 16 E. 79th St., 10021. Tel: (212) 288-3387. Mod.

Margo Pollins Schab, Inc., 1000 Park Ave., 10028. Tel: (212) 861-1816. Mod., Contemp., Cat., Appt.

William H. Schab Gallery Inc., 37 W. 57th St., 10019. Tel: (212) 758-0327. O.M., Mod.

Sindin Galleries, 1035 Madison Ave., 10021. Tel: (212) 288-7902. Mod., Contemp.

Terrain Graphics, 498 Broome St., 10012. Tel: (212) 966-0015. Contemp.

Transworld Art Corp., 600 5th Ave., 10020. Tel: (212) 247-6250. Contemp., Cat.

David Tunick, 12 E. 80th St., 10021. Tel: (212) 861-7710. O.M., Mod., Cat., Appt.

Tunnel Gallery, 232 E. 59th St., 10022. Tel: (212) 688-7141. Contemp.

The Uptown Gallery, 1194 Madison Ave., 10028. Tel: (212) 722-3677. Mod., Contemp.

Vorpal-Soho, 465 W. Broadway, 10012. Tel: (212) 777-3939. Mod., Contemp.

Washington Irving Gallery, 126 E. 16th St., 10003. Tel: (212) 982-3950. Mod., Appt.

Barney Weinger Gallery, 41 E. 57th St., 10022. Tel: (212) 742-6930. Contemp.

Weintraub Gallery, 992 Madison Ave., 10021. Tel: (212) 879-1195. Mod.

E. Weyhe Inc., 794 Lexington Ave., 10021. Tel: (212) 838-5478. Mod.

Zabriskie Gallery, 29 W. 57th St., 8th floor, 10019. Tel: (212) 832-9034. Contemp.

Port Washington

Graphic Eye Gallery, 111 Main St., 11050. Tel: (516) 883-9668. Contemp.

Victor

Merlin Dailey, 27 Main St., 14564. Tel: (716) 924-5830. Japanese

Cleveland *Ohio*

New Gallery, 11427 Bellflower Rd., 44106. Tel: (216) 765-2558. Contemp.

Clarion *Pennsylvania*

The Print Room, Box 585, 16214. Tel: (814) 226-6636. Mod., Contemp.

Philadelphia

Hahn Gallery, 8439 Germantown Ave., 19118. Tel: (215) 247-8439. Mod.

The Print Club, 1614 Latimer St., 19103. Tel: (215) 735-6090. Contemp.

Pittsburgh

Kingpitcher Gallery, 303 S. Craig, 15213. Tel: (412) 687-4343. Contemp.

Dallas *Texas*

Delahunty Gallery, 2817 Allan St., 75204. Contemp.

Houston

Marjorie Kauffman Gallery, The Galleria, 5015 Westheimer, 77027. Tel: (713) 622-6001.

Robinson Graphics (Division of Robinson Galleries, 2nd

floor), 1100 Bissonnet, 77005. Tel: (713) 528-6286. Mod., Contemp.

San Antonio

Glasser's Art Gallery, 1522 N. Main, 78212. Tel: (512) 222-8633. Contemp., Oriental.

Vermont **Ferrisburgh**

Four Winds, 05456. Tel: (802) 425-2101. Contemp.

Virginia **Alexandria**

Wolfe Street Gallery, 420 S. Washington St., 22314. Tel: (703) 836-1332. Mod., Contemp.

Charlottesville

Paul Victorius, 1413 University Ave., 22903. Tel: (804) 293-3342. New, O.P., Rare

Washington **Mercer Island**

Davidson Galleries, 2766 77th St., S.E., 98040. Tel: (206) 232-1580. O.M., Mod., Contemp., Cat.

Seattle

Davidson Galleries, 116½ South Washington St., Pioneer Square, 98104. Tel: (206) 623-8431. O.M., Mod., Contemp., Cat.

Dootson/Calderhead Gallery, 311½ Occidental So., 98104. Tel: (206) 623-8431. Contemp.

Wisconsin **Milwaukee**

Irving Galleries, 404 East Wisconsin Ave., 53202. Tel: (414) 276-5730.

PRINT DEALERS (CANADA)

Montreal

Avant-Garde Gallery, 1545 McGregor Ave. Tel: (514) 935-1713. Contemp.

Galerie B, 2175 Crescent. Tel: (514) 844-6950. Contemp.

Galerie Marlborough-Godard, 1490 Sherbrooke Ouest. Tel: (514) 931-5841. Contemp.

Gallery Moos Inc., 1430 Sherbrooke St. W. Tel: (514) 842-2747. Mod., Contemp.

Waddington Galleries, 1456 Sherbrooke St. W. Tel: (514) 844-5455. Contemp.

Ottawa

Wells Gallery, 459 Sussex Dr. Contemp.

Toronto

Aggregation Gallery, 83 Front St. E. Tel: (416) 364-8716. Contemp.

Walter Engel Gallery, 2100 Bathurst St., Suite 113. Tel: (416) 781-0968. Mod., Contemp.

Gallery Moos Ltd., 138 Yorkville Ave. Tel: (416) 922-0627. Mod., Contemp.

Merton Gallery, 68 Merton St. Tel: (416) 481-1986. Contemp.

Morris Gallery, 15 Prince Arthur Ave. Tel: (416) 922-4778. Contemp.

Pollock Gallery Ltd., 356 Dundas St. W. Tel: (416) 366-8861. Contemp.

Vancouver

Equinox Gallery, 3rd floor, 1535 W. 8th Ave. Tel: (604) 736-2405.

PRINT DEALERS (MEXICO)

Acapulco

Tasende, Costera Y Yanez Pinzon. Tel: 4-10-04. Contemp.

Mexico City

Arte de Colleccionistas, Hotel Maria Isabel, Paseo de la Reforma 325-10A. Tel: 25 90 60, ext. 91.

MACBETH, ROBERT WALKER (1848–1910) *The Trial Proof*
Etching. c. 1887. Ed: 350. 3¼″ x 4⅝″. Courtesy of Mason Fine Prints.

Perhaps of all the creations of man, language is the most astonishing.
Lytton Strachey, *Words and Poetry*, c. 1922.

10. *Glossaries*

GLOSSARY OF FINE PRINT TERMS

acetate cellulose A transparent synthetic material available either in sheets or rolls. Used for relatively short-term protection of prints from surface soiling.

acid 1. A chemical compound used in graphic processes such as etching and lithography.
2. A chemical compound contained in materials such as paper made from wood pulp.

acid-free board A matboard for works of art on paper made from materials containing no acid.

acid-neutralizing paper "Permalife," a trade name, is an example of this type of paper, which contains a neutralizer intended to absorb any acidity that may appear in the environment of a stored work of art on paper.

ad vivum (Lat.—from life) To indicate that a portrait was done from life, not from a painting.

after A print made from another work—a drawing, painting, etc.—by a second artist or craftsman. See *après*. Compare with *ad vivum*.

all-rag paper All-rag paper is made of 100 percent rag materials. Rag *content* paper is made with a smaller percentage of rag fiber.

après (Fr.) See *after*.

aqua forte (Fr.) Etching.

aquatint A method of creating tone or texture on an etching plate by means of rosin dust or spray paint. Aquatints can be recognized by their use of tonal values rather than line or tones built up by line.

Arches The trade name and watermark of a modern French paper manufacturer. Widely used for modern and contemporary prints.

artist's proofs Usually designated on prints as A/P. Prints outside the regular edition which artists may dispose of as they wish.

auction terms See *bid; bid sheet; buy-in; lot; mailed bid; owned property; reserved; sealed bid.*

backing board A smooth, flat, stiff material used to support the back of a print. Also called mounting board.

bath; acid bath The acid solution in which a plate is etched or bitten.

bevel A frame, plate, or stone may have the sloping edge known as a bevel. The act of filing the stone or plate at an angle is called "beveling."

bid The price offered for a lot at an auction.

bid sheet The printed form for submitting written offers, or bids, in advance of an auction.

binocular magnifier A magnifier suitable for use with both eyes, generally supported by a band for placement on the head.

bister or **bistre** An artist's medium having a yellow brown or dark brown color.

bite The penetration of acid into a metal plate. The biting time indicates the period of time a plate remains in the acid bath.

bleeding The seepage of ink beyond the line or shape on the plate. May be caused by too much oil in the ink or too much pressure or both.

blindstamp A colophon embossed or impressed without ink onto the paper used for a print, usually to identify the publisher or printer.

bon à tirer (Fr.—good to pull) The proof so marked is the one by which the edition is guided because it has been found satisfactory. See *printer's proof.*

brayer See *rollers.*

buckling A warp, bulge, or depression in paper.

burin; graver A sharp cutting tool used in etching, engraving, drypoint, etc.

burnisher A tool used to rub lines on a metal plate, thus diminishing their depth and causing them to print more faintly.

burr Area of roughness raised above the surface of the plate by the engraving tool cutting into metal. The burr causes the line, when printed, to appear somewhat blurred or fuzzy. Since burr wears away rapidly, the presence or absence of it often allows estimates of whether a print is an early or late impression. Most common with drypoints. See *steel facing.*

buy-in Purchases by an auction house for their own account during an auction they are conducting.

canceling Defacing the stone, plate, screen, or block in order to prevent its further use.

cancellation proof The proof made from a stone, plate, block, or screen that has been deliberately defaced in order to show that the edition has been completed and that no further impressions can be made. Such cancellation marks can range from an inconspicuous symbol on one corner of a print to a bold X drawn strongly through the image. The practice is largely contemporary, and even today many prints are not canceled.

carbograph A technique on a metal plate by which an effect similar to mezzotint can be achieved with less time and labor through the use of carborundum and a levigator. It was perfected around 1939 in the Pennsylvania Art Project (WPA). See *mezzotint*.

catalog, catalogue Classified list in which each entry is followed by a brief description. An exhibition catalog lists and describes work being shown.

cellocut A contemporary printmaking technique in which a surface is built up on its supporting plate—which may be of almost any material. The surface may be further altered by cutting or scraping. Thus it may combine intaglio and relief processes.

chain lines The widely spaced watermark lines that go with the grain of laid paper. They result from the chainwires that hold the laid wires together.

check list A brief list of items, usually of an exhibition or collection, containing few details.

chiaroscuro (It.—light-dark, clear-obscure) A woodcut technique, developed in the 16th century, that employs a key block printed in black or a dark color for details, and one or more other blocks for the light tones and highlights.

China paper Handmade Oriental paper made from plant fibers and originating in China.

chop The symbol, colophon, or special mark embossed on paper in order to identify an artist, collector, printer, or workshop. See *blindstamp*.

chromolithograph A lithographic technique using different stones or plates for each color. Usually implies reproductive or machine process.

cockle A pucker, bulge, or ripple in paper caused by uneven tension during its manufacture or by atmospheric changes during its use.

collector's mark An identifying stamped mark placed on a print by a collector. Such marks may be helpful in tracing the provenance of a print, although in the past collector's marks were frequently stamped on prints in locations more conspicuous than desirable.

collograph A print pulled from a surface of varying layers achieved in the manner of a collage. A contemporary technique frequently combining surface and intaglio methods.

collotype A photomechanical method for reproducing prints.

colophon An emblematic design. See *blindstamp; chop*.

color print A print of more than one color. Color prints can be made from one or multiple plates, stones, blocks, or screens. See *à la poupée*.

color separations Separate proofs, on individual sheets, of each color that will later be combined on one sheet to form the color print.

conservation Preservation of an object in its current state; the prevention of further loss, injury, or decay.

contemporary In art, circa 1945 to the present.

counterproof Prints other than silkscreens are normally the reverse, or mirror, images of what has been drawn or incised on the plate, stone, or block. A proof made from a wet print would reverse the image again, thus returning it to the way it looked on the plate, stone, or block. Artists frequently make counterproofs in order to correct a print, as it is easier to compare with the plate itself than an ordinary proof.

crayon manner See *stipple*.

criblé or **dotted print** A print made by punching dots into the metal plate. The image may be printed either as in engraving or as a relief print.

cross-hatching A method of creating areas of shading. Sets of parallel lines cross at angles to each other, and depending on how wide the lines are and how close together they are, an effect of shadow can be achieved.

dandy roll A light, wire-covered roll that rides on the wet web of paper to compact the sheet and sometimes impress a watermark.

deckle edge The rough, untrimmed edge usual to many handmade papers. Sometimes commercial paper is torn similarly.

del., delineavit (Lat.—he drew [it]).

deterioration The breakdown of paper, which may be caused by its original properties and materials, the environment in which it has been placed, or the aging process.

direct transfer To convey an image in lithography from an inked material, such as transfer paper, onto the stone or plate.

drypoint An intaglio method using a hard steel or diamond point needle to scratch an image into a copper, zinc, or soft steel plate. The burr raised gives drypoints their characteristic quality when printed, but because it wears away quickly, most drypoints are steelfaced. See *burr; steelfacing*.

Dutch paper Handmade laid paper, usually with watermark, made since the 17th century. Obtained by Dutch paper importers from French paper makers.

edition The total number of prints made by an artist (with or without the assistance of a printer) of a specific image. Most modern prints are issued in one limited edition only. However, some have gone into 6, 7, and 8 editions. A restrike is often called a late edition. See *late edition; limited edition; restrike*.

embossed print A print in which all or part of the image has been pressed into or raised from the paper by the incised or built-up un-inked plate or block.

encaustic color printing A method for printing, developed in the 1940s, in which colored wax or encaustic crayons are used as the medium instead of colored inks.

end grain block The plate used in wood engraving. It is made of small

pieces of wood, usually boxwood or maple, cut across the grain so that the graver can cut in any direction without splitting the wood. This makes it possible to incise very fine detail into the plate. See *plank-grain plate.*

engraving Etching, drypoint, xylography are all varieties of the engraving technique in which a sharp tool is used to incise lines into a metal or wood plate. On metal plates, the lines that have been cut away are printed, making this an intaglio method. In wood engraving, it is the surface remaining after material has been cut away that prints the image.

estate stamp A mark placed, by an authorized person, upon the work of a deceased artist, to document its authenticity.

estimate Price range, published in the appropriate catalog by an auction house, of the probable selling price of a specific lot. The range is usually arrived at by analysis of performance of similar material at recent sales.

etching An intaglio process in which a metal plate is covered with an acid-resistant material before being drawn on. Each mark made by the drawing tool removes the material in the area incised, thus allowing acid to penetrate when the plate is placed in the acid bath. These exposed areas will be *bitten* by the acid to a depth dependent upon the length of time they remain in the solution. The bitten areas, when inked, will print, while the protected areas will not. Also the term for prints made in this way. **etch** In lithography an etch is used to desensitize and/or clean the plate or stone. See *bath; bite.* **etching ground** An acid-resistant coating applied to a metal plate.. It dries hard. **lift ground etching** A method in which the image is painted on the metal plate with a water soluble solution. Etchings made by this method frequently give the effect of brush drawing. It may be combined with other etching techniques. **relief etching** An etching in which a process of biting the plate so that surfaces, rather than bitten lines, are used in printing. **soft ground etching** The acid-resistant material used to protect the plate is "soft," thereby allowing it to take various textural impressions in a manner different from the usual "hard" ground etching. **sugar lift etching** Method of drawing or painting an image on a metal plate by means of a viscous fluid combining India ink and sugar. A ground is then sprayed over the entire plate, covering the drawing. When the ground is dry the plate is placed in warm water, so that the sugar-lift drawing is washed away and the image is exposed. The plate is then bitten in the usual way.

etching needle A tool used to draw the image on the plate by removing the wax ground, thereby exposing the image on the plate's surface.

exc., excud, excudit (Lat.—published by; also printed by) Mainly in popular prints.

f., fec., fecit (Lat.—made by).

feathering To use a feather, when a plate is immersed in an acid bath,

to move the bubbles that indicate that the acid is biting into metal. Thus the depth of the bite is to some degree controlled.

floating hinge Hinge applied to verso of print in such a manner as to be invisible to the viewer.

foul biting The accidental etching of an area when the acid has worked its way through the ground covering a plate.

foxed, foxing Spots of various sizes and intensities, usually brownish, that disfigure paper. May be caused by dampness, fungus, paper impurities, or any combination of these.

glassine A dense, semitransparent paper not easily penetrated by air. Acid-free glassine may be used to protect stored prints.

gouges Tools used for cutting images into wood or linoleum plates.

grain In woodcuts, the grain of the wood block, which varies with tree and type of cut. In lithography, the grain of the stone, which can be coarse or fine.

graver See *burin*.

ground The coating that protects an etching plate from the action of the acid solution when it is placed in a bath. See *etching*.

half-tone A photographic method of producing reproductions. The dots inherent in this method can usually be seen with the aid of a magnifying glass.

handmade paper Paper made entirely by manual techniques. Usually considered most desirable for prints.

hinge A paper or muslin strip that attaches a print to its back board.

hors commerce (H/C) (Fr.—outside commerce) A sample copy for salesmen, not counted as part of the edition, and not intended for sale.

imp., imprimavit (Lat.—printed, printer) Some modern and contemporary artists place "imp" in parentheses after their names to indicate that they have printed the impression themselves.

impression A single print made from a plate—stone, wood, metal, or other material.

inc., incid., incidit (Lat.—engraved)

incunabula Books printed before 1500, when printing was in its infancy.

India paper Often called rice paper. A strong, thin, dull-finished paper. See *rice paper*.

ink Printing inks are made in a variety of ways for different processes. Thus lithography ink differs from etching ink, which in turn is different from the ink used for woodcuts. Inks used in these printing processes are generally made of oil and pigment, but in some instances inks have a water base rather than an oil base.

inkless intaglio A technique in which a raised portion of the plate is printed with heavy pressure, without ink, thereby causing an impressed image. Also called embossing or blind embossing.

intaglio Any one of the printmaking methods in which the portions of the surface of the plate are cut or bitten away, or in which portions of the plate are built up or raised. In either case, with or without ink, portions of the image will be impressed to a greater or lesser degree into the paper. See *drypoint; engraving; etching; mezzotint* for specific intaglio methods, as well as *inkless intaglio*.

intaglio mixed methods More than one intaglio method can be used in one print. For example, Rembrandt combined traditional acid-bitten etching technique with drypoint, in which the line is scratched directly into metal.

intaglio relief A print made by inking the surface rather than the etched or engraved lines of an intaglio plate.

inv., invenit (Lat.—designed or invented)

Japanese paper Very absorbent high-quality paper made from plant fibers, mainly mulberry and hemp.

Japanese print A woodcut made from plank-grain wood in Japan according to traditional methods, sometimes from one block and at others from many.

key plate The wood or metal plate or lithographic stone or serigraph screen used as a guide to registration in printing color editions.

laid down Term used when a print is pasted directly onto a backing material without hinging.

laid paper Paper showing the wire marks of the mold or dandy roll used in the process of manufacture.

late editions Prints pulled any time after completion of original edition.

lifetime impression Prints pulled during artist's lifetime.

lift ground See *etching*.

light stain Discoloration on paper caused by overexposure to any light source containing ultra-violet rays—especially sunlight and fluorescent light and, to a lesser degree, incandescent light.

limited edition A set number of multiple originals, the number publicly acknowledged, of an original print. Usually the plate, stone, or screen is mutilated or destroyed after the determined number of impressions has been made. See *canceling*.

line engraving See *engraving*.

linoleum cut, linocut The technique of cutting an image for a print in linoleum rather than wood or metal or other materials. As in woodcuts it is the raised surfaces remaining that accept the ink and are seen in the completed print.

lith., lith. by Seen after a name, indicates the person who drew the image on the stone, although the design may have been that of another artist. Sometimes has been used to show that the print was made by a lithographic process.

lithographic crayons Grease crayons used in lithography to draw the image on the stone or plate.

lithographic stones Limestone, usually Bavarian, cut in rectangles up to 3 or 4 feet in either dimension and several inches thick, on which the images for lithographs are drawn and from which they are printed on paper by means of a lithograph press. The face of the stone may be ground clean and the stone reused.

lithography One of the major printmaking processes since its invention late in the 18th century. A drawing is made with a greasy material on a stone (or plate or various other substances). When the surface has been treated in the appropriate way, the image (the greased portion) will accept printing inks and the remaining areas repel it. Impressions are printed by means of a litho press. It is a planographic method.

lithotint A lithograph made by means of a wash technique. Obsolete.

lot One or more items offered at auction as a single unit.

machine-made paper Paper made by machine rather than by hand. Because of its lower cost, most prints made in the last 100 years or so have been printed on machine-made paper, which may be of any quality, made by any new or traditional method, and of any degree (or lack) of acidity.

mall bid See *sealed bid.*

margin The unused portion of paper that borders the printed area of a print; the blank paper outside the plate marks.

mat A stiff material, such as cardboard, cut out in the center so that it forms a border between the outer edges of a picture and the inner edge of its frame. Acid-free mat board is specifically designed for use with works of art on paper.

mat stain Stain caused on print by contact with acidic matting material.

metal cut Certain old engravings were printed from the surface rather than from the incised lines—the more usual practice. These were given the name "metal cut" or "relief print."

metal print A type of collograph in which the metal parts carrying the image are soldered together as one plate.

mezzotint An intaglio process in which the entire surface of a plate is roughened with a tool called a rocker to produce a black or dark tone. The printmaker reveals the image desired by scraping and burnishing away certain areas, working from the dark to light tones. While few printmakers use this process today, it was immensely popular in 18th-century England, where it was used to reproduce portraits. It is sometimes called *"la manière anglaise"* or *"manière noir."* See *carbograph.*

minimum price guarantee Auction term meaning the confidential minimum price which, in certain instances, the auction gallery has contractu-

ally agreed that the seller will receive regardless of whether bids at the sale reach the guaranteed sum. The seller pays an additional commission for this guarantee.

mixed intaglio A print in which more than one intaglio method is used—e.g., etching and drypoint, or engraving and inkless embossing.

mixed media A print in which two or more printmaking techniques are used—e.g., silkscreen and woodcut.

modern As applied to prints in this book, the period from 1700–c. 1945. Generally the modern period is said to start with the French Revolution, 1789.

monoprint, monotype One print, usually made by painting or drawing in one or several colors, in any of a variety of media, on a nonabsorbent surface. Paper laid over the surface and pressed will accept a negative image, which is called a monotype. But repetition of the process will not result in an exact duplicate, thereby causing some artists and critics to deny the monotype's classification as a print.

mordant A term for the acid solution in which etching plates are placed.

mount To hinge to backboard. See *laid down.*

mounting board See *backing board.*

multiple One work of art in an edition of which there are numbers of duplicate impressions.

museum board A 100 percent acid-free matting and backing material.

Mylar A trade name for a clear, flexible, plastic sheet used to protect prints for short periods of time.

nickel plating A technique of electroplating a nickel surface onto a copperplate engraving in order to increase its printing life.

offset printing A method, begun late in the 19th century and used mainly for printing large numbers of impressions, in which the image is transferred from one roller (or plate) to another and then printed on paper. A reversed mirror image is inherent in the usual printmaking techniques. This transfer of the image to a second roller before its final transfer to paper allows the reversal to be avoided.

Old Master Those artists in Western Europe whose prints were produced between 1450 and 1700.

owned property The following is taken from a Sotheby Parke Bernet Catalog: ". . . property which, at the time it is offered for sale at auction, is owned solely or partially by the Galleries or an affiliate of the Galleries (and in the sale of which the Galleries is acting as a principal and not an agent)."

paper See *acid-free; acidic; Arches; China paper; dandy roll; Dutch paper; handmade paper; India paper; Japanese paper; laid paper (chain lines; wire lines); machine-made paper; tissue paper; watermark; wove paper.*

paper loss Absence, in any degree, of an area of original paper.

parchment Used before the introduction of paper as a writing surface, parchment is usually made from the inner side of the skin of sheep. Because of its long life, it continues to be used for important documents.

Permalife paper A trade name for an acid-neutralizing paper.

pH scale 7 is neutral: below that, the material is acidic; above, it is alkaline.

photoengraving See *photomechanical process.*

photo-intaglio A method by which an image is transferred photomechanically onto a plate, which is then etched in an acid solution and printed by the usual means.

photolithography A method by which an image is transferred photomechanically onto a prepared lithograph stone or plate, which is then inked and printed by the usual means.

photomechanical process; process prints Procedures whereby the image is transferred to the plate by photographic means. Until relatively recently these techniques were used commercially only. Today some photographic methods have been adapted by some fine artists in making prints.

pin hole A minute, pinpoint-sized opening in paper. Can be caused by deterioration or by the use of pins in drying process.

pinx., pinxl., pinxit (Lat.—painted, painter)

pitting See *foul biting.*

plank-grain plate A plate or block for woodcuts in which the wood has been cut parallel with the grain rather than across the grain, as in "end-grain."

planographic Printing from a flat surface plane, as in lithography. (Compare with etching, which is printed from a recessed or cut-away surface, and collograph, which is printed from several levels or built-up surfaces.)

plaster print A print in which the plate has been made in whole or part from plaster or one made by casting plaster on an inked plate.

plate A surface, usually wood or metal but may also be cardboard, plastic, stone, etc., on which an image is engraved or built, and from which an impression may be printed.

plate mark The marks or ridge of the edge of the plate resulting from the pressure of the printing press onto paper in the intaglio processes.

plate tone Tonal effect produced by manner of the application of ink onto the plate.

plug A wedge of wood forced into a cut-out area of wood block in order to provide a new surface for making corrections.

pochoir (Fr.—stencil) A stencil and stencil-brush process for making multicolor prints; for tinting black-and-white prints; and for coloring reproductions. Sometimes called hand coloring.

portfolio 1. A specially designed cover for a group of original prints, usually related in theme, by one or several artists, sometimes containing a title page and colophon. Sometimes termed "suite." 2. A portable carrying case for prints or drawings.

à la poupée (Fr.) A method of making color prints in which one plate instead of several is used.

print Any one of the multiple impressions made on paper from the same plate, block, stone, screen, or film negative.

print edition The prints included in a set of multiple originals, the numbering based on the artist's decision as to how many are to be pulled.

printer's proof A proof bearing the artist's signature, indicating that the plate is now ready for making final prints. Virtually the same as *bon à tirer*.

print size The size of the printed image exclusive of margins and/or printed titles. Generally given as height before width.

progressive proof In certain color printing processes a plate is needed for each additional color. Progressive proofs show the print as the second plate is printed over the first, the third over the first and second, and so on.

proof An impression of a print in any medium made at any stage of work.

proof before letters Many 17th, 18th, and 19th-century engravings carried printed matter on the lower margin identifying the name of the artists who made the original drawing or painting, and the name of the engraver, publisher, title of the print, date of execution, etc. The prints pulled before this material was added were limited and more highly valued.

publisher A publisher commissions from an artist an entire edition of prints—be they 10 or 300, or buys directly from an artist or his agent an entire edition. The publisher may or may not have anything to do with image, execution, or printing, but has everything to do with the merchandising and distribution of the edition. Artists also frequently self-publish.

pull To print an impression.

rabbet The recess in the frame to hold the glass and mounted print.

rag paper See *all-rag paper*.

recto The side of the paper upon which the image is printed—the front or right side.

register In color printing, successive plates must be so placed on the paper as to print in the correct relationship. When colors print out of alignment they are referred to as "off register" or "out of register." See *key plate*.

registration marks Marks placed on prints used to guide the printer or artists in achieving correct registration in color printing.

relief etching See *etching*.

relief printing A major print technique in which the image is printed from the surface of the plate material, the remainder having been cut away. Woodcuts and linoleum cuts are made by relief methods.

remark An impression in which there is a sketch or comment in the margin of the plate. These may be burnished away and therefore are relatively rare.

reproduction A commercial copy of a print made by means other than the original stone, plate, block, or screen.

reserve Confidential minimum price, agreed upon between the seller and the auction gallery, below which the lot will not be sold.

restoration The attempt to return work to its original condition.

restrike An impression made from a plate, block, lithograph stone, silkscreen stencil, mold, or die of any multiple-replica process after the original edition has been exhausted, especially after the first edition has been out of circulation for an appreciable length of time.

rice paper Any of several soft, tissue-thin artists' papers made in the Far East from the pith or fibers of the rice-paper tree. No rice is used in its manufacture.

rocker A multiedged-ridged tool which, when rocked on the surface of a metal plate, will incise a series of indentations. See *mezzotint*.

rollers also called **brayer** A tool used to roll printing inks onto plates, stones, or wood.

roulette A tool with a revolving, toothed wheel, used to make dotted lines and areas in a metal plate or ground.

rub up In lithography, to bring "up" the drawing on the stone by rubbing the stone with a sponge saturated with thinned lithographic ink and then with a sponge saturated with gum-arabic solution and water.

sandwich mat Its back is the backing board, its front the window mat to which it is hinged. The filling of the sandwich is the print, which is attached to the backing board.

sc., sculp., sculpsit (Lat.—engraved or engraved by)

scraper 1. In lithography, the element of a lithographic press (typically a leather-covered blade), that presses the paper onto the inked stone or plate. 2. In intaglio, a three-faced steel tool used for removing burrs and for other aspects of creating the image.

sealed bid A written offer to an auctioneer indicating the price a buyer is willing to pay for a specific lot. A sealed bid is secret.

serial number Progressive numbering of an edition. Usually the numeral assigned to the print appears first and the second number indicates the total number of impressions printed in a limited edition—e.g., 2/50.

serigraphy or **silkscreen** Different names for the same process. Originally a stencil process through a screen made of silk; today the screen is more frequently made of nylon. Areas not to be printed are stopped up with

paper or glue or other material. The remaining areas allow the ink or paint to pass through and print the image. Several or more screens may be used successively. The *squeegee* is the tool used to force color through the screen to the paper, thus printing the image. Although the process was developed commercially near the beginning of the 19th century, it was little used by fine artists until the 1940s.

signature Autograph or cipher of artist used as documentation of authenticity.

silkscreen See *serigraph*.

"silk" tissue A fine paper of silken texture sometimes used as a temporary slipsheet to protect the face of a matted, unframed print. Also called "gampi."

soft ground See *etching*.

Solander box A hinged box made in various sizes and designed to hold and protect works of art on paper.

squeegee See *serigraph*.

state Each alteration in a print constitutes a state. Artists pull such proofs in order to see the changes and corrections they are making. There are rarely more than a few proofs pulled of each state, since they are in the nature of working notes, and most artists do not save, sell, or sign any but the final state.

steelfacing A thin layer of steel deposited over the face of copper plate, making it less subject to wear during the printing process.

stencil processes See *pochoir; serigraph*.

stipple An engraving technique using small dots to create tones. Similar to *criblé*.

studio stamp Mark or chop of publisher or workshop imprinted on graphics produced under their auspices.

sugar lift intaglio See *etching: sugar lift etching*.

suite See *portfolio*.

sunburn See *light stain*.

surface print Another term for a planographic print—that is, one printed by inking the surface plane of the plate, block, or stone, as in lithography and most woodcuts.

T-bar hinge A method of hinging a print in which the support is crossed by an additional support forming a T. See illustration in text.

tissue paper Thin, lightweight, almost transparent paper. Usually acidic.

transfer paper A paper on which a drawing is made for transfer to a lithograph stone or plate.

trial proof A proof pulled from a plate, block, stone, or screen in order to examine its properties before the final state is determined. Sometimes revisions decided upon will be drawn on a trial proof. Trial proofs are rarely preserved or offered for sale.

Tusche (Ger.—ink) A greasy liquid or solid material used for lithographic drawings as well as in silkscreens.

vellum A parchment made from animal skin, not used for prints. *"Velin,"* the French word for vellum, is used sometimes for papers that imitate the textural quality of vellum—e.g., "Arches velin."

verso In prints, the back of the print or the reverse side of the paper from the image.

vignette Any image, embellishment, or picture unenclosed in a border, or having edges shading off into the surrounding paper.

watermark A design (usually seen by holding a sheet up to light) laid in paper during its manufacture, giving the date paper was made and other facts.

water stain Discoloration of paper caused by direct contact with fluids or by excessive humidity.

window mat Piece of mat board with rectangle cut out to expose image.

wire lines Refers to use of wire in handmade paper molds instituted in 18th-century European paper manufacturing.

woodcut A printmaking method in which the image is cut into a block of wood (usually the wood is cut plankwise). The portions cut away will not print, whereas the surface that remains will be inked and printed. (Typewriter keys and rubber stamps illustrate the same principle.) It is a relief process, the oldest relief printmaking technique.

wood engraving A variation of woodcut using much finer lines and details. The wood engraving employs end-grain or cross-grain wood, thus eliminating problems of grain so that the cuts can freely be made in any direction. Invented in 18th-century England, it was then—and still is—used mainly for book illustration.

working proof A proof on which the artist continues to work—with penciled and/or inked changes and corrections—before printing an edition.

wove paper A paper made by means of techniques that eliminate the irregularities of laid paper. Most modern papers are wove.

xylograph A little-used term for woodcut and wood engraving.

A great deal of the literature in the field of print collecting appears in French or German, including auction catalogs, dealer catalogs, museum publications, general texts, periodicals, and *catalogues raisonnés*. In addition, when collectors travel they often need assistance with specific terminology even if they are familiar with these languages. We have endeavored, therefore, in the following French and German glossaries, to select entries for relevance to printmaking and print collecting, with ancillary words and phrases necessary for understanding such material.

It has by no means been our intention to include all the possible meanings of a given word or phrase; our translations are narrow and consistently print-oriented. But note that with few exceptions these are translations, not definitions. Definitions and explanations of print terminology will be found in the preceding section.

Joan Ludman

FRENCH-ENGLISH GLOSSARY

à bon compte at a good price
à droite at the right; to the right
à gauche at the left
à la main by hand; handmade
à la mode de in the manner of
à la poupée a method of printing color prints in which one plate instead of several is used
à l'angle in the corner
à l'envers upside down; inverted; reversed
à l'instar de following the example of; inspired by; in the manner of
à nu naked; laid bare
à paraître to appear
à toutes marges with full margins; untrimmed
abîmé damaged; in poor condition
abonnement subscription
accidenté rough; uneven
accréditer to accredit; to lend authenticity to
achat purchase
acide nitrique nitric acid (an agent used in etching)
aciérage steel-facing
actuel current; present-day

adjuger to decide; in an auction sale, to accept a final price
affiche poster
affiner to sharpen or refine
agrandir to enlarge
agrandissement enlargement
aigle size of paper dimensions: 50 × 80 cm
aigu acute; sharp
album portfolio
algraphie algraph (a lithograph made from an aluminum plate)
allemand German
amateur collector
amateur d'estampes print collector
ambiant surrounding
amorphe amorphous; formless; indistinguishable
an, année year
ancien old; former; previous
anglais English
anonyme anonymous
antérieur earlier; previous; anterior
aplat flat, even tone
âpre harsh; biting; satirical
après after; following
aquafortiste etcher

aquarelle watercolor

aquarellé watercolored; with watercolor added to the tone of the print

aquarelliste watercolorist

aquatinte aquatint

arraché torn off; torn out

arracher to tear away

arrière-plan background

artiste d'avenir artist of promise

artotypie collotype

atelier artist's studio; workshop

atteinte damaged

au dessous beneath

au dire de in the opinion of

au dos on the back

au pointillé stippled

au revers de on the rear of; on the verso

au verso on the reverse side

augmenté enlarged

authentifier to authenticate

autogravure a 19th-century manual process of mechanical transfer of a drawing to a plate for printing

autorisé authorized

avant-lettre state of a print pulled prior to the inclusion of the artist's written identification

avant tout lettre early state of a print before any identifying words have been added to it

avec la lettre print made after identifying signature has been added

baisse a decline (e.g., in prices)

balafre slash; cut (in paper)

ballotter to shake; to swish (a plate around in acid solution)

barbe burr

barré canceled

bavure fuzziness (of line); running (of ink)

beaux-arts fine arts

bel exemple fine example

belge Belgian

belle épreuve good proof or print

berceau rocker

bévue mistake; error

biais diagonal; at an angle

bibliothécaire librarian

bibliothèque library

Bibliothèque Nationale the National Library in Paris; French equivalent of the Library of Congress

biffage a barring; a crossing out

biffé lined through; erased

bis repeat; again

biseau bevel

biseauté beveled; faceted

bistre yellowish to dark brown color; sepia

blanc et noir black and white

blanchir to whiten; to bleach; to clean

bleu blue; blueprint

bloc de bois block of wood (for making a woodcut); *sometimes*, a woodcut

bois wood; woodcut

bois bien dressé well polished and prepared wood with the smooth surface needed for making a woodcut

bois debout endgrain wood for making wood engravings

bois de fil wood for making a woodcut, cut lengthwise—along the grain

bois épargné spared wood, the surfaces that remain after areas not wanted for printing are cut away

bois gravé engraved wood block

boîte à grain dusting-box, used to sprinkle or dust rosin in aquatint process

bon à tirer "OK for printing"—handwritten by printmaker on proof, indicating approval of its

quality and readiness for printing edition

bon état in good condition

bon marché inexpensive

bord edge; side

bordure border

bosse bump

brossage brushing; brushwork

brosse brush

brunir to polish

burin graver; burin

burin cintré curved or rounded graver

buriniste engraver

buvard blotting paper

Cabinet des Estampes Print Room; Print Collection

cacher to hide; to mask part of a plate during a printing process

cachet stamp or seal; imprint; artist's personal touch

cadre frame; framework; background

cahier notebook; folder (of prints)

calque tracing

calquer to trace

canif small knife for woodcutting

Caricature, La weekly political newspaper to which Daumier regularly contributed cartoons

carré square

cartable folder for carrying prints flat, similar to portfolio

carte map

cartouche enclosed area in a print which carries a body of type or legend; area for lettering within a print

catalographe cataloger who compiles lists of artists' works; author of *catalogue raisonné*

catalogue raisonné catalog or list which gives title of each work and all pertinent data and information (See Chapter 2)

celle reproduite (celui reproduit) the one reproduced; the one shown here

censure censorship

cent one hundred

cérographie process for making embossed prints using wax

certificat de tirage affidavit of the number of prints pulled from a plate in a limited edition

chacun each

Chalcographie du Louvre that part of the Louvre Museum concerned with the preservation and exhibition of graphics. They sometimes also reprint editions from plates in the collection.

champ field; the scope or limits of a given print

champlever to cut away; to clear away unwanted wood or metal so that the remaining surface will take ink and print the image

changer to change; to alter

chaque each

charger to caricature; to lampoon

Charivari, Le weekly political newspaper to which Daumier regularly contributed

châssis frame for holding plate and transparent paper in making a soft-ground engraving

chef-d'oeuvre masterpiece

chevalet easel

cheville wood plug used to restore part of a surface to a woodcut after it has been mistakenly cut away

chiffon rag paper

chiffre figure; number; monogram or characteristic insignia; cipher

chiffré numbered

chiffre du tirage size (or number) of the printed edition

Chine collée China paper

chromo chromolithograph

cinquante fifty

cire wax

cire à border wax composition used for marking off nonprinting areas in certain graphic processes

ciseau chisel; blade

clair light in color; clear; understandable

clair-obscur chiaroscuro

clarté light; clarity

clichage photoengraving

cliché photographic negative; mechanical process of identical reproduction

cliché verre print made photographically from an image needled through a light-resistant coating applied to glass

coin corner; angle

collant sticky; adhesive

colle paste; sizing—an element in paper making

collé glued

coller to paste; to glue

colombier (or **colombe**) French printing paper dimensions: 90 × 63 cm (roughly 36 × 25 in. to the full sheet)

coloré colored

colorier to color

comme like; as

comme il est as it is; like it is

compris included; understood; inclusive

compte-rendu review (of an exhibit, a book, etc.)

concours competition or competitive test; assistance; collaboration, as in an exhibition

connu known; well-known

conservé preserved

consolidé reinforced; strengthened

contenir to contain; to hold

contre against; opposed to

contre-épreuve counterproof; a contact proof made by pressing a sheet of paper against a freshly pulled proof or print

contrefaçon counterfeit; imitation

contrefaire to counterfeit; to forge

coquille size of paper dimensions: 44 × 56 cm

cote quotation (as in the stock market); an artist's standing, his going market value

couler to flow; to run (as ink or color)

couleur color

coulure a running (together, as of inks or colors); smudge

coup de maître master-stroke

coupé cut; opened

couper to cut off

coupure cut

couronné approved; awarded a prize or a special honor

court de marges narrow margins

coûter to cost

crachis spatter process of inking in lithographic printing to give a speckled effect

craie chalk; pencil

craquelure crackling; break in the surface

crayon pencil; crayon; chalk

crayon émeri emery-stone pencil

crayon-encre ink-pencil

crayon lithographique lithographic crayon

crayonnage pencil marks

crevé area on the surface of a plate or ground that is damaged by overbiting of lines laid too close together

criblé dotted print technique

croquis a sketch

cuivre copper; copperplate

cuvette plate mark; the impression made on the paper by the entire engraved plate

d'après according to

d'après nature from nature

de bonne heure early

de marque noted; distinguished

de même likewise; the same

de toute rareté of the greatest rarity

déchiré torn

déchirer to tear

décoloré discolored

découpé cut off; cut out

découper to cut up; to cut out

découpure cut

décrire to describe

défaut flaw; fault; defect

défectueux defective; damaged

dégradé halftone; gradation

dégraisser to clean

demi half

départager to separate

Dépose à la Bibliothèque Nationale passed by the French censor (stamped on prints from 1848–52 and from 1870 to the present)

Dépôt Légal A law in effect in France since 1943—it stipulates that every printer or publisher is obliged to present at least one example of each print published to the Bibliothèque Nationale Cabinet des Estampes

dernier last; newest

dessin drawing

dessin humoristique cartoon; humorous drawing

dessin satirique political or satirical cartoon

dessinateur one who draws; designer

dessiné designed; drawn

dessiner to draw

dessous the under side

dessus the top

destruction cancellation of a plate or a block

déteint faded; discolored

détérioré deteriorated

détériorer to deteriorate

détruire to cancel a plate or a block

détruit canceled

devant in front of

devise motto or slogan

difficile difficult

diminuer to diminish

disparaître to disappear

disponible available

disposé laid out; arranged

disposition layout

distinguer to distinguish; to recognize

dit said

divers diverse

dix ten

d'occasion second-hand; a good buy

don gift; bequest

donner suite to follow up

doré gilt

dorer to gild

dos (le or la) (the) back

doué gifted; talented

droite (la) right

droits d'auteur royalties

d'usage usual; customary

cau water

eau-forte etching

ébarbé trimmed

ébarboir scraper for removing the burr raised by the engraver's tool

échoppe etching needle with an oblique face

éclairer to lighten or brighten

écrirer to write

écriture writing

éditeur publisher

effacer to erase

effet effect

effleurer to skim; to touch lightly

effriter to flake; to chip

égal equal; even

égratignure scratch

élaguer to cut away or simplify

élargir to broaden; to expand

élever to raise; educate

émargé trimmed; margins cut down

embarrasser to obstruct

émérite expert

empâtement filling in; shading the background in an engraving so that the subject stands out

empreinte imprint; stamp; impression

emprunter to borrow

en arrière in the background

en bas at the bottom; below

en chantier work in progress

en dessus above

en fraude illegally

en haut at the top; above

en librairie in print; available

en marge in the margin

en outre in addition to

en pied full-length

en simile in facsimile

en-tete heading

encadré framed

encadrement framing; frame

encadrer to frame; to surround

encadreur picture-frame maker

encan auction sale

enchère auction sale

enchérir to bid higher

encollage sizing (in paper making)

encollé pasted; mounted

encombrer to clutter

encrage inking

encre ink

encre de Chine India ink

encre d'imprimerie printer's ink

endommagé damaged

enduire to coat with

enfoncé embossed

enfumer to smoke; to darken with smoke (as in preparing an etching ground)

enjoliver to adorn

enlever to take away

ensemble together; a group

entailler to cut into

entamé slightly damaged

entier entire

entourer to surround

entre between

entre guillemets in quotation marks

envers toward; verso

épaisseur thickness

épargne (taille d') woodcut

épreuve proof; print

épreuve au charbon carbon print —a photographic type of reproduction

épreuve d'artiste (E.A.) artist's proof

épreuve de luxe luxury proof; a print of a limited run; a special print (on better paper, in smaller numbers, for special distribution, etc.)

épreuve de passe extra impression to substitute for a poor one in the numbered edition

épreuve d'essai trial proof; a print or proof pulled prior to final approval being given for the printing

épreuve d'état print or proof pulled from a given state of the plate, usually before the finished state; state

épreuve du Dépôt Légal proof of a print that is deposited at the Bibliothèque Nationale, Cabinet des Estampes

épreuve unique single proof or print from a plate which has not had other proofs pulled beyond this one print

épuisé sold out; out of print

épure work-plan; a finished drawing

éraflé scraped

éraflure scraped spot

esquisse sketch

esquisser to sketch

essuyage wiping off the ink—one of the most important operations in metal plate engraving

essuyer to wipe

estampe print

estampe en pointillé stippled print (See *criblé*)

estampe originale original print engraved and printed by the artist or under his direct supervision

estampille stamp; collector's mark; identifying mark, stamped on or into the print, sometimes embossed, usually in the margin

estimé valued

état state

état de conservation condition

état reproduit state reproduced here

état réservé print of a special or limited pull, restricted to a given distribution

étranger foreign

étude study

exceptionnellement unusually

exposant the artist whose work is exhibited

exposé exhibited

exposition exhibition

fabriquer to manufacture; to create

façonner to make; to create a work

factice artificial; imitation

facture method or technique used in executing a work

faible weak

fameux excellent

fané faded

faussaire one who makes fakes

faussement attribué falsely attributed

faux false; fake; imitation

fendre to crack; to split

ferme solid

feuille sheet of paper

feuille de garde flyleaf

feuille transparente transparent sheet of tracing paper

feuille volante single print

feuillet folio; page

filet thin line

filet d'encadrement line which marks the limits of a print

filets brisés broken lines

filiforme linear

filigrane watermark in paper

fin-de-siècle turn-of-the-century

flou vague

fond background; subject matter

forme; papier à la forme; papier cuve hand-made paper of fine quality

fort strong

fort estimé highly esteemed

fort rare very rare

fresque fresco or mural

froissé wrinkled

froissures wrinkles; wrinkling

frontispice frontispiece

frottage composing shapes on paper from rubbings

frotté scraped; roughened

frotter to rub

frottis thin wash of color; scumble

fusain charcoal drawing

gauche left; awkward

gaufrage embossed or relief print

génie genius

genre homey, everyday subjects; a particular kind of painting

gillotage 19th-century French reproductive process using mechanical transfer of image, instead of the later developed process of photoengraving. (Daumier's litho-

graphs in *Le Charivari* were reproduced by this method.)

gillotypes print produced by gillotage process

glossaire glossary

gomme eraser

gouache painting done with pigment dissolved in water mixed with gum, i.e., tempera paint

grainage process by which a copper plate is prepared for making an aquatint

grainer to remove an image from a lithographic stone by grinding it down

graisse grease

grand large

grand de marges large margins

granuleux grainy

grattage scratch

gratté scratched

gravé par engraved by

graver to engrave

graveur engraver; printmaker

gravure art of engraving; an engraving; a print

gravure au poincon engraving made with a dotted effect (See *criblé*)

gravure au lavis brush engraving

gravure au poinçon engraving made with a dotted effect (See *criblé*)

gravure au trait line engraving

gravure d'interpretation tone engraving using color effects, giving a halftone effect

gravure en creux intaglio process

gravure en taille douce line engraving; incising with a burin into a copper plate without the use of acid; metal engraving

gravure en trait line engraving

gravure sur acier steel engraving

gravure sur bois woodcut

gravure sur bois debout wood engraving

gravure sur cuivre engraving on copper

grenu grainy

griffé scratched

griffoné with scribblings

griffoner to scribble

gris gray

grisaille grayness; drab; a painting in gray tones

gros fat; thick

hachure hatching; shading

hardiesse durability

haut high; top; upper part

héliographie print made by an early mechanical method of photogravure reproduction

héliographie sur verre early method of creating a reproductive print by the use of glass photographic plates

héliogravé photoengraved

héliogravure photoengraving; photochemical reproduction method used for newspapers

héliotypie photoprinting

hors commerce (h/c) (outside commerce) a sample copy for salesmen, not counted as part of the edition, and not intended for sale

hors-texte reproduction of a print inserted within a book on a separate page, or on different paper from the text

huile oil paint

humidité moisture

illustre famous

illustré illustrated

Image d'Épinal popular simplified illustration

importance du tirage size of the run or pull of the print

impression printing

impression de matière print made from an existing object

impression en creux intaglio printing

impression en relief relief printing, i.e., the process used in printing woodcuts

imprimé printed

imprimer to print

imprimeur printer

inachevé unfinished

inconnu unknown

inédit unpublished

inégal unequal; uneven

inexistant nonexistent; insignificant

infime very small; minute

initié connoisseur

insu not known

intimiste artist who portrays homey scenes

introuvable unobtainable

inventaire inventory or catalog of an artist's work

inversé reversed

Japon Japan paper

jauger to gauge; to measure

jaune yellow

jauni yellowed

jaunissures yellowed marks; foxing

Jésus size of paper: le petit (55 × 70 cm); ordinaire (56 × 72 cm); le grand (56 × 76 cm)—le grand is the most currently used in print publishing

jeune young; the younger

juge judge or member of an art competition jury

juste correct; precise

justificatif (justification) or **justification du tirage** the number of the print and the size of the edition written by the artist in the margin of an original print; e.g., 7/20

laid ugly

laiteux milky

largeur width

lavable washable

lavé washed

lavis wash drawing

lavis à l'encre lithographique wash drawing made with lithographic ink that can be transferred to a lithographic stone

lavis sur papier wash drawing on paper made for transfer to a lithographic stone

lavis sur pierre wash drawing on a lithographic stone

lavis sur zinc wash drawing on a zinc plate

légende caption on a print identifying its title, the artist, etc.

librairie bookstore

ligne line

limité limited

linogravure linoleum cut

lisible legible

lithographe lithographer

lithographie lithography; lithograph

lithographie sur papier drawing on paper intended for transfer to lithography stone or plate

lithographier to lithograph

livre book

loupe magnifying glass

lui-même (by) himself

lumière light

maculé spotted; soiled

maigre thin

main hand; handmade

maison d'édition publishing house

maître master

maître-graveur master printmaker

manière au crayon style of etching which resembles the blurred effects of crayon lines, as contrasted

with the more usual sharply incised lines

manière criblée See *criblé*

manière noire mezzotint

maquette preliminary model of a planned work; sketch

marchand dealer

marché market; transaction

marge margin

marque mark

marque de collection collector's mark

marque déposée registered trademark

marque d'imprimeur printer's mark

mat dull finish; not shiny

matériau medium in which an artist works; raw material

mauvais bad

mauvais goût bad taste

meilleur better than

meilleur, le the best

mélange mixture

même same

méprise mistake

métier specialty

meurtri damaged; bruised

mezzotinte mezzotint

mieux better

mince thin

mine de crayon lead for a pencil

minutieux precise

miroir mirror or mirror image

mise-en-place placement of element in a composition

moindre least

moins less

monté mounted

mordant biting; satirical; degree to which the acid bites into the plate; an acid mixture used for biting an etching plate

mordre a l'acide to apply the acid

mordu bitten into the plate

morsure bite

morsure en profondeur deep etching

mort dead; inanimate

moucheté speckled; spotted

mouillé stained by dampness; moisture

mouiller to moisten

mouillure stain caused by moisture

moulage casting

mourir to die

musée museum

mutilé mutilated

nature morte still life

négociant dealer

net sharp; clear

nettoyer to clean

noir black; dark

noir au blanc reverse printing

nombreux numerous

non chiffré unnumbered

non compris not included

non coupé uncut; mint condition

non ébarbé untrimmed

non numéroté unnumbered

non signé not signed

non terminé not finished

nouveau new

nouvelle new

novateur innovator

nu nude

nul nonexistent

numération numbering

numéro number

numérotage numbering

obscur dark; obscure

obvier to provide against; to obviate; to prevent; to preclude; to forestall

occasion opportunity

oeil eye

oeuvre (une) a work of art

oeuvre (un) the whole of an artist's work

oeuvre capitale major work

oeuvre de jeunesse artist's early work; juvenilia

oeuvre-maîtresse artist's major work

oeuvres choisies selected works

ombre shadow; shade

ombré shaded

ondulé wavy

origine origin

outil tool

outré overdone

ouvert open

ouvrage individual work

page de départ title page

pair (one's) peer

paire pair

pâle pale

pâli paled; faded

panneau panel

pans coupés trimmed corners

papetier papermaker or dealer

papier à la cuve handmade paper

papier autographique type of paper from which it is possible to transfer a drawing to a stone; transfer paper

papier bible Bible paper; India paper

papier couché laid paper; coated stock

papier de couleur colored paper

papier de riz rice paper

papier journal newsprint

papier pigmenté carbon paper

papier report special paper on which the printmaker can draw, then transfer the drawing on to the lithographic stone; transfer paper

papier satiné semi-coated paper

papier velin wove paper; vellum-like

papier vergé laid paper

papiers collés pasted papers; collage

par erreur by mistake

par places in places

parafé initialed

paraître to appear

paravent screen; folding screen

parchemin parchment

parfaire to perfect

parfait perfect

particulier individual

partiel not complete

paru published

parution appearance; publication

passage the action of passing under the press

passé worn; faded

passepartout mat used as the sole frame of a picture—sometimes used with backing and glass

pastiche imitation; copy

paysage countryside; landscape painting

pedigree list of owners of a print

peignant painting (pres. participle)

peindre to paint

peint painted

peintre painter

peintre-graveur painter-printmaker

peinture painting

petit small

peu few

photochromo multicolor reproduction

photographe photographer

photogravure reproduction made by photomechanical means

photolithographie offset printing reproduction process

phototypie print made by a photographic reproduction process

picots burrs; irregularities on the surface of a plate or block

pierre stone

pierre effacée erased or canceled stone, cleared for re-use

pierre lithographique　lithographic stone

pierre originale　stone upon which the artist has made an image for a lithograph

pinceau　paintbrush

pinceau sur pierre　brush drawing on lithographic stone

piqué　with small holes

piqué des vers　worm-eaten

piqûre　hole

plan　map; chart

planche　flat plate on which an engraving or etching is made

plein　dark area; an area where lines are drawn closely together

pli　fold

plié　folded

plier　to fold

plume　pen

plus　more than

plus avancé　more advanced; later stage

plus grand　bigger

plusieurs　several

pochoir　stencil; a stencil and stencil-brush process for making multiple prints; for tinting black-and-white prints; and for coloring reproductions

point　point; dot

point de reperage　method of aligning successive color plates during printing through the use of pin holes in the sheets of paper

point-sèche　drypoint print

pointillé　dotted or broken line

polychrome　multicolored

portefeuille　file of prints; portfolio

portrait en pied　full-length portrait

posthume　posthumous

poussiéreux　dusty

précédant　preceding

premier　the first

premier plan　foreground

preneur　buyer; customer

prénom　first name

près　near

presse　printing press

preuve　proof

prisé　held in esteem; valued

prix　price; prize

prix de vente　sales price

procédé mixte　mixed media

prochainement　soon

propriété littéraire　copyright

provenance　origin; sequence of ownership through which a print has passed

publicitaire　commercial artist

publié　published

publier　to publish

pur chiffon　pure rag (paper)

quel　which one

quelque　some

rabais　discount

raccommodages　repairs

raccourcir　to cut short

raisin　French printing paper size: 50×65 cm (20×26 in.)

raisonné　documented

rapiécé　mended

rapin　art student

rare　rare

rarissime　rarest; extremely rare

rayer　to cross out; to scratch

réaliser　to materialize

rechercher　to look for; to collect

reconnaître　to recognize

recto　front side

recueil　collection

redite　duplication; repetition

reflet　mirror image

regraver　to re-engrave

réimpression　reprint; reprinting

remarque　note or footnote; the pulling of several details of a plate to test the quality of the

print; drawings on margin of plate, sometimes to test quality

renversé reversed

réparation repair

réparé repaired; mended

repérage precise adjustment of an impression during printing, so that each impression is placed on the paper exactly where it must be

réplique duplication; replica

report transfer of the drawing to a stone or plate

repoussage to press or hammer back a plate's low area created either by excessive etching or by scraping on its original level

réserve reserve; the lift-ground process

résine resin

restaurable reparable

restauration restoration or repair of a print

restauré restored

retirage restrike

retirer to take back, to print again

retouche retouching a work

retroussage in intaglio, a technique for enriching the lines in a wiped plate by flicking a piece of cheesecloth or muslin over the surface to cause the ink to spill over the lines

revers the other side

rider to wrinkle or fold

rogné trimmed; cut

rogner to cut down or trim

roussi foxed; browned

sain in good condition

sale dirty

sali dirtied

salissures dirty spots

sanguine drawing done in red chalk

sans without

sans gravité unimportant

savant knowledgeable

scabreux risqué

scène de moeurs picture of current life, usually the seamy side

se gondoler buckling, or waving of paper

se tromper to make a mistake

sécher to dry

sérigraphie silkscreen print

seul single; only

siècle century

sigle symbol; trademark

signature signature

signer to sign

sillon groove (in metal plate)

soie silk

soigné carefully done

soleil size of paper: 60 × 80 cm

souffert injured; damaged

souillures soil marks

sous underneath

sous-titre subtitle

sucre (gravure au . . .) sugarlift, method of making an etching

suite series

superficie surface

support mounting

supprimé suppressed; censored

supprimer to eliminate

surcharger to superimpose

tableau picture

tache spot; stain

taches d'humidité damp spots

tacheté spotted

tachisme technique of using spots of tone or color

taille cut; cutting or engraving

taille d'epargne woodcut

taille-douce See *gravure en taille douce*

taille en facsimilé print which reproduces a picture originally in another medium

tailleur de formes one who cuts

plates from another artist's original drawing

tare defect

teint shaded; tinted

teinté tinted

témoins marks left on a plate or print, such as vise marks

ténèbres shadows

timbrage hand printing

timbre distinctive character of work; the artist's distinctive touch

timbre à sec embossed mark made by the publisher or papermaker on the sheet of paper; chop

tirage number of prints pulled

tirage au frotton hand printing

tirage restreint limited edition

tiré pulled

tiré de inspired by

tirer to print

ton tone; shading

touche artist's characteristic touch

touché lightly damaged

tout all

traces d'usure traces of wear

traducteur translator

traduction translation

traduit translated

trait carré line which marks off the exact framing line of a plate

trait échappé unintentional scratch on the plate

travail work; workmanship

travail de vers signs of worms

tremper to soak; to dip into a liquid

très very

très légèrement very lightly

triage classification

trous de vers wormholes

tusche lithographic ink

usagé worn

usure wear and tear

utile useful

valeur quality

variante another version

velin wove paper; like vellum

vendeur seller

vendre to sell

vendu sold

vente sale

vente à la criée, vente a l'encan, vente aux enchères sale at auction

venu pulled or printed

vergé laid paper

vérité authenticity

vernis dur hard ground

vernis mou soft ground

vernissage exhibition opening

vers worms

verso back of print or sheet of paper; the other side

vicié marred

vicieux having flaws; defective

vide blank

vif vivid; lively

vingt twenty

visage face

voir to see

voir au verso turn to the other side

vrai true; real

xylographe maker of woodcuts; wood engraver

xylographie woodcut; wood engraving

y compris including

zincotypie zinc engraving

GERMAN-ENGLISH GLOSSARY

Abbild image
Abbildungen illustrations
Abdruck impression; copy; reproduction
Abfallen a fall (in prices, etc.)
abgebildet reproduced
abgegriffen worn
abgelöst detached
abgerissen torn off
abgeschnitten cut away
abgesetzt sold
abgezogen pulled; printed
abkürzen to abbreviate
Abkürzung abbreviation
Abonnement subscription
Abriss abstract; abstraction; synopsis; architectural drawing
Abzug proof; proof-sheet
ähneln to resemble
akkreditieren to accredit; to authenticate
aktuell current; present day
Alographie algraph (lithograph made from an aluminum plate, instead of a stone)
alle all
allein alone
allererst very first; first of all
allgemein common; ordinary; general
alt old
an on; by; at
anfeuchten to moisten
Anfrage inquiry; request
(in) Anführungszeichen (in) quotes
angefleckt slightly spotted
angefressen gnawed
angegilbt slightly yellowed
angehängt (an) appended (to)
angerandet beginning to stain on edges
angerissen slightly torn
angeschmutzt slightly soiled

Anhang appendix
Anmerkung annotation
anonym anonymous
anscheinend apparently
anstelle von instead of
Anzahl number; quantity
Aquarell watercolor
Aquarellmaler watercolorist
Aquatintamanier in the manner of an aquatint
Arbeit work
Arbeitsplan work plan
Arbeitsraum workshop; artist's studio
ätzen to etch
Ätzer etcher
auf der anderen Seite on the other side
auf der Rückseite on the back
aufdecken to uncover
aufdrucken to overprint
auffinden to locate
auffüllen filling in (shading of the background)
aufgebaut textured; layered (painting); built up (collage)
aufgeklebt mounted; pasted on
aufgezeichnet recorded
Auflage issue, edition
auflösen to dissolve
Aufnahmen photographs; snapshots
Auge eye
Augen eyes
Auktion auction
Auktionsverkauf sale at auction
aus der Zeit of that time
Ausbesserung repair
auseinandermachen to spread out
Ausgabe edition
ausgebessert repaired
ausgeprägt well-imprinted; well-defined; stamped; raised
ausgeschnitten cut out

ausgestellt exhibited
ausgezeichnet excellent
aushöhlen to hollow out
ausnahmslos without exception
ausradieren to erase
ausradiert erased; scratched out
ausschneiden to cut out
aussehen (wie) to look (like)
ausser except; besides
Aussprengverfahren lift ground etching
ausspülen tò rinse
Aussteller exhibitor (in an art show)
Ausstellung exhibition
Ausstellungsplatz gallery; exhibit hall
austauschen to exchange
ausverkauft sold out
Auswahl selection
authentisch authentic
Autor author

Band (⁼e) volume (s)
Bandzahl volume number
barock baroque
Barverkauf cash sale
bearbeitet reworked; revised
bedeckt covered
begabt gifted
beglaubigen to authenticate
begrenzt limited
begrenzte Ausgabe limited edition
beidseitig on both sides
Beifügung addition
beigebunden bound with
beigedruckt bound together
beigegeben bound or offered with
Beispiel example; instance; illustration
beissend biting
bekannt well-known; renowned
Bekanntmachung announcement
bekritzelt scribbled on
Bemerkung remarque
Berichtigungen corrections

berieben rubbed; scraped; roughened
Beruf profession
Berührung touch
beschädigt damaged
Bescheinigung attestation; voucher
Beschmutzung soiling
beschneiden to trim; cut down
beschnitten cut; trimmed
beschränkt limited
beschreiben to describe; described; inscribed; covered with writing
besonders notably; especially
Besprechung review (of an exhibit, a book, etc.)
besser better
bestimmen to define
Betrug fraud
betrügen to deceive
bezeugen to vouch for
bezogen covered
bezüglich concerning
Bibliothek library
Bibliothekar librarian
Bild picture; image
Bildhauer sculptor
billig cheap
Biss bite (of the engraver's tool or of the acid on the plate)
Blase bubble
Blatt sheet, leaf (of paper)
Bleistift lead pencil
Bleistiftanmerkungen pencil notes
Bleistiftanstriche pencil marks
Bleistiftmarginalien marginal pencil notes
Bleistiftstriche pencil lines
blindgeprägt blind stamped
Boden bottom
borgen to borrow
Brandschaden damage caused by burning
Breite width
breitrandig with wide margins
Briefkopf letterhead

broschiert sewed
Bruch fold
brüchig brittle
Brücke, Die the group of German Expressionists formed in Dresden in 1905, including Kirchner, Heckel, Schmidt-Rottluff, and Pechstein, among others; group dissolved in 1913
Buch book
Buchdruck letterpress printing
Bücherei library
Buchgeschäft bookstore
Buchmarke bookplate
Buchstabe letter
Buckel bulge; bump
Buntstift crayon
Bürste brush
Büttenpapier handmade paper

Carbodruck carbon print (photographic reproduction)
chinesisch Chinese
chinesische Tusche India ink
chromolithographiert chromolithographed

Darstellung exhibition
dasselbe the same
datiert dated
Datierung dating; date
Deckblatt cover sheet
Decke cover
deutsch German
Devise motto
Dicke thickness
Die Brücke See *Brücke*
dreiseitig trilateral
Druck print
Drucker printer
Druckermarke printer's mark
Druckerzeichen printer's marks
Druckfläche printing surface
Druckgraphik print

Druckmeister master-printmaker; master printer
druckreif artist's OK of proof; ready for printing; *bon à tirer*
dunkel dark
Dunkelheit darkness
dünn thin
durchgestrichen crossed out
durchlaufend consecutively numbered
durchlöchert having holes
durchlocht perforated
durchpausen to trace
durchsichtig transparent

ebenso likewise
Echtheit authenticity; genuineness
eigenhändig with your own hands
Einband binding; cover of a book
Einbuchtung indentation
Einfassung frame; border
eingerissen torn
eingeschlossen including
eingraviert engraved
einhundert one hundred
einige several
Einkauf purchase
einmalig one-time; unique
einrahmen to frame
Einriss small tear
einwandfrei faultless
einweichen to soak
Einzeldarstellung monograph
endgültig final
entdecken to discover
enthalten to contain
Entwertung cancellation (of a plate or block)
Entwurf sketch
erfahren expert
erforscht researched
Erhaltung state of preservation
erkennen to recognize
Erklärung declaration; affidavit
erlaucht illustrious

erleuchten to lighten; to make clearer

Eröffnung einer Ausstellung opening of an exhibition

erotisch erotic

erst first

Erstausgabe first edition

Erstdruck first printing

erste former

erweitert enlarged

etwas somewhat

Exemplar copy

Faksimile-Holzschnitt woodcut or wood engraving reproducing a picture first done in another medium

fälschen to fake; to forge

falschmünzen to counterfeit

Falschmünzung counterfeit

Fälschung fake; forgery

falten to fold

Faltspuren crease marks, signs of creasing

Farbe color; ink

Farbendruck color print

farbig colored

Farblichtdruck photographic color reproduction

Färbung tint

Fasergehalt fiber content

Fassung version

Feder pen

Federzeichnungen pen and ink drawings

Fehler flaw; fault; error

fein fine, delicate

feinst most delicately

Fett grease

Feuchtigkeit moisture

Feuchtigkeitsschäden damage caused by moisture

Feuchtigkeitsspuren traces of moisture

Filigran watermark

fingerfleckig finger-marked

Fingerspuren fingerprints; traces of handling

Fläche surface

Fleck spot

fleckenfrei spotless

fleckenlos spotless

fleckig spotted

Fleisch flesh

flexibel flexible; limp

Folge series

forschen to do research

fortlaufend consecutive

französisch French

Frontispiz frontispiece

früher previously; earlier; former

fünf five

fünfzig fifty

ganzseitig full page

gaufrieren to emboss

gebräunt foxed; browned

Gedenkschrift commemorative publication

gedruckt in printed at

gefaltet folded

geflickt patched

gefranst worn; frayed

gegen against

Gegenabdruck counterproof

Gegenstand subject

Gegenstrich crosscut

gegilbt yellowed

geklebt pasted

geknickt dog-eared; bent

gekrönt prize-winning

gelb yellow

gelbfleckig with yellow spots; foxed

Geld money

Gelegentheitskauf a good buy; a bargain

gelöscht canceled

gemäss according to

Gemeinschaft collaboration

gemeinverständlich popular

genau precise; minute

genommen von taken from
Gepräge imprint
gerade straight
gerahmt framed
geringfügig insignificant
geripptes Papier laid paper
gerissen torn
gesammelt collected
Gesamtauflage entire edition
Gesamtausgabe complete edition
Gesamtausstellung exhibition of complete works
Gesamtwerk collected work; entire work of an artist; oeuvre
geschätzt esteemed
Geschenk gift
geschnitten engraved; cut
Gesellschaft Society
Gesicht face
gestalten to make; to create
gestempelt stamped; marked with a stamp
gestochen engraved
gestrichen canceled; destroyed
gesucht sought after; in demand
getönt toned; tinted
gewaschen washed
geweisst whitened
gewöhnlich usual
glätten to smoothe
gleichmässig equal; even
gleichmässiger Ton flat, even tone
gleichwie the same
Glossar glossary
goldgeprägt gilt-stamped
gotisch gothic
Graphiken graphics
Graphitstift pencil-lead
grau gray
gravieren to engrave
Gravierhandwerker engraver-craftsman
Graviermeister master engraver
gross big
Grösse size (in papermaking)
gut well; good

Gutachter appraiser; evaluator
gutes Beispiel fine example

Hadernpapier rag paper
halb half
Halbton halftone
Halbtonschnitt halftone cut
Handbetrieb hand printing
Handbibliothek portable library
Handdruck hand printing
handgearbeitet handmade
handgemalt hand colored
Händler dealer
handschriftlich handwritten
Handwerker craftsman
hart hard
hässlich ugly
hauchdünn ultra thin
Hauptwerk major work
Heliogravüre photoengraving
hell-dunkel chiaroscuro
Hell-Dunkel-Holzschnitt chiaroscuro woodcut
heller lighter colored
herausbringen to bring out; to emphasize
Herausgeber editor
herausgegeben published
herausreissen to tear away
herausstehen to stand out
hergestellt produced
herrlich magnificent
Hilfsmittel helper; aide
Himmel sky
Hintergrund background
hinterlassen posthumous
hinzufügen to add on
hoch high
Hochdruck relief printing
Höcker bulge; bump
Höhepunkt highest point
holländisch Dutch
holperig rough; uneven
Holz wood
Holzgraveur wood-engraver
Holzschnitt woodcut

Holzstich wood engraving
Holzstock wood used as plate for woodcut
Huldigung respect; homage

identifizieren to identify
illustriert illustrated
im Druck in print
im ganzen in its entirety
in der Ecke in the corner
inbegriffen included
innerhalb (von) inside (of)
Inschrift inscription
inspiriert durch inspired by
Inventar inventory
irrtümlicherweise zugeschrieben or **irrtümlicherweise zurückgeführt** wrongly attributed

Jahr year
Jahresgabe annual gift
Jahrhundert century
Jahrhundertwende turn of the century
jugendlich youthful
jung young

Kaltnadel drypoint needle
Kaltnadelradierung drypoint etching
Kante border
karikieren to caricature
Karte map; chart
Käufer buyer
käuflich for sale
Kaufmann merchant
Kenner connoisseur
klebend adhesive
klebrig sticky
Klebstoff glue
klein small
knicken fold
knittern to wrinkle
Kohlepapier carbon paper
Kollege colleague
kolorieren to color

koloriert colored
Kommentar comment
komplett complete
Kontur contour; outline
Kopf head
Kopie copy
körnig grainy
kosten to cost
kostspielig costly
Kreide chalk
kritzeln to scribble
kubismus cubism
Kunst art
Kunstbesprechung art critique
Kunstblatt art print reproduction
Kunsthalle art gallery
Kunsthistoriker art historian
Künstler artist
Künstler mit Zukunft artist of promise
Kunstliebhaber art lover
Kunstsammler art collector
Kunstverein art association
Kunstwerk work of art
Kupfer copper
Kupferplatte copperplate
Kupferstich engraving on copper
Kupferstichkabinett or **Kupferstichabteilung** Print department; Print Room
kurz short

lackieren to varnish
lädiert damaged
Landschaft landscape
lateinisch Latin
laufen to run (as in ink or paint)
lebendig vivid; alive
Lebensgrösse life-size; full-length
Leder leather
leer empty; blank
Lehrling apprentice; pupil
leicht light
leimen sizing (in papermaking)
Leinwand canvas
letzter latter

licht light in color
Lichtdruck photographic process for reproducing an original onto a plate, i.e., collotype, photoengraving
lieferbar available
links at the left
Linolschnitt linocut
Lippe lip
Literaturverzeichnis list of references; bibliography
Lithograph lithographer
Lithographie lithography
lithographische Umkehrung reverse lithography
Lithokreide lithographic chalk
löcherig with holes
Löschblatt blotting paper
löschen erasing
Löscher blotter
Lupe magnifying glass
Luxusabzug special deluxe edition

malen to paint
malend painting
Maler painter
Maler-Bildstecher painter-engraver
Mappe portfolio
Marktpreis market value
mehr more
mehrfarbig varicolored
Meissel burin
Meister master
Meisterwerk masterpiece
Menge amount; quantity
merklich noticeable
merkwürdig unusual; remarkable
Messer knife
Metallschnitt metal cut
Mischung mixture
mit der Hand färben hand-inked; hand-colored
Mitte middle
modisch fashionable
Monogramm monogram

montiert mounted
München Munich

nach according to; after
nach dem Beispiel von following the example of
nach der Art von in the manner of
nach der Meinung von in the opinion of
nachahmen to imitate
Nachahmung imitation; copy
Nachbildung reproduction
Nachdruck reprint
nachgewiesen traced; documented
nackt nude
nahe near
Name name
naturgetreu from life
neu new
Neurer innovator
nicht existierend nonexistent
nicht inbegriffen not included
nicht signiert unsigned
nicht teuer inexpensive
nicht unterzeichnet unsigned
nie never
noch einmal again; repeat
Normalgrund hard ground
notiert quoted (a price)
Notizen notes
numerieren to number
numerierung numbering
nützlich useful

ohne without
Öl oil
original initial; original
Originalausgabe original edition
Originalgraphik original print

Papierhersteller papermaker
Pappe cardboard
Pastellfarbe pastel
Pergament parchment
Photochromdruck color photograph

Photograph photographer
Photogravur photo-engraving
Photostechen photo-engraving
Pigmentpapier photographer's paper which is layered with colored gelatine
Pinselstrich, Pinselarbeit brushwork
Plakat poster
Platte plate (for printmaking)
polieren to polish
postum posthumous
prachtvoll splendid; magnificent
Preis price; prize
Preis auf Anfrage price on request
preisgekrönt prize-winning
Privatdruck privately printed
Probeabzug trial proof
Probedruck proof
Punkt point
punktiert stippled; dotted

Qualität quality
querdurchschneiden to cut across

Radierer etcher
Radiergummi eraser
Radierung etching
Rahmen frame
Rahmenlinie framing line (dimensions to the frame line)
Rand margin; edge
Randeinriss tear in margin
Randwasserflecke marginal water stains
Rechtfertigung substantiation; validation; process of registering a print
rechthaben to be right
rechts at the right
rechtswidrig illicitly
redigieren to edit
reiben to rub
reinigen to clean
reissen to tear

Reisskohle or **Zeichenkohle** charcoal used for drawing
Reklame advertising
Reliefprägung raised stamping; embossing
reserviert reserved
restauriert restored
Richter judge (member of jury at an art competition)
richtig proper
Rille groove
Riss tear
Roman novel
rostfleckig rust-stained
rot red
Rötelstift red ochre crayon
Rötelzeichnung drawing done in red chalk or sanguine
Rückschau retrospective
Rückseite verso
rückwärts reversed
Ruf artist's reputation, standing
Rundschau review (as in art review)

Salpetersäure nitric acid
sammeln to collect
Sammler collector
Sammlerzeichen collector's mark
Sammlung collection
satirisch satirical
saubermachen to clean
Schabkunst mezzotint
Schablone stencil
Schäden damages; defects
schaffen to create
scharf sharp
schärfen to refine
Schatten shadow
Schattierung shading
schätzenz to appreciate; to value
scheinen to appear
schief oblique; slanted; crooked
Schild label
Schlecht bad
schmalrandig with small margins

Schmirgelsteinstift emery-stone pencil or slip-stick
Schmutzfleck dirty spot
schmutzig dirty
schneiden cut off
Schnitt cut
schön beautiful
schönen Künste, die the fine arts
Schöpfer creator
Schraffierung hatching
schräg diagonal
Schräge bevel; slant
schräggeschnitten beveled
schreiben to write
schwach faint; weak
schwarz black
schwarz und weiss black and white
schweizer (isch) Swiss
schwierig difficult
sehr very
Seide silk
Seite (n) page (s); side (s)
selbst himself
selbstbildnis self portrait
selten rare
Seltenheit rarity
Sengschaden scorch damage
Siebdruck silkscreen print
Siegel seal; stamp
signiert signed
Silber silver
skizzieren to sketch
Sonderausgabe special edition
sorgfältig precise
spalten to crack; to split
Spezialdruck special print
Spiegelbild mirror image
staatlich national; state; public
Staffelei easel
Stahlstich steel engraving
Stahlüberzug steel-facing
Stammbaum pedigree; list of owners of a print; *provenance*
stark strong
statt instead of
Stecher engraver

Stecherkunst art of engraving
steif stiff
Stein stone
stellenweise partly
Stempel stamp
sterben to die
Stich engraving
stiften to endow
Stifter donor
Stil style; manner (of expression)
Stilleben still life
stockfleckig foxed; spotted by dampness
Streichen crossing out; to cancel
Strich line
Strichätzung line etching
Strichgravur line engraving
Stück piece
Studie study
Surrealismus surrealism

Tachismus technique of creating effect by spots of color
tadellos flawless, perfect
Tag day
talkpuder talcum powder (for preparing lithographic stone)
Tantiemen royalties
tausend thousand
teilweise partly
Tiefdruck or Intaglio intaglio printing
Tiefenätzung deep etching
Tiermaler artist who portrays animals
Tinte ink
Tintenfleck ink stain
Tintenschrift writing in ink
Titel title
Titelblatt title page
Ton tone
tot dead
trocken dry
Trockenstempel dry stamp
tröpfeln to drip

Tuch cloth
Tuschlavierung wash drawing (in lithographic ink)
typisch typical
typographisch typographical

überarbeiten to redo
überfliessen to overflow
überfüllen to clutter
Übersetzung translation
Übertrag transfer (of a drawing to a stone or plate)
übertrieben overdone
überziehen to coat
umgeben to surround
umgebung surrounding; background
umgekehrt reversed; upside down
Umriss outline; silhouette
Umschlag cover
unauffindbar unobtainable
unbekannt unknown
unbenannt unnamed; anonymous
unberührt perfect; untouched
unbeschnitten uncut
unbestimmt not established; indefinite
unegal unequal
unfertig unfinished
ungefähr approximately
ungeschnitten uncut
unsauber soiled; dirty
unten at the bottom; below
unterhalb beneath
Unterhändler dealer
Unterrand bottom margin
unterscheiden to distinguish; to tell apart
Unterschrift signature
Untertitel subtitle
unterzeichnen to sign
unterzeichnet signed
unverändert unchanged; unaltered
unveröffentlicht unpublished
unvollständig incomplete
Ursprung origin; provenance

Velinpapier wove-paper; like vellum
verbessert corrected; retouched
Verbesserung retouching; correction
verbilligt reduced in price
verblasst faded; pale
verblichen faded
verdorben marred; blemished
verdreht twisted; out of shape
vereinzelt here and there
verfallen to deteriorate
verfärbt discolored
verfügbar available
vergilbt yellowed
vergleichen compare
vergolden to gild
vergrössern to increase; to enlarge
Verkauf sale
verkaufen to sell
Verkaufspreis sales price
Verkauft sold
Verlag publisher
Verlagsgesellschaft publishing firm
Verlagsrecht copyright
Verleger publisher (of graphics, books, etc.)
verloren lost
Vermächtnis bequest
vermehrt increased (in number)
Vermerk remark; note
vermindern to reduce
Verminderung reduction
vernachlässigen to neglect
veröffentlichen to publish
Verschleiss wear-and-tear; abrasion
verschmutzt soiled
verständlich understandable
verstärkt strengthened; reinforced
verstaubt dusty
versteigert sold at auction
Vertiefung impression; depression made on the paper by the entire metal plate
verwenden to use

verwischt blurred
Verzeichnis list; listing; index
verzieren to adorn
viel (e) much; many
viel höher much higher
viel niedriger much lower
Viereck square; rectangle; (quadrilateral)
Vogelperspektive bird's eye view
völlig wholly; entirely
vollrandig full margins
vollständig complete
von Würmern zerfressen worm-eaten
vor kurzem erschienen recently published; just out
Vorbesitzer previous owner
Vordergrund foreground
vorgezogen favorite
Vorn front
Vorname first name
vorrätig available
Vorsatzblatt flyleaf
Vorwort preface

Wachs wax
Wahlspruch slogan
Wahrheit truth
Wandgemälde mural
Wasser water
wasserbeschädigt damaged by water
Wasserfarbe watercolor
Wasserfleck water stain
wasserfleckig waterstained
wassergewellt wrinkled by water
wasserrandig water-stained
Wasserschäden water damages
wasserwellig water wrinkled
Wasserzeichen watermark
wechseln to change
weichgrund soft ground
weiss white
weissmachen to whiten; to bleach
wenig few
Werkzeug tool

Wert value; quality
wertlos worthless; undeserving
wichtig important
wie like; as
wie es ist as it is, like it is
wieder again
Wiedergabe 'rendering; reproduction
wiederherstellung restoration (of a print)
wiederholt repeated
Winkel angle; corner
winzig tiny; minute (in size)
winziger als tinier than
wischen to wipe
wissenschaftlich scholarly
wohlerhalten well-preserved
wohlfeil inexpensive
Wurmfrass worm-eaten
Wurmlöcher wormholes
Wurmstiche wormholes

zahlreich numerous
zehn ten
Zeichen symbol; mark; characteristic insignia; chop; logo
Zeichenstift drawing pen
zeichnen to draw
Zeichnung drawing
Zeit time
zeitgenosse contemporary
zeitgenössisch contemporary
Zeitschrift periodical (publication); journal; magazine
Zeitspanne period in time
Zeitung newspaper
zerknittert wrinkled
Ziffer cipher
Zinkätzung zinc etching
zirka approximately, circa
zu einem annehmbaren Preis at a good price
zu viel too much
zugeschrieben attributed
zunehmen to increase
zur Zeit now; at present

zusammen together

zusammengestellt compiled; collected

Zusammenlaufen blending or running together of inks or colors

zusammensammeln to collect

Zusammensetzung composition; the way a work of art is laid out

zusprechen to adjudge

Zustand statc (of print); condition

Zustandsdruck a state of a print

zuverlässig reliable; authentic

zweifarbig two-color

zweifellos without doubt

zwischen between

Notes

1. WHAT THE PRINT COLLECTOR NEEDS TO KNOW

et passim. Most of the information about Whistler's prices *page* 7
is from Elizabeth Stevens, "The Rise, Fall and Rise of
the Whistler Print Market," ART*news*, November 1972.

The Harlow, Keppel catalog referred to is André Smith, *page* 8
Concerning the Education of a Print Collector (New
York: Harlow, Keppel & Co., n.d.).

2. EXAMINING A PRINT

The Marsh quotation is from Thomas Craven, ed., *A* *page* 16
Treasury of American Prints (New York: Simon &
Schuster, 1939), unpaged.

The story about Seymour Haden signing impressions from *page* 17
periodicals is told by Carl Zigrosser, *Fine Prints Old and
New* (New York: Covici, Friede, 1937), p. 48.

For more about Ben Shahn's prints and his attitude toward *page* 17
them, see Kenneth W. Prescott, *The Complete Graphic
Works of Ben Shahn* (New York: Quadrangle/New
York Times, 1974).

Leonard Baskin is quoted by Joanna Eagle, *Buying Art* *page* 19
on a Budget (New York: Hawthorn, 1968), p. 135.

Zigrosser, *Fine Prints*, p. 51. *page* 19

The information about Whistler and the quotation from *page* 20
Harry Katz are in Elizabeth Stevens, "The Rise, Fall
and Rise of the Whistler Print Market," ART*news*,
November 1972.

page 22 Rubens' print is mentioned in William Ivins, Jr., *Notes on Prints* (New York: Da Capo Press, 1967, a reprint of a 1930 edition published by the Metropolitan Museum of Art), p. 91.

page 23 S. W. Hayter, *About Prints* (London: Oxford University Press, 1962), p. 131.

3. BUYING A PRINT

page 42 Sophy Burnham, *The Art Crowd* (New York: McKay, 1973), pp. 59–60.

page 43 R. E. Lewis, "The Pleasure of Learning, Looking, the Excitement of Buying," in Arthur Vershow, Sinclair Hitchings, R. E. Lewis, *Print Collecting Today* (Boston: Boston Public Library, 1969), p. 36.

page 45 Adrian Eeles, "Bidding by Mail," *Print Collector's Newsletter*, New York: vol. III, no. I (March–April 1972), p. 6.

page 53 Arthur Vershow, "A Collector's View of Print Collecting Today," in Vershow, Hitchings, Lewis, *Print Collecting Today*, p. 11.

page 54 Lewis, "The Pleasure of Learning," pp. 33–34.

page 55 S. W. Hayter, *About Prints* (London: Oxford University Press, 1962), p. 161.

4. THE CONTEMPORARY AMERICAN PRINT

page 62 A concise overview of American printmaking by David Shapiro can be found in "SAGA: Fifty Years of American Printmaking," the catalog of the 50th Annual Exhibition of the Society of American Graphic Artists presented at the Associated American Artists Gallery, 663 Fifth Avenue, New York City, May 5–May 30, 1969.

page 62 A brief outline of the evolution of Pratt Graphic Workshop, written by Fritz Eichenberg, appeared in *Artist's Proof*, vol. 1, no. 1, 1961. He tells about founding Pratt's undergraduate graphic art department in *Education in the Graphic Arts* (Boston: Boston Public Library, 1969).

page 63 The quotation is from the catalog, "Two Decades of American Prints: 1920–1940," June 21–September 8, 1974, National Collection of Fine Arts, Smithsonian Institution, Washington, D.C. Readers will find this essay by Janet Flint valuable for information on the

period. Lynd Ward's remarks were taped during an
interview in 1975.

Garo Z. Antreasian talked about his efforts to learn lithog- *page 64*
raphy when he spoke on "Some Aspects of Process
and History in My Work" on the occasion of the
Twenty-First Annual Research Lecture at the Univer-
sity of New Mexico, where he is Professor of Art, on
Tuesday, April 27, 1976. It is expected that his talk and
that of Clinton Adams, Dean of the College of Fine
Arts and Director of Tamarind Institute, called "Mind,
Eye, Hand and Stone" will be published in the near
future.

Una Johnson's comment is from the Brooklyn Museum *page 65*
exhibition catalog, "Ten Years of American Prints,
1947–1956." Brooke Alexander's figure is from his re-
sponse to our questionnaire.

A sympathetic article by Herbert Mitgang in ART*news*, *page 66*
March 1974, tells the story of Tatyana Grosman's work-
shop. The authors also interviewed Mrs. Grosman and
visited the ULAE workshop.

Some of the history of Associated American Artists, its *page 68*
prints and printers, can be found in Robert H. Glauber's
introduction to the catalog, "Prints at Popular Prices:
An exhibition celebrating the 40th anniversary of Asso-
ciated American Artists, 1934–1974." It was held at the
Lobby Gallery, Illinois Bell, 225 W. Randolph, Chicago,
Illinois. See also the introduction by Sylvan Cole to the
Fortieth Anniversary Exhibition catalog.

An edited transcript of a discussion about the pricing of *page 69*
prints was published in the *Print Collector's Newsletter*,
vol. VI, no. 1, March–April 1975: René Block, a pub-
lisher of multiples; Sylvan Cole, director of Associated
American Artists; Kenneth Tyler, founder of Gemini
G.E.L. and the Tyler Workshop; John Loring, artist and
critic; Jo Miller, then curator of prints and drawings at
the Brooklyn Museum. The direct quotation of Cole is
from this source. Hank Baum's remark was included in
his response to our questionnaire.

5. PRESERVING PRINTS

Two works that have been particularly helpful throughout
this chapter are *Framing and Preservation of Works of*

Art on Paper, a pamphlet prepared by Mary Todd Glaser for Sotheby Parke Bernet Galleries, and *How to Care for Works of Art on Paper* by Francis W. Dolloff and Roy L. Perkinson, published by the Museum of Fine Arts in Boston in 1971. The latter is recommended as an excellent source of further information and is widely available in museum bookstores.

6. BUILDING A PRINT REFERENCE LIBRARY

For further information on art book sources both here and abroad, refer to the books noted below. We are indebted to all of them.

Cummings, Paul, ed. *Fine Arts Market Place: 1975–1976 Edition.* New York and London: Bowker, 1975.

The 1973–74 AB Bookman's Yearbook, Part II: The Old and the New. Newark, N.J.: Antiquarian Bookman, 1975.

International Directory of Arts. 2 vols. Frankfurt: Art Address-Verlag Müller GmbH & Co. KG, 1975.

7. CATALOGING A PRIVATE COLLECTION

page 115 The information here and on the following pages about John Sloan's prints was found in Peter Morse's *catalogue raisonné, John Sloan's Prints.*

page 116 The remarks about Whistler's signature are quoted from Burns A . Stubbs, *James McNeill Whistler: A Biographical Outline Illustrated from the Collections of the Freer Gallery of Art* (Washington, D.C.: Smithsonian Institution, 1950), pp. 12–13.

page 117 The Keppel editions of Twachtman's etchings are noted in Mary Welsh Baskett's essay in *A Retrospective Exhibition: John Henry Twachtman,* Cincinnati Art Museum, October 7–November 20, 1966, p. 34.

8. SELLING A PRINT

page 125 The Lessing Rosenwald quotations are from "The Treasure of Jenkintown, Pa.: Lessing Rosenwald's 25,000 Prints," by Fred Ferretti, ART*news*, March 1973, pp. 42–44.

page 126 Robert Rauschenberg's 1973 comment, widely reported

earlier, is repeated by Roy Bongartz in "Writers, Composers and Actors Collect Royalties—Why Not Artists?" *New York Times*, February 2, 1975, Section 2, p. 1. The problem has been discussed over a long period in a range of periodicals. Related recent articles include Carl Baldwin, "Art and the Law: Property Right vs. 'Moral Right'," *Art in America*, September/October 1974, p. 34; and Carl Baldwin, "Art and Money: The Artist's Royalty Problem," *Art in America*, March/April 1974, p. 20. See also *The Visual Artist and the Law* (New York: Associated Councils of the Arts, 1971). A brief article by Rubin Gorewitz, "Royalties for Artists: A Practical Proposal," can be consulted in *American Artist*, January 1975, pp. 28–29. The *Art Workers News* cited on page 126 is published monthly by the Foundation for the Community of Artists, 32 Union Square East, New York, N.Y. 10003. An overview of action to date appears in "Artists Rights: Pros and Cons," Sylvia Hochfield, *ARTnews*, May 1975, pp. 20–25.

"A La Tour Is Acquired by Chrysler," by Grace Glueck, *New York Times*, February 11, 1975. *page 131*

Ruth Ziegler's remarks are from an unpublished, taped interview conducted by one of the authors at Sotheby Parke Bernet, May 13, 1975. *page 136*

9. SEEING PRINTS

Major research sources for the lists in this chapter are noted below. For our list of print collections we surveyed by questionnaire almost 600 print rooms and museums. We developed the small list of print clubs in various ways over a period of time. The selected list of print dealers was put together by consulting directories, by studying advertisements in the *Print Collector's Newsletter* and one or two general art magazines, and by means of our own knowledge and experience over a long period with dealers in this country and abroad.

American Art Directory. New York: Bowker, for the American Federation of Arts, 1974.

Ash, Lee, and Denis Lorenz. *Subject Collection: A Guide to Special Book Collections and Subject Emphasis as Reported by University, College, Public and Special Libraries*. 3rd ed. New York: Bowker, 1967.

Brody, Jacqueline, ed. "American Print Cabinets: A Directory." *Print Collector's Newsletter* 4 (1973), i–iv.

Cummings, Paul, ed. *Fine Arts Market Place: 1975–1976 Edition.* New York and London: Bowker, 1975.

International Directory of Arts. 2 vols. Frankfurt: Art Address-Verlag Müller GmbH & Co. KG., 1975.

Museums of the World: A Directory of 17,500 Museums in 150 Countries, Including Subject Index. 2nd ed., enlarged. Munich, New York, and London: Verlag Dohumentation and R. R. Bowker Company, 1975.

The Official Museum Directory: United States and Canada. Washington, D.C.: American Association of Museums and Crowell-Collier Educational Corp., 1970.

Shadwell, Wendy J. "Early American Print Resources in the United States," in John D. Morse, ed., *Prints in and of America to 1850: Winterthur Conference Report.* Charlottesville: University of Virginia, 1970.

Index